THE ART OF CONTROVERSY

THE Art OF
Controversy

POLITICAL CARTOONS
AND THEIR ENDURING POWER

VICTOR S. NAVASKY

ALFRED A. KNOPF NEW YORK

2013

THIS IS A BORZOI BOOK
PUBLISHED BY ALFRED A. KNOPF

Grateful acknowledgment is made to *The Nation* magazine for permission
to reprint excerpts from "Letters to the Editor" (1988) by Jules Feiffer,
J. C. Suares, Robert Grossman, and Bill Charmatz; and "The Grim Reaper"
(1933) by Georges. Reprinted with permission of *The Nation* magazine.
For subscription information, call 1-800-333-8536. Portions of each week's
Nation magazine can be accessed at http://www.thenation.com.

Library of Congress Cataloging-in-Publication Data
Navasky, Victor S.
The art of controversy : political cartoons and their enduring power /
Victor S. Navasky.
pages cm
Includes index.
ISBN 978-0-307-95720-7 (hardback)
1. Political cartoons. I. Title.
NC1763.P66N38 2013
320.02'07—dc23
2012038247

Jacket design by Jason Booher

Manufactured in the United States of America
First Edition

To Milo, Gideon, Victor, Izzy,
and the New World a-Comin'

One picture is worth ten thousand words.

> —Chinese proverb (perhaps wrongly attributed to
> Confucius, but if he didn't say it, he should have)

My subject had become a victim and his dark features black-
ened, resembling my drawing even more.

> —RALPH STEADMAN, 1970

Engravings or lithographs act immediately upon the imagi-
nation of the people, like a book which is read with the speed
of light; if it wounds modesty or public decency the damage
is rapid and irremediable.

> —French interior minister, FRANÇOIS RÉGIS DE LA
> BOURDONNAYE, COMTE DE LA BRETÈCHE,
> September 8, 1829

A good caricature, like every work of art, is more true to life
than reality itself. —ANNIBALE CARRACCI

A caricature is putting the face of a joke on the body of a
truth. —JOSEPH CONRAD

Contents

Introduction xi

The Cartoon as Content 3
The Cartoon as Image 15
The Cartoon as Stimulus 23
Caricature 28

THE GALLERY

William Hogarth 55
James Gillray 61
Francisco Goya 65
Charles Philipon 69
Honoré Daumier 73
Thomas Nast 77
Pablo Picasso 83
The Masses: Art Young and Robert Minor 87
Käthe Kollwitz 93
George Grosz 97
John Heartfield 103
Der Stürmer 107
David Low 113
Philip Zec 117
Victor Weisz (Vicky) 121
Bill Mauldin 123
Herbert Block (Herblock) 129
Al Hirschfeld 133

CONTENTS

Raymond Jackson (Jak) 137
Ralph Steadman 141
Robert Edwards 145
Naji al-Ali 151
Edward Sorel 155
Robert Grossman 161
Steve Platt and the *New Statesman* 167
The New Yorker Images 171
Doug Marlette 175
Plantu and the Danish Muhammads 181
Qaddafi and the Bulgarians 187
Jonathan Shapiro (Zapiro) 191
David Levine 197

Timeline 201
Acknowledgments 211
Selected Bibliography 213
Index 221

Introduction

In something like thirty years at *The Nation*,* first as the magazine's editor, then as owner and publisher, only once did the staff march on my office with a petition demanding that we not publish something. That something was a cartoon, a caricature.

At the time (February 1984) I thought that the staff's anger had to do primarily with the fact that they thought the cartoon in question was politically incorrect (or in the argot of the day un-PC). No matter that the caricaturist was the late David Levine, perhaps America's, if not the world's, leading practitioner. And no matter that his caricature was a powerful work of art. Indeed, that was the problem.

It all started with a phone call from David, known to me as a former contributor to *Monocle*, "a leisurely quarterly of political satire" (which meant it came out twice a year) I had founded as a student at Yale Law School in the late 1950s. By now he was known to his fellow artists as one of the great (if unfashionable) realist painters. He was known to the media and intellectual communities as the genius responsible for the artfully witty but wicked crosshatched pen-and-ink caricatures that had helped define the look of the prestigious *New York Review of Books* since its founding in 1963.

David called because he had done a caricature of Henry Kissinger on assignment for the *Review*,† which his editor felt was "too strong." The magazine said it would publish the drawing "later." David was not so sure about that, and anyway, wanted to publish it right away. The cartoon, he told me, showed Kissinger in bed on top and the world in the form of a naked woman underneath him. She had a globe where her head should have been, and Kissinger was "screwing her" under

* *The Nation*, founded by abolitionists in 1865 following the Civil War, is America's oldest weekly magazine, known for its dissenting, radical, and often troublemaking left-liberal politics.
† The caricature was to accompany a meditative essay on the Kissinger Commission's recently issued Caribbean Basin report calling for economic aid to Central America.

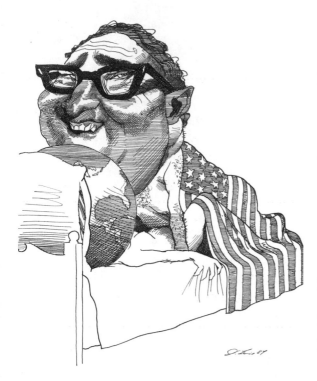

David Levine,
"Screwing the World"
(1984)

an American-flag blanket. Were we interested? "David," I said, "it will get me in all sorts of trouble with my staff, but send it over." "Why will it get you in trouble with your staff?" he asked. "I don't know," I said, "but I know it will."

The cartoon arrived an hour later. It was, as expected, a magnificent caricature. But the look on Kissinger's face, mingling ecstasy and evil from behind thick black horn-rimmed glasses, made it somehow more than just a caricature; it seemed to capture Kissinger's complicated soul. I called David and with enthusiasm told him we would publish his drawing. Two hours later, the petition landed on my desk, signed by twenty-five people in an office that I had thought employed only twenty-three. Many of the signatures were followed by little comments. "Sexist!" one had written. "Why isn't he doing it to a Third World male?" asked another.

I called an office-wide meeting. At the outset, I told everyone that it was important to keep three things in mind: First, although I took the staff concern seriously, there would be no vote at the end, because you can't, or at least shouldn't, decide a question of aesthetics by majority vote. (Lucky for me, no one asked, "Why not?") Second, this work had been offered to us on a take-it-or-leave-it basis, so while anyone was free to say whatever he or she pleased, suggestions to change the drawing would have no operative effect. Third, because I had already told Levine that we intended to use his drawing, although the magazine could always change its mind, I thought that a decision not to use it would have about it the whiff of censorship, fairly or not.

The most articulate staff objection to Levine's drawing was that *The Nation* was supposed to fight against stereotypes, and this cartoon reinforced the stereotype that sex was dirty and something that

an active male on top does to a passive woman on bottom. My favorite moment came when our then-columnist Christopher Hitchens said he thought that the cartoon was not about an act of sex, but about an act of rape, Kissinger ravaging the world. "But if you look at the woman's hand," replied the young woman who had made the point about stereotypes, "it seems to be gripping the mattress in what could be the grip of passion." The white-suited, suave, British-born Christopher, who in those days enjoyed playing the office roué, leaned over and, gripping the young woman's hand, said, "Trust me, my dear, it's not the grip of passion." The discussion, sometimes tense, lasted for a couple of hours, and at my suggestion we invited Levine to join the conversation a few days later, when it was resumed.

David pointed out that as a caricaturist he dealt in stereotypes—which poses a problem when one is rendering, for example, members of a minority race. How do you make a comment on racism without falling into its trap? Nevertheless, it's the cartoonist's job to play off of stereotypes that a majority of readers and viewers will recognize. David being David, he also said all the wrong things. When asked why the man had to be on top, for example, he replied (in a room that included people of various sexual preferences), "I'm just showing what *normal* people do."

After he had spent two hours on the griddle, having been shown not a jot of deference, I asked him whether he was sorry he came. Levine said he had been doing this work for twenty-five years and had never had such a serious discussion of it, and for that he was grateful. He had gotten some new insights into the problematics of cartooning. But he added, "If I had it to do again, I wouldn't change a line. I think it's one of the strongest pieces I've ever done."*

My thought at the time was that beyond the political objections, the

* Six years after the fact, Levine's judgment was, arguably, vindicated. When the American studies and art-history departments of Columbia University decided to mount an art exhibit to commemorate *The Nation*'s 125th anniversary, the curators—having surveyed the work of thousands of candidates, including such fine artists as Louis Lozowick, Ben Shahn, Rockwell Kent, George Grosz, and William Gropper—in ignorance of the dispute, chose Levine's Kissinger as one of forty pieces to be exhibited; when the exhibit moved to the José Luis Sert Gallery at Harvard, they put the drawing on the catalogue cover.

staff's emotional reaction (which I saw as overreaction) was probably a delayed protest over my general failure to consult as much as I might have, or my generational insensitivity to matters of sexual politics. Looking back, I can see that in underestimating the power of Levine's *über*-un-PC image to provoke, I may have internalized the views of the many art critics, art historians, and artists who themselves have, over the years, dismissed cartoons and caricatures as fundamentally "not serious," "inconsequential," "irrelevant," "marginal," "harmless," "frivolous," "a benign—even childish—indulgence," "immoral," and "silly."

"Caricature had been considered a dangerous infraction against the canons of beauty, at least since the eighteenth century. Diderot had spoken out against it, as had Goethe," wrote Aimée Brown Price, associate professor of art history at Queens College, in 1983. Even Sir Ernst Hans Josef Gombrich, the distinguished art historian, author of the justly praised celebratory study *The Cartoonist's Armory* (1963), tells us that early in the last century, cartoons were merely tolerated as "the pardonable license of the low medium of illustration." And since caricature is but one form of illustration, consider what it means that Ralph Steadman, among our most brilliant contemporary caricaturists, says with characteristic self-deprecation that it is "a low art. Shoulder to shoulder with a work of fine art, it is nothing but a cheap joke, a space filler, propaganda."

But it was not until 2005, when the Danish newspaper *Jyllands-Posten* famously published a dozen cartoons depicting the prophet Muhammad, that I thought to focus on the power of cartoons as cartoons. After all, from Asia to Europe hundreds of thousands of Muslims took to the streets to protest. Embassies were shut down. Ambassadors were recalled. In Pakistan, protesters burned Danish flags. Worldwide, more than a hundred people were killed, another five hundred injured. Danish goods were boycotted. The cartoonists were forced to go into hiding, with million-dollar price tags put on their heads. And most of these protesters never even saw the caricatures in question. It was the very idea that Muhammad had been caricatured that caused the outrage. What, I asked myself, was going on here?

Suffice it to say that the emotional response of millions of Mus-

lims the world over to the Danish Muhammads, in retrospect, made me suspect that *The Nation* staff's reaction to Levine's Kissinger cartoon had as much to do with the medium as it did with the message it contained.* It seemed to me that the complex and fascinating issues raised by the impassioned responses to both the Muhammad and Kissinger caricatures warranted further exploration, especially given the gamut they represented—the one involving matters of life and death whereas the other, an in-house revolt, was, on the surface, trivial (although one wouldn't know it from the intensity of the outrage it provoked).

I quickly discovered what I should have already known: that cartoons and caricatures have been causing controversy for centuries. Hence, this book, which reaches far beyond the Danish Muhammads and David Levine to look at cartoons and caricature worldwide from before the time of Honoré Daumier, the legendary nineteenth-century French sculptor and printmaker who was thrown into jail by King Louis Philippe, up to and after contemporary cartoonists like Naji al-Ali, the Palestinian illustrator who was murdered on the streets of London in 1987.

What accounts for the supercharged outrage of those affronted by cartoons and caricatures? And what accounts for the outsized political influence of cartoonists throughout the world—from the vicious anti-Semitic caricatures of the Nazi periodical *Der Stürmer*, which helped turn a generation of Germans into Jew haters, to the civil-libertarian cartoons of America's Herblock, who gave Senator Joseph McCarthy a bucket of tar with a big brush, and literally gave McCarthyism its name? Or what about the controversies that seem to be sparked by the cartoonist Art Spiegelman virtually every time he picks up his pen? What makes political caricature in particular so incendiary? Whence does it derive its power? Is there a correlation between the artistic quality of a caricature and the response it evokes? Why do cartoonists and caricaturists inspire such fear in tyrants and bureaucrats alike? And what do art historians, critics, psychologists, neuroscientists, psychiatrists, miscellaneous academics, the cartoon-

* When I first wrote about this episode in 2005 in *A Matter of Opinion* (see pages 356–9 in that book), I focused on Levine's message, neglecting the importance of his medium.

ists, artists, and illustrators themselves, and other interested parties have to say about all of this?

My methodology was anything but scholarly. I plunged into what literature I could find on my subject. My reading included scores of books and articles, ranging from scholarly tomes on art history (see bibliography) to books like Scott McCloud's *Understanding Comics: The Invisible Art* (1993). I discovered and joined a LISTSERV called Comix-Scholars. I also discovered and contacted an organization called the Cartoonists Rights Network International (CRNI), a network set up to help cartoonists around the world in political trouble. I consulted the files of the Committee to Protect Journalists (cartoonists included), on whose board I sit. I visited the Billy Ireland Cartoon Library & Museum at Ohio State University, the British Cartoon Archive in Canterbury at the University of Kent's Templeman Library, and the Cartoon Museum in London, of which I became a member, and the Museum of Comic Art in New York City. I visited the Wilhelm Busch Museum in Hanover, and the *Stürmer* archives in Berlin. And I talked to anyone who seemed to have something to say on my subject who would talk with me.

And far from pretending to objective detachment, I want to make clear my biases. Bias number one: as you might deduce from my mention of *Monocle* above, I have long believed in satire as a particularly effective instrument of social criticism.* It is probably no coincidence

* My belief in the power of satire to achieve social change was reinforced one day in the spring of 1962. I was sitting in my *Monocle* office when I had an unexpected visitor. It was a little-known recent graduate of Harvard Law School named Ralph Nader, who went on to found the public interest law movement. He was just back from the Soviet Union, where he had been on assignment for *The Christian Science Monitor*, writing on *Krokodil*, the Soviet satire magazine. He was full of stories about how in Eastern Europe satire magazines—deploying cartoons—served the function of an ombudsman, and he thought the same thing could happen in the U.S.

"A visit from the *Krokodil* man is feared," he told me. Not only that, but, as he would later report, *Krokodil* "is the granddaddy of twenty-two similar endeavors published in the native languages of the Soviet Republics. . . ." In addition, each Communist country in Eastern Europe had its own satire journal, such as Poland's *Szpilki* and Hungary's *Ludas Matyi*.

He was most impressed with *Krokodil*'s use of cartoons. As *Krokodil*'s editor told him, "We don't have much success in eliminating the evils of capitalism abroad, but we do expose corruption, irresponsibility, and other bad elements in our country's economic, social, and cultural life."

that the first article I ever published (as a Yale Law School student in 1958) was about parody. It appeared in *Frontier* magazine, a West Coast–based progressive journal of opinion that is no longer with us, and argued that parody deserved Supreme Court protection as free speech. It was pegged to the U.S. Supreme Court's decision in a case called *Benny v. Loews,* which involved my favorite radio comedian, Jack Benny. In his TV parody of the 1944 movie thriller *Gaslight,* Charles Boyer tries to persuade Ingrid Bergman, his movie-wife, that she is going crazy, as part of his plot to kill her. Benny's parody was called *Autolight.*

I'll say a little more about the case only because it occurs to me now these many years later that in some respects parody is analogous to caricature, and as such, germane to our subject, which will come in due course (patience, dear reader). The Supreme Court split 4–4 in the *Benny* case, thereby upholding the decision of the lower court, which in my view had counted what it couldn't comprehend.

I think the court assumed that parody should be judged by the same standards as traditional copyright-infringement cases, an assumption that ignored parody's physiology. Parody is parasitic, approaching its subject from within. Go ahead and parody, said the lower court, only keep your distance, thereby ignoring the insight of *The New Yorker*'s great parodist Wolcott Gibbs, that "parody should be pitched so little above (or below) the original that an intelligent critic, on being read passages of both, might honestly be confused." (It was Gibbs who famously wrote of *Time* magazine's much-mocked style, "Backward ran sentences until reeled the mind [. . .] Where it all will end, knows God!")

The lower court's decision seemed to me mindless, and I said so, invoking John Stuart Mill as my ally, by quoting each of the classic arguments for free speech that he put forward in his essay "On Liberty." I did my sophomore-law-student best to show why parody fit under each of them.

A typically powerful cartoon attacking the listlessness of sales personnel showed a row of mannequins and salesladies interspersed. One customer was telling another, "They are all just as attentive!"

I concluded that since speech should promote the good and the beautiful as well as the true, parody, which amuses, criticizes, satirizes and creates, should enjoy the same constitutional protection as political speech and that, given the courts' miserable record in the *Benny* case, perhaps "artists, not judges, should draw the relevant lines."

Like parody, caricature distorts the original, it can be unfair, and it uses humor to reveal the shortcomings of, and occasionally to humiliate, its subject. For all that, it's the difference between cartoons and caricatures, which speak in the language of images (which sometimes come with words attached), and words, which speak in the language of, well, words, that makes us ask when, how, and why visual language trumps verbal language when it does.

Bias number two: I am a free-speech absolutist. Even before I entered Yale Law School, where I took Professor Thomas Emerson's internationally renowned seminar on political and civil rights and liberties, the first of its kind, I was a card-carrying member of the American Civil Liberties Union.

Also, long ago I fell under the influence of Jürgen Habermas, one of the few living survivors of the Frankfurt School, the interdisciplinary group of Marxist theorists associated with the Institute for Social Research, founded in Frankfurt in 1923. I find his notion of the public sphere, a civil society dominated by neither the market nor the state, but rather governed by what he has called the power of the better argument, a compelling one, which is not to say that I have been unaware of the importance of the image in the history of art. Nor, having read Vance Packard's *The Hidden Persuaders* (1957), am I ignorant of the way advertising can manipulate public opinion. And like everyone else, I have been exposed to the uses of visual propaganda in war- and peacetime political campaigns. Nevertheless I had always assumed that Habermas's "better argument"—and it has to do not just with Habermas but also the American Civil Liberties Union, the First Amendment, the Enlightenment, and ultimately the case for free expression—would express itself in words, rationalize itself in logic, document itself with "best evidence," prove itself in argumentation. But if it turns out that on significant occasion tyrants, presidents, courts, people—readers, viewers, citizens, illegals, what have you—are more

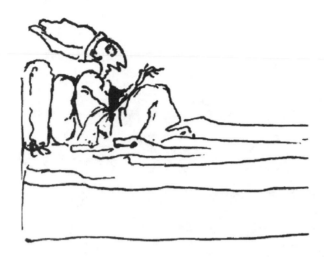

Gianlorenzo Bernini,
caricature of Pope
Innocent XI (1676)

moved to take political action by cartoons (especially caricatures) than
by words, logic, and argument, then what? Stay tuned.

What follows, however, does not pretend to be a history of car-
toons and caricature, for two reasons. First, I am not an art scholar
or a historian; but more important, as far as I can see, those who are
can't seem to agree with each other on much of anything. Take, for
example, the history of caricature. Although there have been any num-
ber of so-called histories of caricature, I can tell you that the experts
can't even agree on its date of origin. Some date its birth as early as
1360 B.C., in Egypt, when an anonymous artist skewered Akhenaten,
Queen Nefertiti's pharaoh husband. Others point to Gianlorenzo Ber-
nini's doodle of Pope Innocent XI (1676), because it was one of the
first drawings to assert that no one is beyond ridicule.

Caricature has meant different things to different artists. The Vien-
nese art historian Werner Hofmann argues that Albrecht Dürer's
"Ten Heads in Profile" (1513) represents a kind of proto-caricature.
He writes that caricature "according to Dürer is a mathematical exer-
cise that disrupts ideal beauty which is conceived as a norm." But for
Leonardo da Vinci, whom many consider to have invented the form,
caricature is rather "an extrapolation of realism taken to its logical
extreme. . . . Moving beyond Universal Beauty, Realism searches in
the particular for an image of secular truth."

Albrecht Dürer, "Ten
Heads in Profile"
(1513)

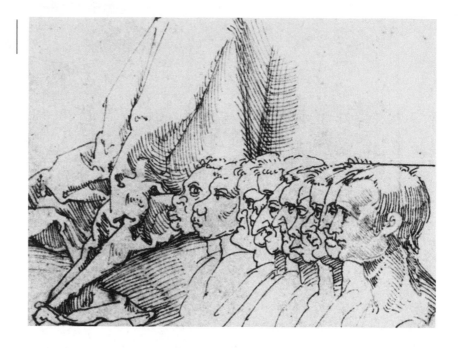

In the sixteenth century, the Italian artist Annibale Carracci wrote that a good caricature should "reveal the very essence of a personality"—i.e., it should reveal its subject's character. But William Hogarth, generally credited as the "father" of English caricature, didn't agree; and not only that, he seemed to have had little use for the form. In his famous print *Characters and Caricaturas*, he juxtaposed the two; and later he wrote, "There are hardly two things more essentially different than characters and caricature. Characters are portraits presumably reflecting reality, and caricatures are something else again." And he added, "Caricature may be said to be a species of lines that are produced by the hand of chance rather than of skill."

And consider this: Despite Hogarth's disavowal of the form, when art director and critic Steven Heller published his own book on caricature a few years ago he observed that by the late eighteenth century, "caricature . . . had been perfected in savage reflections of Britain's high and low society." Whom did he include on his list of "delightfully bawdy and scandalously irreverent" caricaturists, along with Thomas Rowlandson, James Gillray, and George Cruikshank? William Hogarth, of course.

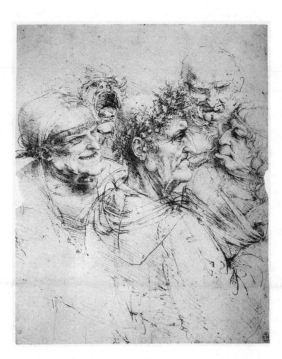

Leonardo da Vinci,
"Five Grotesques"
(1490)

So far from being a definitive history, what follows is an inquiry into how cartoons and caricatures get their power and their ability to make a difference, based in part on my own experience, that of a word person attempting to understand the impact of images.

. . .

I commence this journey in the growing conviction that, far from trivial, under certain circumstances cartoons and caricatures have historically had and continue to have a unique emotional power and capacity to enrage, upset, and discombobulate otherwise rational people and groups and drive them to disproportionate-to-the-occasion, sometimes violent, emotionally charged behavior. I'm talking about everything from overheated and irrational letters to the editor and subscription cancellations to censorship, prosecution, incarceration, and, as indicated above, violence and murder.

I explore three theories that explain why. The first focuses on substance: people get upset about cartoons because of their content (the Content Theory). The second focuses on form—people react so emo-

**William Hogarth,
*Characters and
Caricaturas* (1743)**

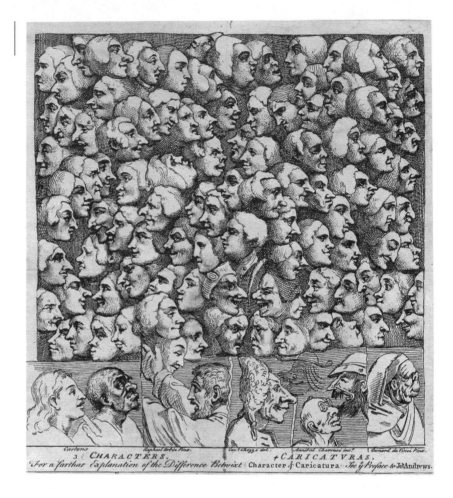

tionally because of the form or image they see (the Image Theory). The third considers content and image together as a stimulus, and focuses on the brain's response to it (the Neuroscience Theory). In what follows I briefly consider each of these theories; and then, before inviting you to wander on an unguided tour through the cartoon gallery, I subject you to my lecture on caricature, because it is the one subcategory of cartoon that most frequently seems to cause more than its share of comedy and tragedy, not to mention mischief.

THE ART OF CONTROVERSY

The Cartoon as Content

The Content Theory—that in most cases, the cause for agitated discontent has to do with the cartoon's political content—seems on the surface to be true almost by definition, and other than "Duh!" not that much more needs to be said. But as you will see from what follows, for better or worse, I have a lot more to say. So in the interest of transparency let me confess in advance that out of the countless examples one might have chosen, the basis of selection for the cartoon content discussed below is largely autobiographical.

As a founding member of the Committee to Protect Journalists, I have spent forty years on the board of an organization that works on behalf of journalists who got in trouble for something they wrote. But in all of those years, it never occurred to me until now to ask about cartoonists who got in trouble because of the content of their cartoons. Hence I include some startling examples of what I would have discovered. Then, because I witnessed it, I also include the firestorm caused by another *Nation* cartoon—this one by Ed Sorel, one of the world's most talented graphic complainers about injustice and hypocrisy, also a former *Monocle* contributor and old friend. Beyond my personal experience I have included the UK cartoonist David Low's caricatures of Adolf Hitler because his psychological insight into both his subject and his audience of one (Hitler himself) is so illuminating that I could not not share it. And finally, I have included the controversy surrounding the content of Barry Blitt's *New Yorker* cover of the Obamas as terrorists because the response to it—which included candidate Obama's decision to interrupt his campaign for president to air his displeasure—contains a lesson that no one who cares about the nature of caricature can afford to miss. Herewith, then, what I would have known about at the time had I invaded CPJ's files (and, not incidentally, the files of the Cartoonists Rights Network International, mentioned earlier):

- In 1987, Naji al-Ali, the leading Palestinian cartoonist of his day, was murdered in London while on the way to his newspaper office. Ironically, it is still not known whether he was assassinated because he exposed the brutality of the Israeli occupation or because he criticized the hypocrisy of Yasser Arafat. Either way, it had to do with the political content of his cartoons. (See pages 151–3.)
- In 1992 the Sri Lankan cartoonist Jiffry Yoonoos drew a series of cartoons critical of then-president Ranasinghe Primadas. Yoonoos was beaten and stabbed, his family terrorized, forcing his wife and child to go into hiding.
- In 1995, Yemeni cartoonist Saleh Ali was arrested after publishing his anti-censorship cartoon showing a Yemeni man with his hands tied behind his back, his mouth locked, as the arresting officer explains, "Democracy is what I say."
- In 2002, Paul-Louis Nyemb Ntoogueé (aka Popoli), a longtime critic of Paul Biya's Cameroonian regime, and founder of *Le Popoli Messager,* an investigative journal in comic-book form, was beaten by security officers, and arrested for his cartoon referring to the first lady's alleged past as a prostitute.
- In 2005, cartoonist Oleg Minich was charged with defaming the president of Belarus, and that country's internal security service gave him the choice of five years in prison or permanent exile.
- In 2006, the Iranian government, responding to riots among its minority Azeri population over a children's cartoon Azeris found offensive, jailed the artist, Mana Neyestani, in Tehran's notorious Evin prison. In the riots, which killed nineteen people, his home was stoned and his newspaper's office was burned down. His crime: a cartoon that showed a cockroach responding to a Farsi-speaking boy with the Azeri word *"Namana?"*—meaning roughly, "I don't get it." Although Neyestani stressed this was also a commonly used Persian slang word, many Azeris thought the cartoon implied that they were ignorant cockroaches.
- In 2011 the Syrian cartoonist Ali Ferzat was attacked by masked members of Syria's security forces, who broke both of his hands, dumped him by the side of the road, and said, "This is just a warning."

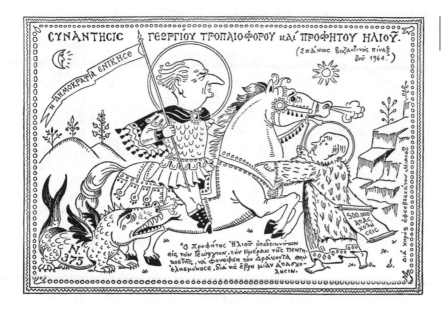

Bost, "St. George Triumphant and the Prophet Iliou" (1964)

The examples of cartoonists punished for the content of their cartoons could go on and on, but unlike the cartoons that gave rise to them, they are not funny—with the possible exception of what happened to the Greek cartoonist Crysanthos Mentis Bostantzoglou, aka Bost:

On April 5, 1964, the Greek newspaper *I Avgi* published Bost's cartoon "St. George Triumphant and the Prophet Iliou." Set in Byzantine style, it showed the newly elected prime minister, George Papandreou, as St. George, beset by Ilias Iliou, the parliamentary leader, as the prophet Elijah ("Iliou" being the Greek equivalent of that name), carrying a screed calling for five hundred thousand more jobs. Because Iliou loved the cartoon so much, Bost made him a copy in oil paint, which Iliou kept in his office. When a military junta seized power in 1967, it also seized Iliou, its leading foe, and the painting. In 1973, Iliou, by then a free man, received a summons that directed him to contact the deputy commissioner "in order to collect a painting." Iliou retrieved the painting and affixed the summons to the back, along with his own note, which reads, "This picture was a political prisoner from 23 April 1967 to 11 April 1973."

Closer to home, as Jerelle Kraus, the former art director of *The New*

Brad Holland,
"Attica Uprising"
(1971)

York Times Op-Ed page, reports in her book *All the Art That's Fit to Print (and Some That Wasn't)*, "nearly any notion is palatable when rendered in prose. When the same notion is pictured, however, the record shows that Op-Ed editors see it as a far greater threat." Her account of how *Times* editors rejected artist Brad Holland's illustration following the 1971 Attica prison uprising reinforces the point: the editors deemed it "pro-prisoner," perhaps influenced by the fact that the Op-Ed article it was meant to accompany itself took the prisoners' side.* Holland donated the drawing to the Attica Defense Fund, and Kraus reports that a year later the *Times* published the drawing as a "cultural artifact" with a caption that read, "A poster from the Attica Defense Fund." Which, of course, is not to say that written content doesn't matter. It always has and always will; just ask Salman Rushdie about the fatwa placed on his head after he published *The Satanic Verses.*

These days, especially when cartoons deal with such matters as sex, sexism, sexual orientation, race, racism, religion, and religious fundamentalism, they can evoke primal responses. When that happens, while the viewer may denounce the cartoon, the irony here, as was the

* In 1971, inmates at the Attica Correctional Facility in New York State revolted, taking prison guards as hostages. The prison was stormed resulting in a firefight that killed thirty-nine.

case with David Levine, is that it is precisely because the caricature has artistic depth and merit that the outrage is so keenly felt. The more powerful the caricature, the more outraged the protest.

As Bob Mankoff, cartoonist and longtime cartoon editor of *The New Yorker*, notes, we like the joke or not depending on what we believe. For each person, the sweet spot (and the offended one) is different. Let us then by way of demonstration inspect three very different cartoons, all by world-class cartoonists, each of whose content profoundly offended a different constituency. First, a panel by Ed Sorel, who took time out from his regular attacks on organized religion to comment on a publisher's hypocrisy, but in the process outraged a wide swath of feminists. Second, a cartoon by the UK's David Low, one of his series on Hitler, all of which caused the Führer to have a fit of rage bordering on hysteria. And third, Barry Blitt's aforementioned *New Yorker* cover on the Obamas, which led then-candidate Obama to interrupt his campaign for president to air his displeasure.

ED SOREL

This brilliant American cartoonist, caricaturist, muralist, moralist, freethinker, author, and graphic designer has won so many honors and awards as to threaten his reputation as America's number-one scourge of the establishment. His cartoons have been called "vehemently anti-clerical," an all-time understatement, but in this notable case his target was the late Frances Lear and her new American magazine, *Lear's*, which was aimed at women over forty years old.

Here was a case where the written message was clearly what upset people, but equally clear, in my view, is that it was the pictures that not only drew people to the words and reinforced them, but together give the message its emotional meaning. The pictures, one might say, bring the words into focus.

In this case, the panels show Lear in a variety of poses as the narrative proceeds apace (see next page). After having her assert that men had said a woman with no experience couldn't start her own magazine for older women, Sorel shows Lear getting carried away and increasingly cross-eyed as she concludes that, "All a woman needs is vision,

•Enter Queen Lear, Triumphant EDWARD SOREL

**Edward Sorel,
"Enter Queen Lear,
Triumphant" (1988)**

determination and a very rich hus-
band who'll give her $112 million
for a divorce."

Once again *The Nation* staff
descended (albeit this time with-
out a petition). And once again the
grievance had to do with a feminist
political issue—although in this
case the episode was infected by
the sort of petty charges that small
offices seem to specialize in. Sorel
believed that a leader of the pro-
test was angling to go to work for
Lear. Sorel's critics believed that he
was retaliating against Lear for a
turned-down cartoon. In a letter to
the editor (the whole text of which
appears on page 156), the noted art-
ist Jules Feiffer wrote that "after
thirty years of work on a level that
is simply extraordinary, [Sorel]
shouldn't have to pass an ideological means test to get in *The Nation*'s
pages."

My own guess as to what was going on here is that Sorel thought he
was simultaneously making a joke about her divorce settlement from
TV producer Norman Lear and a statement about what he saw as Fran-
ces Lear's hypocrisy in claiming that other (less important, less afflu-
ent) women could do as she had done; the objections took issue not
so much with Sorel's point as with his premise that divorced women
should not be presumed to have "earned" their settlement (whatever
its size). But I would add that what really caused the blood to boil over
was his deftly drawn images of a wacky but recognizable Lear getting
increasingly disheveled, not to mention cross-eyed, as she was carried
away by her own message. Images command attention in a way that
words don't (even offensive ones).

Moreover, one suspects that had Sorel written a prose poem criticiz-

ing what he regarded as Lear's hypocrisy, he would not have referred to her as wacky or goggle-eyed (which she wasn't), or if he had, I hope/assume that his copy editor would have crossed it out—all of which suggests either that editorial standards for prose are stricter than (or at least different from) standards for images, or that there is no visual equivalent when it comes to eliminating the gratuitous insult. Almost by definition cartoonists are allowed visual leeway denied to word people.

DAVID LOW'S HITLER

In the run-up to World War II, David Low, generally thought to be the most brilliant cartoonist of his day, produced regular caricatures of Hitler and Mussolini for London's *Evening Standard*. Unlike the vicious, cruel, and revolting depictions in the Nazi weekly *Der Stürmer*, on the surface Low's caricatures had an innocence, on more than one occasion showing Hitler as a spoiled brat.

When I was a boy growing up in New York City during World War II, few things gave me more pleasure than listening to and chiming in on Spike Jones's rendition of "Der Fuehrer's Face" ("Ven Der

LITTLE ADOLF TRIES ON THE SPIKED MOUSTACHE.

David Low, "Little Adolf Tries On the Spiked Moustache" (1930)

9

Fuehrer says ve iss der master race / Ve heil, heil right in Der Fueh-rer's face . . ."), so I was especially interested to read of Der Führer's reactions to Low's deceptively innocent but politically cutting car-toons of him which appeared with regularity in the 1930s. After Lord Halifax, the British foreign secretary, returned from a November 1937 meeting in Berlin with Joseph Goebbels, Hitler's propaganda minis-ter, to discuss tensions between their governments, Halifax reported to Low's publisher at the *Standard:* "You cannot imagine the frenzy these cartoons cause. As soon as a copy of the *Evening Standard* arrives, it is pounced on for Low's cartoon, and if it is of Hitler, as it usually is, tele-phones buzz, tempers rise, fevers mount, and the whole governmental system of Germany is in an uproar. It has hardly subsided before the next one arrives. We in England can't understand the violence of the reaction."

But hoping to make peace with Germany (actually, appeasing Ger-many), the government approached the *London Evening Standard*'s business manager, Michael Wardell, to see if they might get Low to ease up on the Nazis and their leader. According to Michael Foot, the acting editor of the *Standard* who went on to become a leader of the Labour Party, Wardell was "a fascist sympathizer," but when Lord Halifax met with him, even he said that Low was not controllable: "Low has a contract which gives him complete immunity. Of course, I could refuse to publish a cartoon, if it were blasphemous or obscene or libelous, or in such bad taste as to bring discredit on the newspaper. But Low's cartoons don't fall into any of those categories. They just make you mad, if you don't agree with them."

In the end, however, Low relented when the foreign secretary took him to lunch and explained his problem. "Do I understand you to say that you would find it easier to promote peace if my cartoons did not irritate the Nazi leaders personally?" Low asked. "Yes," Halifax replied. "I said, 'Well, I'm sorry,' " Low explained later. "Of course he was the foreign secretary, what else could I say? So I said, 'Very well, I don't want to be responsible for a World War.' But I said, 'It's my duty as a journalist to report matters faithfully and in my own medium I have to speak the truth. And I think this man is awful. But I'll slow down a bit.' So I did."

Sir David Low himself had a theory to explain the fits thrown by Hitler and his general staff over Low's cartoons showing him as ineffectual: "No dictator is inconvenienced or even displeased by cartoons showing his terrible person stalking through blood and mud. That is the kind of idea about himself that the power-seeking world-beater would want to propagate. It not only feeds his vanity, but unfortunately it shows profitable returns in an awed world. What he does not want to get around is the idea that he is an ass, which is really damaging."

Low's theory, in addition to being this gifted satirist's original insight into dictators as a class, turned out to have had particular relevance to Hitler himself. In 1932, Hitler showed Ernst "Putzi" Hanfstaengl, his foreign-press secretary, a particularly irksome anti-

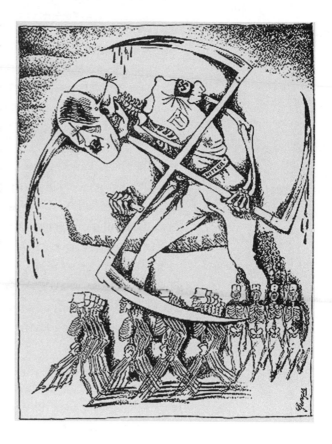

Georges, "The Grim Reaper," *The Nation* (1933)

Hitler cartoon, and dreamed aloud of retaliation. Hanfstaengl suggested that they publish a book of such offensive cartoons pointing out the cartoonists' errors. The result was Hanfstaengl's fancily bound volume *Hitler in der Karikatur der Welt: Tat gegen Tinte (Hitler in the World's Cartoons: Facts Versus Ink)*, which was published by an obscure house in order for the book to appear independent. The cartoons he chose to rebut, writes Cris Whetton of the Political Cartoon Society, reveal something of Hitler's insecurities:

Fourteen (20%) of the cartoons selected for Hanfstaengl's rebuttal clearly respond to the question, popular at the time: Who really controls Hitler? . . . Allegations of militarism are the next most common category, with eleven (15%) cartoons, mostly published after January, 1933, and mostly from the foreign press. One is led

to wonder why. Hitler's militarism, as presented to the German public at that time, was limited to repudiation of the Versailles Treaty, re-armament, and the presentation of the new Germany as an armed bulwark against "Bolshevism." These were all popular with the average German. Was Hitler afraid that the foreign press could see behind the mask?

Rather than have a series of conniptions, with Putzi's help Hitler strove to "answer" each cartoon selected. Since the attempt to answer visual charges with verbal responses was doomed from the outset and since the refutations were spurious, the book had a short life.

Nevertheless, I am particularly pleased to report that one of the cartoons Putzi chose to reprint in the book came from, of all places, a small New York–based magazine called *The Nation*. It depicted Hitler as a Grim Reaper with an army of skeletons marching at his feet. The blades on the Reaper's scythe, in the shape of a swastika, dripped with blood.

In the following pages Putzi added his gloss, to make sure the readers laughed for the right reasons. After summarizing the cartoon's content—"*The Nation* suggests Hitler was a war-monger"—Putzi added "the facts: On July 15, 1933, Hitler authorized the German ambassador to Rome to sign the Four Powers Pact, through which Italy, England, France, and Germany ensured peace in Europe for the next ten years."

BARRY BLITT'S FIST BUMP

The New Yorker is perhaps America's most prestigious magazine. Its readers are presumed to be literate, sophisticated, informed, and vaguely liberal, but above the fray. Yet in Barack Obama's first presidential campaign, when the magazine featured cartoonist Barry Blitt's version of candidate Obama and his wife, Michelle, dressed in terrorist garb, doing a fist bump, not only did thousands of agitated readers complain, but the Democratic candidate for President of the United States of America, who one might have thought had more pressing matters on his mind, took time out from his campaign to denounce the cover as offensive.

In fact, the avalanche of threats, denunciations, and subscription cancellations by previously loyal *New Yorker* readers was the result of a misunderstanding. The cancellers saw the cover as an accusation that Obama was in league with the terrorists, whereas, as editor David Remnick explained, "It's not a satire about Obama—it's a satire about the distortions and prejudices about Obama." The objecting readers, however, were not to be dissuaded, persuaded as they were that the cartoon, called "The Politics of Fear," does not so much lampoon the smear as perpetuate it, and the national director of the Arab-American Anti-Defamation League chimed in that "what needs to be challenged is the underlying assumption that being Muslim is the same as being Un-American, that being Muslim is the same as being violent, that being Muslim is the same as being Osama Bin Laden."

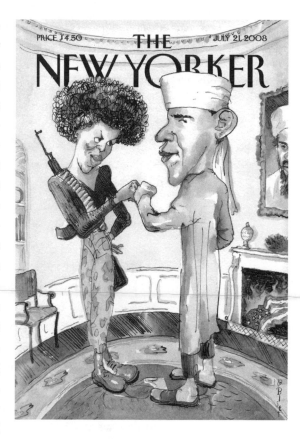

Barry Blitt, "The Politics of Fear," *The New Yorker* (2008)

But what seems inarguable is that, although over the years readers of *The New Yorker* have taken serious and noisy exception to articles that have appeared in the magazine (think, for example, of Hannah Arendt's "Eichmann in Jerusalem"), this cover cartoon seems to have stimulated unprecedented emotional blowback. And the fact that readers misinterpreted it (if one takes the artist's word as to his intent and accepts Remnick's explication of its meaning) only underlines the fact that readers may interpret and respond to visual "argument," if there is such a thing, in a different way than to words.

As cartoonist Steve Brodner and scholar Jytte Klausen observe elsewhere in these pages, too often images and especially cartoons are subject to misinterpretation, especially when they are viewed out of cultural context.

This particular cartoon, I believe, ran into trouble because it

mixed satire and caricature. Barry Blitt was not merely caricaturing the Obamas. He was simultaneously satirizing the right-wing view that they were Muslim terrorists. Maybe the moral is that this sort of meta-caricature (a caricature of a caricature) reveals the limits of the caricature form. Satire requires rational distance. For many viewers the cartoon didn't convey the message Blitt and Remnick intended because Blitt's Obama caricature had its own life force.* Hypothesis: once particular caricatures are released, they function as uncontrollable totems.

In each of these cases—Sorel's nonfeminist premise, Low's revelation of the pitiful sissy behind an *über* dictator's façade, and Barry Blitt's presentation of the Obamas (misread as an accusation of support for terrorists)—the cartoon's content was seen as objectionable, but it was the visual language that caused the combustion.

Thus far I have discussed the cartoon's content as if it were a message contained in the visual envelope of the cartoon itself. But it is important to remember, as the critic Cleanth Brooks once wrote about attempts to paraphrase poetry, "that the paraphrase is not the real core meaning which constitutes the essence of the poem." Form and content are inseparable. And as with poetry, to paraphrase a cartoon's content is at best an inadequate guide to its real meaning or impact. To get at that we must consider the cartoon as visual language. Hence, the Image Theory.

* As *New Yorker* followers know, the Obama fist bump was only the latest in a series of cover imbroglios all caused by cartoon content.

The Cartoon as Image

Before I discuss the Image Theory, let me take what at first glance may seem like what a Yale Law School professor of mine would have called "a frolic and detour." I tell the following story here because it reveals my early exposure to the idea that when it comes to caricature, even the most minimal image can capture a subject's essence. In an early issue of *Monocle* we ran a fable by my Little Red School House classmate Karla Seidman Kuskin called "The Rocky Road Upwards." I had known Karla, who went on to become a prolific and prize-winning children's book author and illustrator (*James and the Rain, Roar and More*), since we were classmates at the Little Red, a progressive school in Greenwich Village with more than its share of bohemian and leftist parents.*

Anyway, rather than tell you about Karla's 1961 fable (written under

* I will never forget the hot summer day in 1950 when my friends Jeremy Connolly and Richard "Spike" Goldberg and I presented ourselves in the Fifth Avenue offices of Harry M. Stevens, who controlled the food concessions for all of New York City's parks (including the ball parks). Our plan was to persuade him that in addition to hot dogs, Cracker Jacks, ice cream, and Cokes, he ought to include watermelon among the products offered, and to hire us to do the selling. We had asked Karla to do up some posters for the occasion.

We put on our suits, jackets, and ties and, without an appointment, told the receptionist at his Fifth Avenue office that we were there to see Mr. Stevens. "Which Mr. Stevens?" she asked. "*The* Mr. Stevens," we replied, since in truth we had not known there was more than one. Whereupon we heard her ring someone up and tell him that "there are three musketeers out here asking to see you."

We were ushered into Stevens's baronial office and saw what seemed to us a wizened old man clutching the sides of his chair, which could have been a throne. "What can I do for you, boys?" he asked, and I launched into our pitch. "What is it that people can eat and drink at the same time?" I began, but it wasn't until Jeremy and Spike unrolled and held up the posters Karla had prepared and illustrated in bright watercolors that Stevens seemed to perk up. "Feeling sunk? Buy a hunk!" the first one said, showing a happy lad chomping on a slice of watermelon. "The slice is immense. The price? Ten cents!" said the second, displaying an immense slice of watermelon.

Stevens, if not awestruck, was sufficiently impressed to tell us that if we were interested, we could show up at Yankee Stadium at 4 a.m. with the rest of the would-be vendors, and if we were lucky, we could get jobs selling ice cream and Coca-Cola. It was Karla's posters—the images—that did it.

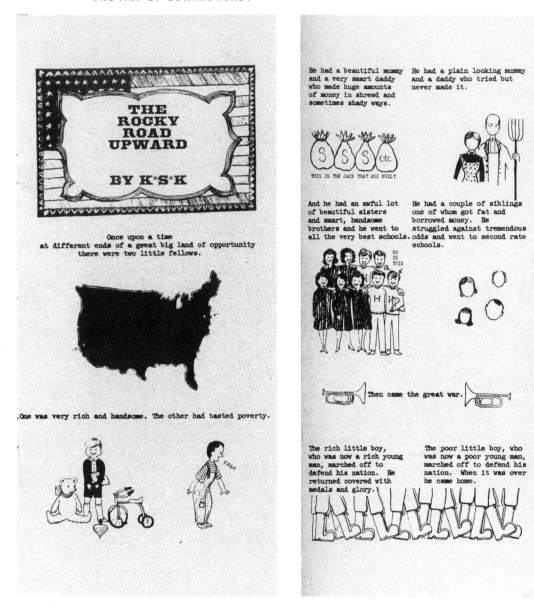

the pen name K*S*K), I reprint it here: first and foremost because it makes astonishingly clear that in certain caricatures, the fewer lines the better: Karla's rendering of young JFK (a shock of hair, a smile) and young Dick Nixon, with his widow's peak, is a case study in the triumph of minimalism over elaboration (see the bottom of the third page above); but also because it shows better than I can tell how the

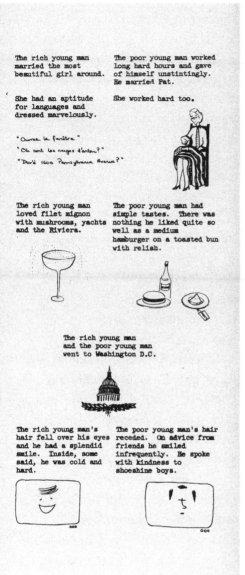

The rich young man married the most beautiful girl around.

She had an aptitude for languages and dressed marvelously.

"Ouvrez la fenêtre."

"Où sont les neiges d'antan?"

"Doré 1600 Pennsylvania Avenue?"

The rich young man loved filet mignon with mushrooms, yachts and the Riviera.

The rich young man and the poor young man went to Washington D.C.

The rich young man's hair fell over his eyes and he had a splendid smile. Inside, some said, he was cold and hard.

The poor young man worked long hard hours and gave of himself unstintingly. He married Pat.

She worked hard too.

The poor young man had simple tastes. There was nothing he liked quite so well as a medium hamburger on a toasted bun with relish.

The poor young man's hair receded. On advice from friends he smiled infrequently. He spoke with kindness to shoeshine boys.

On January 20th, 1961 the rich young man became President of the United States of America. His beautiful wife was there to see him take the oath of office. So were his mummy and daddy and his sisters and brothers and masses of glorious people like statesmen and humanitarians. Robert Frost and Tony Curtis were there.

The poor young man was forty-seven years old and he went home with Pat.

Think it over, Horatio, baby.

interaction of words with pictures can transcend the communicative potential of either.

Whether the caricatures are minimalist à la K*S*K or over-the-top surrealist distortions à la Ralph Steadman, or Barry Blitt's terrorist Obamas, the point is that images have a life of their own.

If the Content Theory has to do primarily with the rational mes-

sage of the cartoon, the Image Theory has to do with the cartoon as cartoon, with the look or the visual aspect of the cartoon, the cartoon as totem.

I would add that political cartoons, perhaps because they contain a condensed argument either along with the image or incarnated in it, provide the power of the image *plus*—a one-two punch, if you will. They have what one observer calls "pre-oedipal access to the observer's emotions," an inescapable immediacy; and although cartoons often include a caption or a label, at their best—unlike, say, modern poetry—they don't require nuanced interpretations. (And like all good poetry, they resist paraphrase.)

There is a vast literature on the totemic power of images, paintings, statues, and art per se. Jean Baudrillard, Martin Jay, Guy Debord, and Ferdinand de Saussure all make the point that images have power. Especially where the image involves depiction of a person. And where that "person" is a divine being it's a different matter entirely.

Moreover, as everyone knows, it is not just Islamic fundamentalists who object to the depiction of their god. The Second Commandment of the Old Testament forbids worship of graven images, and in Exodus 20 the Hebrew god proclaims, "Thou shalt not make unto thee any graven image, or any likeness of anything that is in heaven above, or that is on the earth beneath, or that is in the water under the earth." Of course scholars are forever interpreting the meaning of such religious injunctions. For instance, some experts now believe that the Koran's reference to seventy-three virgins may be a mistranslation of "seventy-three raisins." And it turns out that the Byzantine iconoclasts destroyed all the icons they could between 700 and 843 (when idol worship was restored) because they thought the Church was violating the Second Commandment by making and venerating them.

The thing to keep in mind about the Image Theory is that, while many art historians have undervalued the artistic relevance of cartoons, they have also recognized the power of the image—and cartoons are images. Not only that, but anthropologists and others report that people have responded to images as if they were real; as if, in the words of art historian David Freedberg, they "partake of what they represent."

The *New York Times* critic Michael Kimmelman reminds us that the early Greeks painted eyes on the prows of their ships to enable them to find their way through the water, and they used to chain statues to keep them from escaping. Buddhists in Ceylon believed that a portrait would be brought to life once the eyes were painted. The European tradition of execution-in-effigy entailed hanging and decapitation of dolls and pictures of the accused.

Of course, photographs are also images and have their own power, although people don't blame photographers for their pictures the way they blame cartoonists for their cartoons. Kiku Adatto, author of *Picture Perfect: Life in the Age of the Photo Op*, suggests that that may be because "photographers are thought to deal with the surface, so people don't pay attention. Whereas, with a caricature, on some level one believes that it gets to the essence." Or perhaps as the illustrator Marshall Arisman's editor once speculated, lay people erroneously assume that photographs are objective pictures of the world as it really is, whereas, because an artist's rendering clearly is his own, they assume that a cartoon or caricature is the cartoonist's invidious spin on real life.

W. J. T. Mitchell, Gaylord Donnelley Distinguished Service Professor of English and Art History at the University of Chicago, guru of what has come to be called the visual culture movement, wrote a whole book devoted to the question *What do pictures want?* He makes the point that we have only begun to comprehend the power of the image, which goes way beyond images themselves.

The Image Theory helps counter our tendency to patronize and condescend to those we consider our intellectual inferiors: the so-called primitive, the heathen, the savage, the native, the indigenous, who believed (or believe) that pictures were/are alive, possessing secret or magical powers (what E. P. Thompson, the late, great British social historian, referred to in another context as "the enormous condescension of posterity"). In the past, we dismissed them as naive in their beliefs that pictures were to be worshiped or feared. We said they were guilty of idolatry, fetishism, animism, totemism. Well, maybe these people were in some sense right after all. Maybe these so-called primitive peo-

ple who were ignorant of political correctness, identity politics, Freud, neuroscience (not to mention neuroaesthetics), and contextualization, intuited something that we have yet to fully comprehend.

Maybe that is what Kimmelman is talking about when he writes that "a deep, abiding fact about visual art [is] its totemic power: the power of representation. This power transcends logic or aesthetics. . . . To many people, pictures will always, mysteriously, embody the things they depict."

And maybe that is what Mitchell is getting at when he tries to explain how images function: "It seems that images are not just things that appear in media, but also in some sense a medium, perhaps a meta-medium that transcends any specific material incarnation, even as it always requires some concrete form in which to appear."

But Mitchell may be onto something when he writes that images "can come alive because viewers believe they are alive." "The best evidence for the life of images," he writes, "is the passion with which we seek to destroy or kill them. Iconophilia and iconophobia only make sense to people who think images are alive." Freedberg, in effect, seconds the motion when he asks, "If paintings and sculpture are simply pieces of wood and stone, inert and insignificant, why destroy them? Images are feared not because they are dead but because they seem to be, and often are believed to be, alive."

Although nothing would please me more than to discover that the primitives rather than the postmodernists got it right, that pictures are alive and magical, my jury is still out on that. The Image Theory raises as many questions as it answers in terms of why cartoons and caricatures often evoke more powerful emotions than prose. But either way, it tells me that if cartoons and caricatures can function as totems, once unleashed these totems are sometimes uncontrollable.

THE DANISH MUHAMMADS

At first glance it would appear that no recent example better illustrates the power of the image than the hundreds of thousands of Muslims who protested the Danish cartoon images of Muhammad. Well, yes and no. Let's look a little more closely at what happened.

A Danish children's-book author looking to write a book about the life of Muhammad "in the spirit of religious tolerance" found no illustrator, presumably because all the artists he approached feared retribution from Muslim extremists. In response, the conservative Danish paper, *Jyllands-Posten,* commissioned a dozen cartoonists to provide their own depictions. At the time, it was explained by many in the press—as it turned out, somewhat simplistically—that the Koran forbids the depiction of the prophet and that the *Jyllands-Posten* cartoons were blasphemous. They included one showing Muhammad wearing a turban in the shape of a bomb. Another had him saying that paradise was running out of virgins for suicide bombers. (According to some interpretations of scripture, each suicide bomber was entitled to seventy-three virgins.)

Blasphemous or not, the cartoons were incendiary because they portrayed Muhammad as a terrorist, and they violated the Muslim clergy's prohibition against *laghv,* a Persian-derived word for "nonsense."* It was not merely that the cartoons were mocking the prohibited, but that they were simultaneously mocking the prohibitors. They were in effect saying if this be provocation, make the most of it.

On the other hand, it turned out that most of the hundreds of thousands of protesters had never seen the cartoons but only heard about them; that as Professor Jytte Klausen, Wien Professor of International Cooperation at Brandeis University, has documented in her careful study, *The Cartoons That Shook the World,* the so-called worldwide Muslim outrage was in part a put-up job. Professor Klausen reports that imams traveled across the Muslim world to stir up trouble. They claimed to carry copies of the offending cartoons, but mixed in with them were some that were never published, including one showing the Prophet's genitals! Another critical point: even the authentic cartoons

* See the third verse of the Twenty-third *Sura* of the Koran, which describes Muslims as people who "turn away from ill speech." Ayatollah Ruhollah Khomeini famously said, "There is no fun in Islam. There can be no fun and joy in whatever is serious." See foreignpolicy.com, June 1, 2012. I would note, however, that avoidance of humor is by no means a monolithic tendency in the Muslim world. For example, from 1906 to 1931, the Azeri writer Jalil Mammadguluzadeh published *Molla Nasraddin,* a satirical magazine that featured caricatures and cartoons mocking religious fanaticism and espousing women's equality.

were not merely images of the Prophet but were also, for the most part, simultaneously image-arguments, portraying Muslims as terrorists, or otherwise nefarious.

The fact that most Muslims did not see the offending images (or saw inauthentic images) complicates but does not undermine the Image Theory, since, seen or unseen, it was the idea of the image that caused the controversy.

Moreover, as Professor Adatto told me, "The Muslims didn't have to see the Danish caricatures to be offended. By definition, they were a desecration. Like the Ku Klux Klan burning a cross on your lawn."

But the Danish cartoons raised a subsidiary issue for publications, not to mention electronic media around the world: whether or not to reproduce them. *The New York Times,* along with much of the rest of the U.S. news media and many European papers, reported on the cartoons but didn't show them. The *Times* ran an editorial that said: "That seems a reasonable choice for news organizations that usually refrain from gratuitous assaults on religious symbols, especially since the cartoons are so easy to describe in words." At the time I disagreed with them on two grounds. First, civil liberties: I felt that the cause of free expression suffered a blow. Second, existential: the whole point, it seemed to me, is that one has to experience the image by seeing it before one can know its real impact (leaving aside the possibility that only a devout Muslim can know its full impact). I felt that the *Times* missed the point. Cartoons may indeed be easy to describe in words, but that is not the same as experiencing them. I still believe that, but I have subsequently had second thoughts (which I elaborate on pages 180–5) on how that proposition applies to the matter of reproducing the Danish Muhammads.

And for what it's worth, I continue to believe that the most baffling aspect of the Danish cartoon controversy has to do with why the terrifying torture photographs of Abu Ghraib, documenting the events, and seen regularly on Al Jazeera if not so much in the U.S. mainstream media, failed to provoke the widespread violence that greeted the made-up Danish cartoons that relatively few of the protesters saw.

The Cartoon as Stimulus

The Neuroscience Theory posits that neuroscience can provide the link between cartoons-as-stimulus and our profound emotional response to them. If the Content Theory emphasizes a cartoon's logical argument, and the Image Theory emphasizes a cartoon's totemic power, the Neuroscience Theory has to do with a cartoon's target—the structure of the brain itself. When I asked Milton Glaser, the legendary art director and creator of the "I ♥ NY" logo, his first thought was that it "has to do with the right hemisphere of the brain."

Some of the most gifted art directors have difficulty explicating aesthetic principles. Not Milton, a Fulbright scholar with an international clientele who is more articulate than most of the editors he has worked with over the years (including me), and he is not shy about letting you know what he knows. He adds that "our brains have two sides, or hemispheres. The left is analytical and logical, or linear-thinking. The right is creative, making connections, expressing emotions. The emotional response is what is important here. Imagery combined with [its implicit] narrative is the most powerful form. Cave drawings of animals helped the people recognize a story—a narrative—how to capture or kill these animals. That's pre-language. The images are translated into a narrative."

But of course the psychologists and neuroscientists have their own language to describe what's going on.

In *Thinking Fast and Slow,* psychologist and Nobel laureate Daniel Kahneman, instead of referring to the right- and left-brain split, refers to two systems:

- System 1 operates automatically and quickly, with little or no effort and no sense of voluntary control.
- System 2 allocates attention to the effortful mental activities that demand it, including complex computations. The operations of Sys-

tem 2 are often associated with the subjective experience of agency, choice, and concentration.

The automatic operations of System 1 generate surprisingly complex patterns of ideas, but only the slower System 2 can construct thoughts in an orderly series of steps.

Whether one calls it "System 1" or the brain's right hemisphere, one senses that something is going on that helps explain the link between how cartoons look and our profound emotional response to them. And it's not just Milton and neuroscience that tell us so. There's a whole new subfield called neuroaesthetics. One of its founders, Professor Semir Zeki, defined neuroaesthetics as the study of "the neural basis of creativity and achievement, starting with the elementary perceptual process." In other words, says neuroaesthetics, the response to cartoons has as much to do with what's in the brain as with what's in the cartoon. It has to do with the psychology of the viewer, the audience, the consumer, the respondent.

Ask any neuroscientist and he will neatly (too neatly?) explain how the visual stimulus travels to the thalamus, which in turn passes the information to the region of the brain called the amygdala, the brain's fear center, while simultaneously visual information goes via a slower route to the visual cortex.

Despite the jargon, even a lagging left-brained retrograde like yours truly can see that some recent findings in the fast-developing world of neuroscience can also offer some insights into how we respond to cartoons—not just explanations, but experiments too. One of my favorites has to do with something called "the peak-shift effect," a concept that evolved from experiments with, of all things, herring-gull chicks.

Because these chicks are entirely dependent on their mothers for food, when they see a yellow bird beak with a red dot at the end like their mother's, they beg for food by pecking at the dot. It took a neuroscientist to discover that when the chicks are exposed to a fake beak—a wooden stick with a red dot at the end—they peck vigorously at that, too, and the more red dots, the more avidly they peck. The pecking

peak comes as a result of shifting the stimulus (more red dots): hence, the peak-shift effect.

The connection between this phenomenon and cartoons and caricatures is said to lie in that area of the brain involved in facial recognition—the fusiform gyrus—which turns out to react more quickly to caricatures than photos of real faces. This is no surprise, since caricatures emphasize the same features we use to distinguish one face from another.* The neuroscientist V. S. Ramachandran thinks that caricature works on the same principle as the peak-shift effect: "Consider the way in which a skilled cartoonist produces a caricature of a famous face, say [Richard] Nixon's. What he does (unconsciously) is to take the average of all faces, subtract the average from Nixon's face (to get the difference between Nixon's face and all others) and then amplify the differences to produce a caricature. The final result, of course, is a drawing that is even more Nixon-like than the original." Ramachandran argues that if chicks had an art gallery, they would hang a long stick with red dots on it, worship it, "pay millions of dollars for it, call it a Picasso."

Milton and other artists I have asked don't know from the so-called peak-shift effect and herring-gull neuroaesthetics. And when it comes to understanding art and its impact, not all scholars are believers in neuroscience, not to mention neuroaesthetics. The author of *Out of Our Heads: Why You Are Not Your Brain, and Other Lessons from the Biology of Consciousness,* Alva Noë, a City University of New York Graduate Center philosopher specializing in the study of perception, cautions against a brain-based approach to art for two main reasons. "We lack an adequate neural or biological account of thought or perception or consciousness. And neural approaches have not yet found a

* Margaret Livingstone, the neuroscientist, writes "Faces are among the most informative stimuli we ever receive. Even a split-second glimpse of a person's face tells us their identity, sex, mood, age, race and direction of attention." Psychologist Eric Kandel adds that for a face to be recognized, it is enough that the face be abstracted to just a few special contour lines—those defining the eyes, the mouth, and the nose, which "allows artists room to make extreme distortions to a face without affecting our ability to recognize it. As Kris and Gombrich emphasized, this is why caricaturists and expressionists are capable of moving us so powerfully."

way to bring art into the laboratory." He adds, "It is people, not brains, that make and enjoy art. You are not your brain. You are a human being."

But Eric Kandel, Nobel Prize–winning psychologist, cautions against the caution, reminding us that in every era, advances in science scare people. In 1628, William Harvey was met with fierce opposition for discovering, describing, and thus demystifying the inner workings of the heart, and he turned out to be right. Kandel writes: "Understanding the biology of the brain in no way denies the richness or complexity of thought. Rather, by focusing on one component of a mental process at a time, reduction can expand our view, allowing us to perceive previously unanticipated relationships between biological and psychological phenomena."

When I read Noë I say yes, but when I read Kandel I don't disagree. In other words, when it comes to the brain, I have an open mind. But before I take up caricature I should say that I like the idea that the same exaggeration that causes the animal brain to respond with extra avidity to what some scientists call a "superstimulus" can cause the human brain to respond with extra emotion to caricature. For example, rats trained to avoid squares in favor of rectangles show a preference for elongated rectangles—the more elongated, the better. This is fertile territory for further exploration, and it would be nice if neuroaesthetics provided an all-purpose answer to our question; but my skeptical left hemisphere reminds me that the brain, which I am told consists of 100 billion cells making a quadrillion connections every second, is too complex a mechanism to provide such a simplistic explanation of why we respond to caricatures the way we do.

So much for the neuroscientists. When I asked a Freudian psychoanalyst how he would explain what seemed to me my otherwise superrational staff's over-the-top hostile and emotional reaction to the Levine caricature of Kissinger, he asked, "Would you say most of the objections came from feminist-activists?" And when I allowed that that was probably right, he said, "You know, dreams consist of images, just like cartoons and caricatures, and dreams deal with the unconscious ideas and feelings that we often don't want to admit to ourselves that we have. It would not surprise me if some of the outrage at an

image which shows women as submissive comes from women who in a part of their subconscious yearn to be submissive. But don't quote me." Among other things, the theory doesn't account for the straight male feminist-activists who signed the petition. Bottom line: I'm not yet persuaded that either neuroscience or psychology—Freudian or otherwise—can explain the power of the image, no less cartoons and caricatures.

Neuroscientists and neuroaestheticians have much to teach us and seem to come up with new discoveries and new experiments and new findings on a daily basis. I'm a believer in peak shifts, herring gulls and rats, and rectangles. But try as I might, what I have earlier called my lagging left brain seems not yet willing to make the leap from scientific findings to aesthetic conclusions. A part of me suspects—or perhaps I should say "hopes"—that those so-called primitives were right after all. Pictures are alive. They called it magic. It's just that we have a different way of talking about it: we call it neuroscience—or should I say "neuroaesthetics"?

I suspect that you have already figured out that besides the Content Theory, the Image Theory, and the Neuroscience Theory, there is My Theory: namely that each of the above theories complements rather than cancels out the others and that to understand what is going on one needs to take into account not only content, imagery, neuroscience, and psychology but also, where relevant, anthropology, sociology, race, and religion—and other disciplines and factors too fierce to mention.

Caricature

Especially since such authorities as David Carrier, the distinguished philosopher and art historian, have observed that the proper study of caricature "has barely begun," it deserves close scrutiny. Caricature—the term derives from the Italian *caricare,* meaning "to load," as in a vessel or a weapon—seems to set off more alarms than any other form of cartoon; as we have seen, the very idea of caricaturing Muhammad set off worldwide protests among people who never even saw the Danish art that allegedly caused the provocation. So what's with political caricature? *The New York Times* Op-Ed page bans it. The Bible, as we know, proscribes graven images (which can be said to be a form of caricature). Honoré Daumier and countless others went to prison for it. Although it was not technically part of the charge, I would argue that Julius Streicher, *Gauleiter* of Franconia, executor of racist policies, and the owner-editor of *Der Stürmer,* which weekly featured vicious anti-Semitic caricatures on its front pages, was hanged at Nuremberg mainly for publishing them.

I have already mentioned that the experts can't agree on when political cartoons and caricature began. Regardless of caricature's paternity, it is generally agreed that in the sixteenth century Italian caricaturist Annibale Carracci was referring to Leonardo's grotesques when he wrote:

> Is not the caricaturist's task exactly the same as the classical artist's? Both see the lasting truth beneath the surface of mere outward appearance. Both try to help nature accomplish its plan. The one may strive to visualize the perfect form and to realize it in his work, the other to grasp perfect deformity, and thus reveal the very essence of a personality. A good caricature, like every work of art, is more true to life than reality itself.

The perfect deformity—that's a high ambition, which we shall return to. But here let me say that, personally, I like anthropologist

David Thorn's idea that the man responsible for the birth of political cartoons and caricature is, of all people, Martin Luther.

In the sixteenth century, Martin Luther, who was engaged in bitter theological debate with Pope Leo, believed he could get the support of the peasant masses for the reforms he wanted the church to adopt. He was aware that the majority of the peasant masses could not read, so he sent forth his message via one-page posters and illustrated booklets. Listen now to David Thorn: "In these prints [Luther] showed the depictions of biblical scenes that everyone could immediately recognize, and next to it he would print the same pictures but with caricatures of members of the Catholic Church in the positions of the antagonist. This was the birth of the political cartoon"—and it soon was imitated throughout Europe.

Lucas Cranach the Elder, "The Birth and Origin of the Pope" (1545)

Hans Holbein the Younger himself created a woodcut depicting Martin Luther as "the German Hercules," in which Luther beats such scholastics as Aristotle and St. Thomas Aquinas into submission with a nail-studded club.

Luther commissioned such artists as Lucas Cranach the Elder to make woodcuts in support of the Reformation, among them "The Birth and Origin of the Pope" (one of a series entitled *The True Depiction of the Papacy*), which depicts Satan excreting the Pontiff. (He also commissioned Cranach to provide cartoon illustrations for his German translation of the New Testament, which became a best seller, a major event in the history of the Reformation.)

Caricature developed throughout Europe in different ways. Art historian Diana Donald assures us that the golden age of caricature occurred in Georgian England, from 1759 through 1838, when artists added visual metaphor, personification, and allegory. The critic

Judith Wechsler writes about another "golden age" occurring in nineteenth-century France, where scores of caricature journals codified the "Parisian's characteristic preoccupation with visible bodily cues to class, profession, character and circumstances," culminating in the high art of Honoré Daumier. (Both of these were undoubtedly golden ages for caricature, but they make me wonder, What were or are the golden ages for caricature in Africa, Asia, and the Middle East?) Where caricature helped Martin Luther communicate with the illiterate, in England and France it helped create a popular and political urban culture.

Since different countries and cultures gave birth to different styles, and each treated caricaturists in its own way—again, rather than pretending to provide the unprovidable: a comprehensive, definitive history of caricature—here are some country-by-country snapshots of what has been going on:

GREAT BRITAIN

Napoleon is reported to have said that the English caricaturist James Gillray "did more than all the armies of Europe to bring me down."

James Gillray, "Maniac Ravings, or Little Boney in a Strong Fit" (1803)

THE REAL MENACHEM BEGIN STORY

BEGIN WAS BORN IN BREST-LITOVSK

VOT A LOVELY NOSE HE HAS GOT!

DURING THE WAR HE WAS A MEMBER OF THE RED "POLISH LIBERATION ARMY"

GOOD PRACTICE UNTIL I GET TO PALESTINE

POLISH OFFICER

FOR UNEXPLAINED REASONS THE SOVIETS PERMITTED BEGIN TO LEAVE FOR PALESTINE IN 1942 AND THEN....

NKVD

USSR

Michael Foot, the British Labour party politician, observed that David Low "changed the atmosphere in the way people saw Hitler." And of course the British tradition of hospitality to irreverent commentary—Lord Byron is reputed to have said, "Ridicule is the only weapon the English climate cannot rust"—gave the caricature one of its premier venues in *Punch*, featuring John Leech, John Tenniel, Max Beerbohm, and a galaxy of others. Even so, as recently as 1981 Great Britain threw the Holocaust-denying cartoonist Robert Edwards into prison for his visual crimes (see pages 145–9).

Robert Edwards, from "The Real Menachem Begin Story" (1981)

FRANCE

France was a different story entirely. As Robert Justin Goldstein reminds us, the French interior minister informed his prefects on September 8, 1829, that "engravings or lithographs act immediately upon the imagination of the people, like a book which is read with the speed of light; if it wounds modesty or public decency the damage is rapid and irremediable." In 1835, King Louis Philippe reestablished censorship (it had been repealed after the revolution) explicitly to limit caricature. Louis Philippe was, famously, the king who had Daumier put behind bars for his version of Charles Philipon's brilliant pear-shaped caricature "La Poire." When asked, "Why penalize caricature rather than print?" the king explained: "A pamphlet is no more than a viola-

tion of opinion; a caricature amounts to an act of violence." French legislator Joseph Jacquinot-Pampelune argued that visual impression should be held to a higher standard than written impression because "caricature drawings offer a means of scandal that is very easy to abuse and against which [postpublication] pressure can only be of little help. As soon as they are exhibited in public they are instantly viewed by thousands of spectators and the scandal has taken place before the magistrate has time to suppress it." All of which led *Le Grelot,* the caricature journal, to pose (in 1878) the question "By what right can one prevent the crayon from saying what the pen is allowed to?"

THE UNITED STATES

Although Benjamin Franklin published the first cartoon in America, for me and most observers, the American cartoon didn't really come into its own until 1871, when Thomas Nast's caricatures brought down Boss Tweed, the infamously corrupt head of Tammany Hall, the seat of New York's Democratic Party political machine (see pages 76–80). President Abraham Lincoln called him "my number-one recruiting sergeant" for his Civil War cartoons, and it was, incidentally, Nast who gave the Democrats their symbolic donkey, the Republicans their elephant, Tammany its tiger, and Boss Tweed the fat, grubby image that came to symbolize the most corrupt politician in the country. Tweed escaped from jail and fled to Spain, where he was found working as a seaman on a Spanish merchant vessel. On the run, he was reportedly apprehended by a Spanish customs official who, though he spoke no English, recognized him from Nast's drawings.

HOLLAND

Many students of the genre would argue that in the twentieth century no cartoonist exercised greater influence than Louis Raemaekers. During World War I his caricatures of Kaiser Wilhelm as Satan and of Germans as barbarians led the German government to offer a 12,000-guilder reward for his capture, dead or alive. According to the English critic H. Perry Robinson, a German newspaper, summarizing

the terms of the peace Germany would exact after it won the war, declared that indemnity would be demanded for every one of Raemaekers's cartoons.

GERMANY

Pre–World War II Germany had its own golden age of caricature anchored by the satirical journal *Simplicissimus.* Ralph Steadman, a student of the form, said that "cartoonists and painters like George Grosz, Otto Dix, John Heartfield, and Max Beckmann were forced to migrate or face extermination. The power to expose and lay bare famous lies and potent immoralities made their flight imperative." Lest you think that Steadman exaggerates the power of cartoons and caricatures, he continues to claim to believe that "to this day, the cartoon remains a poor man's art, a dogsbody seen as a space-filler; a last-minute scribble that, in its humblest form, jockeys for a place somewhere between the crossword puzzle and the small ads."

Louis Raemaekers, "The German Tango" (1918)

I have omitted a whole range of caricatures that, far from causing distress, rallied the troops and were an incalculable influence for the good. Caricature, which is, after all, both a cartoon and an image, is an image with a difference. And the difference has to do with its doubleness. It is both recognizable and a distortion, sometimes grotesquely so, simultaneously like and unlike its subject, and the unlike part can involve either idealization or deformation, if not defamation, debunking, and downgrading.

In 1938 E. H. Gombrich and Ernst Kris co-authored an article in the *British Journal of Medical Psychology* in which they went farther than Carracci and observed, "If the portrait painter's task was to record

33

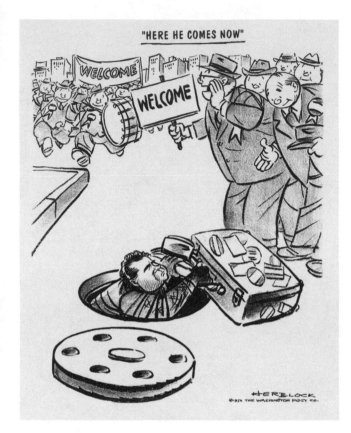

"HERE HE COMES NOW"

HERBLOCK
©1954 THE WASHINGTON POST CO.

Herblock, "Here He Comes Now" (1954)

the character, the essence of a man in the heroic sense, the caricaturist had an opposing goal. He did not seek the perfect form, but the perfect deformity . . . to penetrate through the outward appearance to the inner being in all its ugliness."

Perhaps this is why at their most memorable, cartoons and caricatures can cross class and cultural boundaries and transcend history in the sense that although they may instantaneously wound, they live on beyond their moment of inception. Therein lies the paradox: Cartoon language, wrote Art Spiegelman, uses "the discredited pseudo-scientific principles of physiognomy" to create indelible degradations. Think, for example, of Herblock's Richard Nixon. Who will ever forget that gifted American artist's renditions of the ski-nosed schemer with frail, hunched shoulders, angry jowls, and five o'clock shadow? My favorite is pictured here.

And then again, perhaps I am being unfair to cartoonists in other times and places, who lacked Nixon as a subject. After all, Doug Marlette, the American newspaper *Newsday*'s incomparable cartoonist, once observed, "Nixon was to cartooning what Marilyn Monroe was to sex. Nixon looked like his policies. His nose told you he was going to invade Cambodia."

Sometimes the response to a caricature is laughter. As Arthur Koestler has written, this can come from an effect "which is at the same time visually plausible and biologically impossible." And sometimes the response is nothing less than moral outrage. If the distortion involves exaggerating a racial or religious stereotype, or violating a

religious injunction—caricaturist, beware! As Gombrich pithily put it, the caricaturist is in the business of "mythologizing the world by physiognomizing it." Translation: "By linking the mythical with the real, the caricaturist creates that fusion, that amalgam, that seems so convincing to the emotional mind." Example: you can call a cabinet minister a parasite; but to make the charge visually, as in James Gillray's famous print of Prime Minister William Pitt as a toadstool growing on the crown, is something else again.

Unfairness, by the way, is the point—there really is no such thing as a balanced or objective caricature. Kiku Adatto has written that what portrait photography is really about is "the ability to interpret the meaning of the person captured in the frame." But, as I have already discussed, since caricatures by definition deal in distortion, they can be more troubling in a different way than photographs, which, she notes, can "frame you for a crime you did not commit."

An Excrescence;— a Fungus;—alias— a Toadstool upon a Dunghill.

James Gillray, "A Toadstool Upon a Dunghill" (1791)

I have always believed that another reason the victims of cartoons and caricatures (or those who identify with them) overreact is frustration over the fact that if you don't like something that is written about you, you can always send a letter to the editor, even if only in your head. The wounding caricature does not easily lend itself to such a remedy. And because an image is more "public" than words—it can be seen simultaneously by any number of viewers—it can be more humiliating. The caricature brands its subject and floats into the public sphere, and its target may feel unfairly victimized and impotent to do

anything about it. The only way really to answer a cartoon is with another cartoon, and there is, for all practical purposes, no such thing as a cartoon to the editor.

Cartoons may be our totems, carrying messages that once launched into the world are uncontrollable and speak for themselves; when, in addition, they are caricatures, they may function (here comes that peak-shift effect again) as superstimuli. Ask your local neuroaesthetician about it.

And then there are those caricatures that go over the line, which I will call, for lack of a better term, hate caricatures. All caricatures, as David Levine noted, are based to some degree on stereotypes. *The New Yorker*'s Bob Mankoff says it slightly differently: "All cartoons are based on types." *Der Stürmer*'s vicious, ugly, and anti-Semitic portraits of Jews are obviously hate caricatures, but there is a less obvious version as well. Steve Heller gives an illustrated hour-long lecture on racist images. During it, he shows an unending parade of negative images of African-Americans, among them cannibals, mammies, minstrels, criminals, Sambos, pickaninnies, miscegenators, the fat-lipped and kinky-haired, chimpanzees, servants, vagrants—collectively a searing statement of how cartoonists over the years have portrayed black Americans: individually, many of them harmless, but collectively, the visual equivalent of "nigger," "Jap," or "kike."

When it comes to minorities, the disadvantaged, and the dispossessed, I am at something of a loss in defining the line between the stereotype and the hate cartoon, though having grown up during World War II reading comics that invariably showed Japanese with leering slanted eyes, fangs for teeth, and bright yellow skin, as the late Associate Supreme Court Justice Potter Stewart once said of pornography, "I know it when I see it."

Steve Platt, then editor of the *New Statesman,* once wrote about a cartoonist who portrayed the late publishing magnate Robert Maxwell in bed with a pig receiving payoffs from Israel. He had a large Jewish nose and rolls of fat, looking like the classic cartoon Jew. "But why not?" he asked, "and how else does a cartoonist portray Jews other than as Jewish?" The British cartoonist Martin Rowson once was asked by his editors at the *Independent* to draw a caricature of a corrupt Brit-

ish television personality five times because the nose was too big. He finally satisfied the *Independent* by drawing the man with no nose at all.

As Platt observed, "Perhaps it is unfortunate that from the politically correct caricaturist's point of view, Charles de Gaulle was not Jewish. For the caricaturist the man was his nose. There was no other way of representing him. That is the nature of caricature—to take a distinctive feature and exaggerate it—literally to overload it."

. . .

Enough theorizing. Why not ask some caricaturists what they think?

I once was critical of an advocacy journalist who had gotten some trivial facts wrong in a supportive and friendly article about *Monocle*. I wanted to send a letter to the editor, not exactly complaining, but setting the record straight. His editor declined to run it. The writer in question distorts, his boss conceded, "but he distorts in the direction of truth." He was right. The surrealist artist Steve Brodner's caricatures distort in the direction of surrealism, but his mind makes a beeline for truth and sanity. He points out that most of the cartoons that have enraged and made news in recent years have been misunderstood; for example, the Obama fist bump depicted on the cover of *The New Yorker*. Brodner says that for the most part, "it was not *The New Yorker*'s constituency who misunderstood, but rather TV interviewers who never read the magazine." He also says the Danish Muhammads were misinterpreted, as have been the works of Robert Grossman and Edward Sorel. I think he's hit on an important truth here. Because cartoons speak in image language rather than words, they are especially vulnerable to misinterpretation.

I would add, however, that it's important to keep in mind (as was the case with Barry Blitt's Obamas) that an artist's intention is one thing and the message transmitted by a cartoon, which once released functions as a totem beyond control, is another.

One of the things Brodner demands from his visual-arts students is "clarity." For a prime example of the damage a misinterpreted cartoon can cause, consider Philip Zec's, published by Britain's *Daily Mirror* in 1942, which depicted a shipwrecked sailor clinging to a life raft. It ended up being debated in Parliament and almost resulted in the paper's

being shut down, all because Winston Churchill and others misinterpreted the meaning of the caption in relation to the image. A colleague had persuaded Zec to change his caption from "Petrol is dearer now" (meant to underscore how critical oil was to the war effort) to "The price of petrol has been increased by one penny!—Official" (which Churchill and others mistakenly read as an accusation that the government was colluding with war profiteers). So here was a case where words intended to clarify may have contributed to an ersatz interpretation of the image.

While we're on the subject of the age-old competition between words and images, let's not forget Plato, who thought the artist was an imitator and therefore not to be trusted. Art historian Werner Hofmann deduces from Plato's dismissal of images as having nothing to do with truth and veracity that "consequently verbal precision is superior to visual allusions." He goes on to note that Pope Gregory the Great "tried to make use of the sensuous appeal of the image but not without first asserting its inferiority. 'Pictures are the books of the illiterate,' he said."

His theory: art (read caricature and poetry) allowed the primitive to prevail over the rational, which he considered the higher aspect of being human. (One could argue that stereotypes are an example of the dangers Plato had in mind.)

When I visited with Ralph Steadman, who personally is as manic as his caricatures are otherworldly, at his home in Kent, England, about an hour away from the British Cartoon Archive in Canterbury, I asked him why he thought caricatures had such power. He cited Nietzsche as his authority and then said something that on its face seemed to be ducking the question, but on reflection said it all. "The only thing of value is the thing you cannot say. That's where drawing is so important. You can do with drawing what you can't put into words." When I thoughtlessly asked him to say a little more—i.e., to elaborate in words—he reminded me of what I had told him about Levine's Kissinger drawing. "It was powerful," he said, "because it was a drawing . . . but to just describe it in words is too crude. When people say that something is unspeakable, that's what they're getting at."

A paradox (at least on the surface): many "victims" of the caricatur-

ist's art line up to buy the originals to hang them on their walls, presumably to show off their thick skin, but in so doing to try to reappropriate the offensive material. Although it is difficult to imagine politicians lining up to buy the originals of Steadman's unflattering unlikenesses, it has been known to happen. But in 1988 he took the ultimate step to make sure it would never happen again (or at least for a year), issuing a manifesto urging other artists to follow his example. He explained to me as he has to others, in conversation and in writing, that "I urged all cartoonists in the world to stop drawing. I considered that if all cartoonists did that, even for one year, politicians as we know them would change. If we denied them the benefit of our attention, insight, and wit, they would suffer withdrawal symptoms of such withering magnitude that the effect on their egos could only be guessed at. Not even a tyrant can survive the whiplash of indifference." When I saw him in his studio in May of 2011, twenty-three years after he issued his manifesto, he seemed to be drawing only birds. A few months later, though, he broke his rule, and drew three political cartoons for the *New States-man*, which included one of his nemesis Margaret Thatcher.

"You have a remarkable opportunity to get through to people in a direct way," Steve Bell, the English cartoonist, told me. "They read it in a second." Whereas Steadman said you showed what you couldn't ever say, Bell spoke in body metaphors about the pleasure he took "in getting under people's skin" or "up their nose," and he reveled in what he called an "unfair process" because "there's no comeback."

A few weeks earlier Bell had told a newspaper interviewer that cartooning was "blazingly important because everything about politics screams imagery at you. We live in a mega-visual universe where thousands of things are pouring out of the screen at us every day, so you have to process it. You have to stop and have one still image. People think, 'Ah, it's old-fashioned' but it's not. You can actually say a lot of things in a single picture, making people stop and look. What's wrong with that? I think drawing is a way of inquiring about the world and it mystifies me why it should have gone out of fashion, and why it should be considered somehow inferior, because there is definitely a hierarchy between high art and low art. Certainly comic art is at the bottom."

Since, unfortunately, the cartoonist I most wanted to talk with, David

Low, who had, as it were, gotten to Der Führer, is dead, I contacted his biographer, Colin Seymour Ure. Ure believes that "the dangerousness of a cartoon stems partly from the fact that its meaning depends largely on the reader." This, he told an audience on the occasion of delivering the Hocken Lecture at the University of Otago, New Zealand, in 1996, "is due chiefly to the use of graphic images instead of words. The artist is dependent on the reader making the correct connection. Moreover the point of the cartoon may be oblique, implicit, indirect, or ironic. This gives the cartoonist deniability. 'I never meant that and it's not my fault if readers interpret it that way.' "

When I talked with the British cartoonist, broadcaster, and theologian Ted Harrison, we quickly discovered an unexpected bond: the poet W. H. Auden. As an undergraduate at Swarthmore College in Pennsylvania I had written an article for the college paper, *The Phoenix,* on Auden, who had taught at Swarthmore during World War II. In the course of researching the story, I fell victim to his idiosyncratic charm. (His final exam in his English composition course was to "write the events of the day backwards." He would proudly tell visitors to his flat that his bed had "originally belonged to Ehrlich, the inventor of the syphilis cure.") Harrison recalled persuading Auden to sit for a caricature portrait. ("He sat wearing slippers and a sloppy jumper and wreathed in cigarette smoke. He was grumpy and taciturn.") *The Times Literary Supplement* printed it, Harrison's first in a national publication.

Harrison, who had become fascinated with the political cartoonist's art as a student at the then brand-new University of Kent, where he studied and tried to emulate the work of Low and Victor Weisz (the German-English cartoonist better known as Vicky), combined a professorial perspective with a working cartoonist's knowledge of the trade. He lost his first job doing weekly sketches for the *Kentish Gazette*. "When I drew a certain councilor," said Harrison, "with a cigarette in one hand and a G and T in the other, she took offense, and as she was a friend of the proprietor, I was sacked."

Harrison has a tripartite theory of caricature: "There are three things all caricaturists look for: the subject's DNA (essential bone structures), the subject's acquired characteristics (obesity, etc.) and the subject's vanities (Hitler's mustache would be an example)."

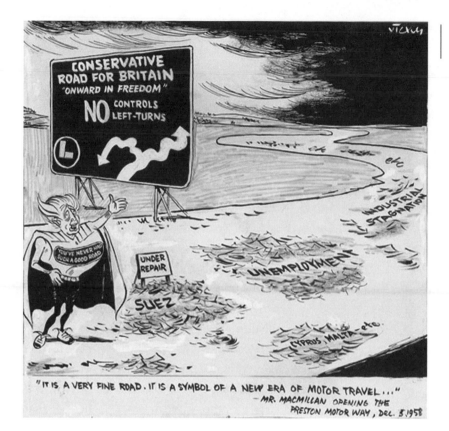

Victor Weisz, "Conservative Road for Britain" (1959)

Knowledgeable about the grammar and symbolism of caricature, he made the interesting point that when it comes to satirical portraits of an era, cartoons in particular and images in general tell the story better than the written word because written styles are ever evolving, whereas symbols seem more durable. "I can't think of much satirical eighteenth-century political writing that I've ever read, yet if someone drew like [the eighteenth-century English caricaturist Thomas] Rowlandson, he'd get a job today."

Harrison's point has resonance. I take it as a given that cartoons and caricature can, under certain circumstances, live on. See for example David Levine's depiction of President Lyndon Baines Johnson, showing his appendectomy scar in the shape of Vietnam, which has already found its way into the history books even as Daumier's and Philipon's contemporaries would forever be unable to think of Louis Philippe

David Levine, Lyndon Baines Johnson (1966)

without thinking of "La Poire." Says Steve Heller of Levine's LBJ, a great caricature "has to be surprising and that was amazing, the timing right, the image perfect, as great as any Daumier, a piece of history."

And to mention only drawings reprinted herein, Brits won't soon forget Vicky's Supermac or Steve Bell's John Major with his Airtex underpants over a dark blue business suit, even as Americans won't forget Herblock's Nixon with his five o'clock shadow and all the rest.

Regarding the Content Theory of cartoon impact, put together Steve Brodner's observation that much of the recent hullabaloo about cartoons stems from misunderstood meanings with the conclusion of the renowned creator of *Maus*, Art Spiegelman, that it is usually not the cartoon but the "reverberation in people's heads" that we are talking about, and we inch closer to an understanding. But since content alone doesn't account for the political and social impact of cartoons, it's important to keep in mind that, as every schoolchild is taught, form and content are all too often intertwined. Whether or not art historians, aestheticians, and critics take this into account, down through the ages and right up through today, tyrants, bigots, political bosses, and religious fundamentalists, human rights, gay rights, and feminist activists, judges, and just plain citizens seem to intuitively understand it.

The best way to make this point about form and content being interconnected may be via the art of Saul Steinberg, because as Gombrich once wrote, "One of the problems in writing about Steinberg's wit is precisely the fact that his drawings make the point so much better than words ever could."

Those familiar with *The Masses,* the groundbreaking Socialist magazine of the early twentieth century, remember that contributor

Art Young was tried for treason for his anti–World War I cartoons. Over the years I have seen the powerful cartoons of *Masses* artists like Young and Robert Minor, but it wasn't until the spring of 2011, when I visited the Billy Ireland Cartoon Library & Museum at Ohio State University, where I had the opportunity to thumb through entire issues of *The Masses*, that I understood for the first time how images dominated the reading experience. It was as if the words "illustrated" the art, which outranked them. I have mentioned Hitler's reaction to Low, and let's not forget that George Grosz was tried for blasphemy, slander, and obscenity without printing a word, before he left Germany; and let's not forget that it was a cartoonist's victim who best understood the damage that

Saul Steinberg, untitled, *The New Yorker* (1963)

a cartoonist's armory can inflict. In Boss Tweed's much-quoted words about Thomas Nast's caricatures of him: "Stop them damned pictures! I don't care a straw for your newspaper articles. My constituents can't read. But they can't help seeing those damned pictures."

With respect to the Image Theory of cartoons—the (possibly magic) power of the image—take Steve Bell's thought that "there's no comeback." It confirms me in my belief that since most of us lack the capacity to answer a cartoon with a counter-cartoon, the cartoon target's frustration and sense of impotence may be what leads to implosion (especially if the cartoonist has focused on one of what Ted Harrison has termed his subjects' vanities).

Regarding the cartoon as stimulus, though it's true that Freudians and neuroscientists differ among themselves about what happens when our brains are exposed to certain cartoons, a growing group of scientists seem eager to reconcile neuroscience and psychiatry into a unified

theory. The findings and speculations of men like V. S. Ramachandran and Semir Zeki suggest that neuroaestheticians, despite their nonaesthetic appellation, may have something to teach us after all.

Despite the neuroskepticism I share with Alva Noë, we already know from these two men and others that exaggeration and distortion, particularly of a face, provokes a stronger response in the viewer than a photo would. "The laws of aesthetics may have been hardwired into the visual areas of our brain," reasons Ramachandran. What's more, he adds, the caricaturist's pared-down style, the lines that conjure only the essential, add power to the image. "This is why an outline drawing or sketch is more effective as 'art' than a full color photograph." As many have said, sometimes less is more. By reducing people to their essence, artists can force us to focus on what we might otherwise miss. So perhaps the distortions and the leanness with which most caricatures are rendered combine to form a kind of hyper-charged, streamlined delivery vehicle for the ideas, arguments, narratives, and associations they contain.

· · ·

In early November, 2008, I went to see my friend John Leonard, the former editor of *The New York Times Book Review,* known for having read everything (yes, everything). I asked for his recommended reading list with regard to political cartoons. "I would read Arthur Koestler," he told me. "I used to think his ideas about humor were too pat and pompous, but I've been rereading him, and I think he was onto something." John, alas, died a few days later, before I could ask him which ideas of Koestler's, in which of his umpteen books, he was talking about.

Then, a couple of years later, I was talking with my Columbia Journalism School colleague, the Pulitzer Prize–winning science writer Jonathan Weiner, and I asked him the same question. He advised that I read a writer named Mark J. Turner. Turner, he explained, thinks that the brain works in metaphors, and applies his theory to literature, but maybe it could apply as well to cartoons, which are, after all, metaphors.

Lo and behold, in *The Way We Think,* by Turner and the scholar

Gilles Fauconnier, the authors cite the idea Koestler first suggested in his 1964 book *The Act of Creation*. He called it "bisociation of matrices." Turner and Fauconnier developed it much further, into a set of algorithms and more, and this time called it "conceptual blending."

They describe what they call a subconscious, cognitive process unique to the human brain wherein two ideas unlike one another are made to blend together (think "this surgeon is a butcher") forming what they call an emergent structure containing associations mapped onto one another. To oversimplify a little, what I take from this is that if the brain thinks in metaphors, and since cartoons are, in effect, metaphors, maybe the brain has a special place for them. Maybe it converts them into those superstimuli that neuroscientists like to talk about. (See a *Stürmer*

Das Ungeziefer

Das Leben ist nicht lebenswert,
Wo man nicht dem Schmarotzer wehrt,
Als Nimmersatt herumzukriechen.
Wir müssen und wir werden siegen.

Fips, *Der Stürmer*, "Das Ungeziefer" (The Vermin) (1944)

caricature of Jews as vermin enough times and one's mind may start to link them subconsciously.)

Can it be that taken together, neuroaesthetics and conceptual blending will suggest a way of understanding how the brain processes caricature and why it can cause such highly charged emotional responses? That, like the sharpest knife, the condensed exaggeration of caricature carves its way into your brain and yields a conceptual blend that, unlike text, which must be studied, arrives with the speed of light?

But suppose Noë is right and all these neuros (both the scientists and the aestheticians) are wrong. Suppose all the talk about the right and left hemispheres of the brain, System 1 and System 2, peak-shift effect and conceptual blending, is merely our translation into twenty-first-century-ese of the idea that images are alive, that pictures have powers beyond our understanding. Science still has much to

teach us about how images work, and not just neuroscience. Remember, it was Charles Darwin who said, "There is something distinctive about responses to danger. They are instinctual responses toward self-preservation."

All of which is consistent with the idea that caricatures are in a class by themselves in their potential for engaging and occasionally outraging the emotional mind. What can be more dangerous to one's sense of self than caricature's implicit claim that, in the guise of jokey exaggeration, the grotesque distortion in fact reveals the truth about one's miserable character?

The sentimental idea that outward appearance reflects inner character may indeed be discredited pseudoscience. But the more subversive idea that the masters of the universe of lines—the great cartoonists— by tinkering with physiognomy, can get at, expose, and portray the sometimes ugly truth beneath the surface of those lines, seems not only possible, but plausible. If the subjects of a cartoon (or those who identify with them) worry that the grotesquely deformed self may signify the real self, the true self, the soul beneath the surface, no wonder they react so emotionally to the bad news about their inner core.

So was the golden age of caricature in the England of Hogarth, Gillray, Rowlandson, and Cruikshank, all of whom went about their business in full and splashy colors in the eighteenth and nineteenth centuries? Or was it in the France of Daumier and the caricature journals? Or was it decades later in the pre-television U.S., when Boss Tweed foresaw that Nast's black-and-white caricatures with their universal accessibility would cause his downfall in a way that words could never do? Or was it during Watergate, when cartoonists, including Herblock, did so much to bring down President Nixon and his gang?* Or given the World Wide Web and the new "apps" that seem to surface daily, is the golden age yet to come? History suggests that a new golden age is always on the horizon, so it's fitting that a historian—Arthur Schlesinger Jr.—wrote in his introduction to *Watergate Without Words* that caricatures "catch the spirit of the age and then leave their own

* See *Watergate Without Words* by Jean-Claude Suares, Jr., whose cover showed Nixon with his hand up the Statue of Liberty's dress.

imprint on it—they create political heroes and villains in their own image; they teach historians their trade."

The ultimate faith of democracy is that through free and unfettered rational discourse good ideas will drive bad ideas out of circulation. But the ultimate fact about art is that one image may indeed be worth more than ten thousand words. That means we would do well to pay attention to images in general, and caricatures in particular, built as they are on stereotypes, which have the power to distort and degrade, and may involve archetypes, which touch on the deepest questions of identity—personal, political, and cultural. Like it or not, cartoons and caricatures are here to stay. Rather than dating them, the World Wide Web and digital media appear to extend their reach.

. . .

At the outset I identified two pillars of faith: one, free-speech values *über alles;* the other, the idea that parody, cartoons, and caricatures are a form of satire, and as such deserve to be protected along with speech itself. My belief in the power and importance of visual language is, if anything, deeper and stronger than when I began, although I understand that often words and images together are what cartoons are all about.

In the case of *Hustler Magazine Inc. v. Falwell* (1988) the U.S. Supreme Court reassuringly reaffirmed that parody and caricature are and ought to be protected by the First Amendment, even when they are in execrable taste. Jerry Falwell, the Baptist minister, sued the raunchy adult magazine for featuring him in a parody of a Campari ad, in which Falwell recounts his first sexual encounter (with his mother) while the two of them were "drunk off our God-fearing asses."

The concept of parody and the American tradition of editorial cartooning featured prominently in the Court's decision:

> The appeal of the political cartoon or caricature is often based on exploitation of unfortunate physical traits or politically embarrassing events—an exploitation often calculated to injure the feelings of the subject of the portrayal. The art of the cartoonist is often not reasoned or evenhanded, but slashing and

one-sided. . . . Several famous examples of this type of inten-
tionally injurious speech were drawn by Thomas Nast, probably
the greatest American cartoonist to date, who was associated for
many years during the post–Civil War era with *Harper's Weekly*.
In the pages of that publication Nast conducted a graphic ven-
detta against William M. "Boss" Tweed and his corrupt asso-
ciates in New York City's "Tweed Ring." . . . Despite their
sometimes caustic nature, from the early cartoon portraying
George Washington as an ass down to the present day, graphic
depictions and satirical cartoons have played a prominent role in
public and political debate. . . . Lincoln's tall, gangling posture,
Teddy Roosevelt's glasses and teeth, and Franklin D. Roosevelt's
jutting jaw and cigarette holder have been memorialized by polit-
ical cartoons with an effect that could not have been obtained by
the photographer or the portrait artist. From the viewpoint of
history it is clear that our political discourse would have been
considerably poorer without them.

At a minimum, visual language deserves the same protection as ver-
bal language. But suppose, as we have seen on more than one occasion,
visual language carries more emotional power than (mere?) words.
What does that say about my belief in Habermas's ideal of a public
sphere where democracy depends on continuous conversation, argu-
mentation, and debate, all calculated to inspire, protect, and promote
Enlightenment values?

And suppose that cartoons and especially caricatures are indeed
image facts that contain arguments and become totems that cannot
always be controlled once released? If so, what follows?

Let us assume that the public sphere is indeed governed by what
Habermas has called the power of the better argument. I have always
imagined that argument to take place in the land of words. But if car-
toons, which live in the land of images, are a medium that speaks to
the emotions in a polity based on sweet reason, must I now revise or
replace that presumption? I'm not sure I know the answer, but I find
the beginning of wisdom in the words of a couple of Habermas's fel-
low philosophers.

Ronald Dworkin, a fierce free-speech proponent and a philosopher who teaches at Oxford and New York University, seems to have a feeling for visual language. When the Danes did their Muhammads, Dworkin wrote eloquently in *The New York Review of Books* on the right to ridicule:

> Ridicule is a distinct kind of expression: its substance cannot be repackaged in a less offensive rhetorical form without expressing something very different from what was intended. That is why cartoons and other forms of ridicule have for centuries, even when illegal, been among the most important weapons of both noble and wicked political movements.

It's not merely that ridicule by caricature is almost by definition the sort of symbolic expression that the framers wanted to protect, but that its form is connected to its power. Or, to put it another way, caricatures have totemic power.

Arthur Danto, of Columbia University, a philosopher reflecting on his lifetime's immersion in the arts, made a related point about caricature in one of his *Nation* columns (on Philip Guston's Nixon):

> Caricature has at times succeeded in putting certain public figures in a light so unflattering that their power has been damaged and even destroyed. It became almost impossible for the French to take Louis Philippe seriously once they saw him through Daumier's drawings as having the form of a pear—the term connotes stupidity. Thomas Nast found such damaging ways of drawing Boss Tweed and his corrupt Tammany cohort that they were graphically and then politically discredited.

Danto adds: "The powers that images can release are unpredictable, which is why censorship exists."* I would add to "unpredictable" "uncontrollable."

* *The New York Times* reported in 2011 that Floyd Abrams, arguably America's leading free speech lawyer, had persuaded a federal judge to rule that the U.S. Food and Drug Administration could not require tobacco companies to put new graphic-warning labels on cigarette packages. The images on the labels would have included a corpse and a man breathing smoke out of a tracheotomy hole in his neck. The *Times* reported: "The judge ruled that the labels

Together, these philosophers implicitly make the case for why images (especially when they involve satire and caricature) can speak as loud as, if not louder than, words. Images and words don't speak the same language. That doesn't mean they can't relate to, learn from, collaborate, communicate, and, yes, argue with each other. It falls to us, along with critics, scholars, philosophers, neuroscientists, neuroaestheticians, and whomever, to come up with the rules of engagement. And given all of the questions I have left hanging along the way, I don't underestimate the difficulty of the task. Art Spiegelman, for one, observes that whatever neuroscience says about the brain, "you know that visual grammar doesn't function the way verbal grammar does. Verbal grammar has all those semicolons and punctuation marks, all calculated to add nuanced qualifications, which are designed to make for a more civilized discourse, whereas the image has none of that."

I have not begun to explore such related issues as the role of art in politics, and politics in art. Caricatures are indeed weapons in the cartoonist's armory, a part of the assault of laughter. But as Mark Twain himself observed, "Against the assault of laughter, nothing can stand." I know mine are not original questions. They go back to Aristotle and before. I have also not dealt here with the power of comic strips, animation, television, moving pictures, new visual technologies, and the latest apps. But if one picture is worth ten thousand words, and a journey of a thousand miles begins with a single step, then consider these words that step, and think about it as you ponder the cartoons on the pages that follow.

. . .

were not factual and required the companies to use cigarette packages as billboards for what he described as the government's 'obvious anti-smoking agenda.' "

Abrams, who praised the ruling, saying the companies had objected to what he called "grotesque" images, was representing Lorillard Tobacco of Greensboro, North Carolina. Five tobacco companies had brought suit, objecting to the use of graphic warnings as an unconstitutional infringement on free speech. The judge agreed with them on the grounds that "it is abundantly clear from viewing these images that the emotional response they were crafted to induce is calculated to provoke the viewer to quit, or never to start, smoking, an objective wholly apart from disseminating purely factual and uncontroversial information."

Because this will be an unguided tour, I have prepared a short inventory of propositions that will remind you of what has gone before, but that you might also want to test against the political cartoons and caricatures that you see. I hope that as you wander through the upcoming gallery (which means traveling across the seas and back in time) you will keep in mind the many unanswered questions already raised. And as you do, know that your mind may or may not be operating on more than one track: the logical and the psychological, the literal and the symbolic, the verbal and the visual among them.

PROPOSITION NUMBER ONE: The political cartoon, with or without words, is an argument.

PROPOSITION NUMBER TWO: When that cartoon is a caricature, once released, it can become a totem and as such is uncontrollable.

PROPOSITION NUMBER THREE: The political cartoon, as a form of expression, deserves (as it already has in the U.S.) constitutional protection.

PROPOSITION NUMBER FOUR: Images (especially when they are cartoons) are second-class citizens in the land of words, and that ought not to be the case.

PROPOSITION NUMBER FIVE: The curators of our culture have yet to devise ground rules for adjudicating disputes between words and images.

PROPOSITION NUMBER SIX: Images can speak louder than words, and one caricature may indeed be worth more than ten thousand words.

PROPOSITION NUMBER SEVEN: The term "illustrator" needs to be reexamined. Images convey ideas on their own and don't merely "illustrate" words.

PROPOSITION NUMBER EIGHT: Physiognomy may indeed be a discredited pseudoscience, but don't forget Ernst Gombrich's insight that the caricaturist is in the business of "mythologizing the world by physiognomizing it."

PROPOSITION NUMBER NINE: The so-called primitives who thought images were in some sense alive and had magical powers may have been right.

PROPOSITION NUMBER TEN: Neuroscientists and neuroaestheticians who tell us that the emotional power of art can be explained by the structure of the brain are winning the argument, but have yet to prove their case.

Because these propositions are set forth only in words, I am beginning to feel discomfort, and will stop here, but I invite amendments—visual, semantic, or otherwise.

THE GALLERY

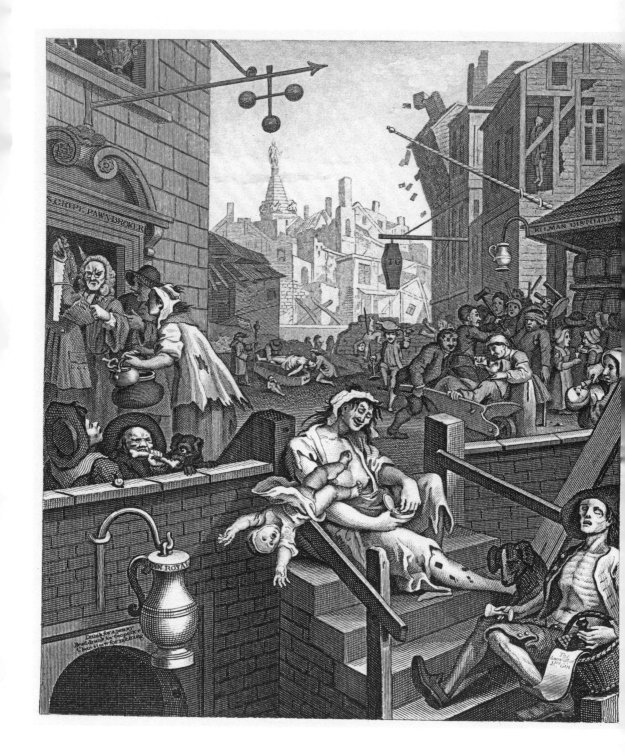

William Hogarth

Even though he dismissed the very idea of satiric art, William Hogarth (1697–1764) is called "the father of caricature." He, however, thought he was better than that.

Opposite:
William Hogarth, *Gin Lane* (1751)

I include Hogarth in this gallery even though he denied that he was a caricaturist, calling caricature "a species of lines that are produced, rather by the hand of chance, than of skill." I include him for three reasons:

First, as Ralph Shikes—the author of several books on art, including *The Indignant Eye: The Artist as Social Critic in Prints and Drawings from the Fifteenth Century to Picasso*—has pointed out, Hogarth's "reputation was based, quite justifiably, on his magnificent satirical prints. Ironically, the very fact that his prints were so popular militated against his paintings being taken seriously. His contemporaries never recognized his great contributions to English painting." This reminds me of no one more than David Levine, whose brilliance as a contemporary caricaturist may have undermined potential critical appreciation of his gifts as a realist painter. (Levine, who had a higher regard for satiric art than Hogarth, believed that his realist paintings would be discovered after he died.)

Second, London at the dawn of the eighteenth century was democratic, gracious, aristocratic, bourgeois, and intellectual. But Hogarth, who as a child experienced Fleet Street Prison where he lived with his bankrupt father, captured its darker, stinky, brawling, crowded, filthy, and vulgar side. Hogarth has captured both Londons in his paintings, engravings, and etchings. For example, see his series *Marriage à la Mode,* which exposes the boredom and emptiness of those living in high society but without values. And see especially his *Beggar's Opera.*

It was the spring of 1953, in my third year of college, when I first read *The Beggar's Opera* by John Gay. Whenever I think of it, I think of William Hogarth.

I feel a special connection to Hogarth's *Beggar's Opera,* which he painted six times, because when I moved back to New York in the early 1960s I took a small apartment in Greenwich Village and it turned out to be across the street and a few doors down from the Theatre de Lys, which was staging Brecht's *Threepenny Opera* (based on Gay's *Beggar's Opera,* with songs by Brecht and Kurt Weill). Entranced by such lowlifes as Mack the Knife, Polly Peachum, Lucy Brown, and their ilk, I couldn't stay away.

And when I discovered that Hogarth painted *The Beggar's Opera* six times, I could understand his obsession. So every time I look at one of them, his *Gin Lane,* his *Harlot's Progress,* his *First Stage,* I think of them as his version of the lowlifes in *Threepenny.* And although he and Brecht couldn't have been farther apart politically, I believe that this artist-reformer belongs in the long line of those he condemned (partly for tactical reasons, I believe—because he wanted to be thought of as a serious painter) to "the lowest aesthetic category." (He put himself in the middle category, what he called "the comedy of character.")

"Hogarth's political prints of the early 1760s were the precursors of the myriads of graphic squibs which have since poured so abundantly from the press, and made so marked a feature in the political history of the country [that] George III's reign (1760–1820) hereafter may well be designated the age of caricatura," wrote Diana Donald, head of the Department of Art History and Design at the Manchester Metropolitan University, in her magisterial *The Age of Caricature: Satirical Prints in the Reign of George III* (1998).

He called his own works not caricatures but "modern moral subjects." "My picture is my stage," he said, "and men and women are my players." He believed neither in distortion, nor in showing his characters in poses, but, as Werner Hofmann noted, with Montaigne he wanted to observe life *"de minute en minute."* And he wanted more. Some of his pictures were sermons, like *The Rake's Progress,* first painted, then engraved.

But always he was an artist-reformer. *A Harlot's Progress* laid the basis for the founding of Magdalen Hospital, the oldest home for prostitutes in England. *Gin Lane* bolstered the efforts of writers like Henry Fielding to push for the Tippling Act against the sale of cheap

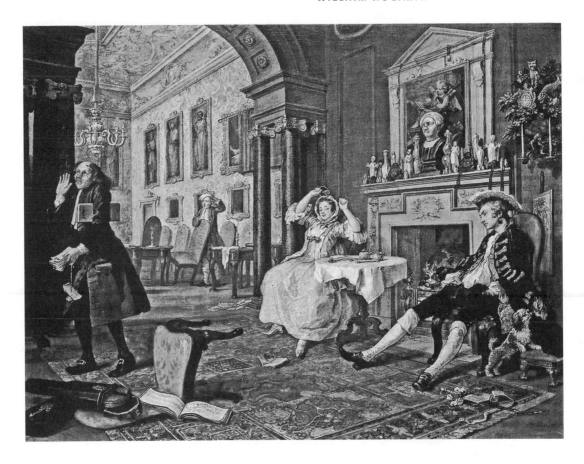

gin. *First Stage*, featuring a boy wearing the badge of St. Giles Charity, was an attack on a corrupt charity-school apprenticeship program.

Last but far from least on the list of reasons for including Hogarth here is his *Characters and Caricaturas* (1743). Perhaps the most famous print in the history of caricature, Hogarth showed in it different types of heads, endeavoring to distinguish character from caricature. On the print itself he referred the viewer to Fielding's Preface to *Joseph Andrews*. Fielding, the first to define the difference between caricature and character in print, had written that characters "consist in the exactest Copy of Nature . . . whereas in Caricatura we allow all license . . . and all Distortion and Exaggeration were within its proper Province."

As for Hogarth's decision to go out of his way repeatedly to distance

William Hogarth, "The Tête à Tête" from *Marriage à la Mode* (1743)

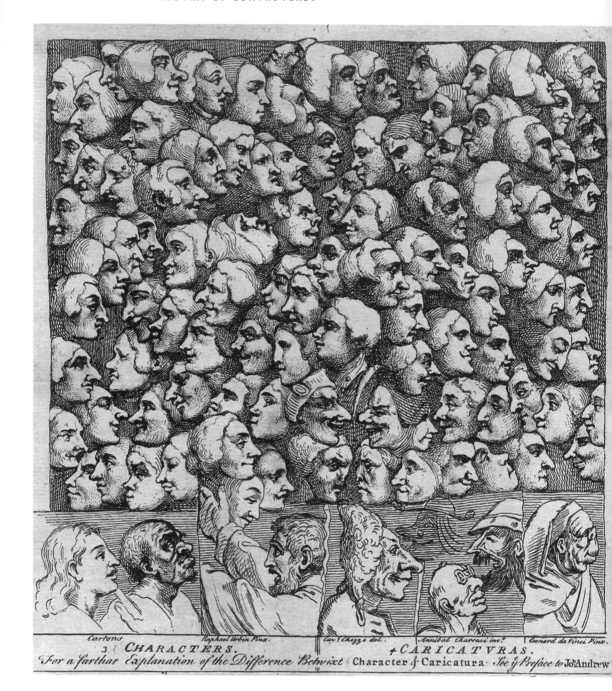

himself from it, perhaps the late Moshe Barasch, the art historian, had it right when he wrote that "in its strictest sense the neo-classsical conception of art as a moral form incorporates rejection of all distortion as frivolous and immoral." Perhaps Hogarth's attraction to theories of physiognomy was related to this idea, and his rejection of caricature was part of it.

Was the father of caricature being too modest when he denied his paternity, or did he really want to disown what he saw as bastard offspring?

Opposite:
William Hogarth,
Characters and
Caricaturas **(1743)**

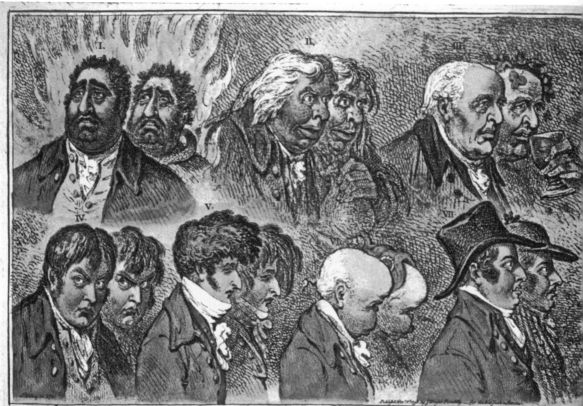

DOUBLURES of Characters; — or — striking Resemblances in Phisiognomy. — "If you would know Mens Hearts, look in their Faces."

| I. The Patron of Liberty. Doublure. The Arch Fiend. | II. A Friend to his Country. Doubᵗ. Judas selling his Master. | III. Character of High Birth. Doubᵗ. Silenus debauching. | IV. A Finished Patriot. Doubᵗ. The lowest Spirit of Hell. | V. Arbiter Elegantiarum. Doubᵗ. Sixteen-string Jack. | VI. Strong Sense, Doubᵗ. "A Baboon". | VII. A Pillar of the State. Doubᵗ. A Newmarket Jockey. |

James Gillray

n *Doublures of Characters: or, Striking Resemblances in Phisiognomy* James Gillray (1756–1815) provides what one of his biographers has called "a superb representation of the moral weakness of the Whigs"— one of two political parties then in the Parliament of England. He also provides a perfect example of what physiognomy, popular at the time, but now generally discredited as a pseudo-science, was all about.

Opposite:
James Gillray,
*Doublures of
Characters* (1798)

Physiognomy purports to classify individuals by character type according to outward bodily signs. In *Doublures*, Gillray classifies particular Whig leaders as a motley crew—sinners, criminals, and drunks—far removed from the respectable political leaders they presented themselves as being. Indeed, if all one had to go on was *Doublures*, especially if one shared its anti-Whig politics, one might well accept physiognomy as a valid science.

His method is to depict seven leaders of the Opposition next to their "true" selves, whom he helpfully identifies in a caption at the bottom. Thus Charles James Fox, the archrival of Gillray's eventual patron William Pitt the Younger, appears next to his double, Satan; Richard Brinsley Sheridan, the playwright and politician, is Judas; the Duke of Norfolk is Silenus (in Greek mythology associated with Dionysus, often portrayed as a drunk); Charles Tierney is "the lowest spirit of hell"; Lord Derby is a baboon replete with a French revolutionary's "Cap of Liberty"; and the Duke of Bedford, known for his high-living, gambling ways, is "A Newmarket Jockey."

The subtitle, "If you would know Mens Hearts, look in their Faces," a quote from Johann Kaspar Lavater (1741–1801), in some ways says it all. Lavater was the Swiss theologian who popularized the "science" of physiognomy and the idea that art should reveal the soul. As Cindy McCreery has written in the catalogue on Gillray's Legacy, the exhibit that coincided with Ohio State University's 2004 Festival of Cartoon Art, "By linking the individuals together Gillray creates a powerful

impression of a political party that has lost its moral as well as its political way."

Werner Hofmann wrote in his classic book *Caricature: From Leonardo to Picasso* that Hogarth, Rowlandson, Gillray, and Cruikshank raised English caricature during the Napoleonic Wars "to a shrill, aggressive intensity" and "showed with a frequently terrifying clarity that the art of caricaturing . . . goes back to an actual wounding of the person attacked."

Although Hofmann ropes in the others, clearly Gillray was the greatest culprit. It is worth noting, however, that while Gillray was gleefully drawing outrageous and occasionally grotesque and scatological caricatures, unlike his counterparts in France (but like Hogarth and his British confreres) he came to no harm. He was charged once for blasphemy, but does not appear ever to have been tried in a court of law. Perhaps the explanation is that in a society with a burgeoning political class, caricature was deemed an important political tool, useful to both sides—in fact Gillray, a hired pen, indeed drew for both Whigs and Tories—and outlawing caricature would have limited the weapons available for political warfare.

Also, liberty of the press was one of the most cherished principles of Georgian society. Nevertheless, with the onset of the French Revolution, even the British laissez-faire attitude toward publication gave way to a new concern for "state security" amid fear of the "dark masses," and several publishers, including one William Holland, publisher of Gillray's caricatures among others, were imprisoned for sedition in the early 1790s.

Although his contemporaries considered it in poor taste for him to focus on physical weakness, his images exaggerate unappealing facial or other physical characteristics of eighteenth-century pols. Moreover, as the catalogue that accompanied the 2004 Ohio State Gallery exhibit makes clear:

> It is hard to visualize George III, Queen Charlotte, the Prince of Wales or Charles James Fox today without thinking of Gillray's caricature images. The King's bewildered expression, the Queen's greedy grin, the Prince of Wales's self-satisfied

FASHIONABLE CONTRASTS; _or _ The Duchess's little Shoe yielding to the Magnitude of the Duke's Foot

air . . . Gillray's characterizations captured the imagination of the public and were imitated by many other caricaturists. They set a new standard for the public representation of prominent figures. Now an individual's depiction reflected his or her personal mannerisms as well as his or her social status.

Duendecitos.

Francisco Goya

I came to know the caricatures of Francisco Goya y Lucientes through Ralph Shikes, whom you have already met as author of *The Indignant Eye: The Artist as Social Critic in Prints and Drawings from the Fifteenth Century to Picasso.* And for reasons I will briefly explain, it was altogether fitting and proper that I was put in touch with Ralph by one F. Palmer Weber, who had been blacklisted during the McCarthy years and so had to give up his consulting for various congressional committees, and went to work on Wall Street, where, using Marxist categories of analysis (looking at patterns of production and consumption), he beat capitalism at its own game.

Palmer had a Ph.D. in Hegelian dialectics. Most of his early clients were blacklistees like himself, and he in effect tithed them—told them that if he made money for them in the market, he expected them to donate at least 10 percent of what he made for them to good causes. This Marxist on Wall Street raised a good chunk of the money that bankrolled the peace and civil rights movements of the 1950s and 1960s.

Shikes, whom he had known when they both worked on Henry Wallace's campaign for president in 1948 (Shikes was public-relations director, and Palmer was in charge of the southern states), was one of Palmer's clients. He and Samuel Chavkin, another blacklistee forced to go into private enterprise, had started what became a quite successful scientific publishing business. (Ralph, Samuel, and Palmer all became modest investors in *The Nation.*)

When he wasn't investing in good causes or participating in the weekly peace vigil in Lakeville, Connecticut, where he had a second home with his wife, Ruth, he was working on a study of the French neoimpressionist Camille Pissarro and his book about caricature.

It turned out that he had co-edited *The Best Humor of 1949–50* with Louis Untermeyer, also blacklisted. Perhaps this background as a political subversive with a sense of humor is what qualified him to reject

Opposite:
Francisco Goya,
"Duendecitos" (1860)

the consensus that as Goya scholar Hugh Stokes wrote in 1914, "there is no evidence to prove that Goya actively assisted in any scheme of protest against the established order of society." But as Ralph Shikes wrote, "Only twelve days after he first published [*Los Caprichos*], a frightened Goya withdrew them probably under threat of prosecution by the touchy Inquisition. In a letter written a quarter of a century later, he said that 'it was because of *Los Caprichos* that I was accused by the "*Santa*"—an abbreviation of the Inquisition.' " Goya, Shikes wrote, had reason to fear. Although he disguised many of his social and political references, "his double meanings were probably clear to his contemporaries."

Ben Shahn, the Lithuanian-born American social realist painter, also on the left, agreed: "Of course Goya did actively assist; indeed he protested with . . . the most effective, the most unforgettable indictment of the horrors of religious and patriotic fanaticism that has ever been created in any medium at all. Beauty? Yes, it is beautiful, but its beauty is inseparable from its power and its content. Who is to say when a weeping face becomes a trenchant line? And who may presume to know that the line might have been trenchant apart from the face?"

And as my *Nation* colleague Christopher Hitchens wrote on the occasion of the 1989 exhibition Goya and the Spirit of Enlightenment at the Metropolitan Museum of Art in New York City: "Probably there has never been a finer vial of scorn than the one that Goya emptied so gracefully over the clowns and toadies and witch doctors who made up the Spanish 'restoration of traditional values.' "

Although we never got to discuss it, I now believe that one of the things that attracted Ralph about, and gave him insight into, Goya, was that the auto-da-fé, for several centuries a common spectacle in Spain, was still around in Goya's day (1746–1828). "In such an atmosphere," Ralph has written, presumably drawing on his knowledge of the McCarthy years, "it would have been unthinkable for an artist, if he did have a subversive thought, to draw critically of society. But as always when the lid was lifted slightly, the accumulated pressure exploded, even if only temporarily, and Goya's genius burst upon the world."

In the summer of 2010 in an elevator at the estimable Hotel

Raphael in Rome, I spotted *Time*'s brilliant former art critic, the late Australian-born Robert Hughes, and reminded him that we had once met. He asked what I was working on, and when I told him of my interest in cartoons and caricatures, he invited me to join him for a drink, where he said, among other things, "If you are interested in caricature, study Goya." And so I did, or at least I read his definitive Goya biography. "Goya," wrote Hughes, "was the first important visual artist to let his work speak out against the Inquisition while it was still in existence and presented a threat, however notional, to its critics; and he was the last and perhaps the only one to be threatened by its investigators." As in "Duendecitos," Hughes notes elsewhere that Goya's gift is to expose hobgoblins to the light of day, "so that you are always left feeling that such monsters *may* be chatting to one another . . . just around the corner . . . [To present] these goblins, these *duendecitos*, in the white sunlight of the printed page was to have power over them, more power than mere birth could give you; it was to have dominion over your own fears, and society's as well."

Here is Goya, speaking humbly of himself, in his own words:

> The author is convinced that it is as proper for painting to criticize human error and vice as for poetry and prose to do so, although criticism is usually taken to be exclusively the business of literature. He has selected from amongst the innumerable foibles and follies to be found in any civilized society, and from the common prejudices and deceitful practices which custom, ignorance, or self-interest have made usual, those subjects which he feels to be the more suitable material for satire, and which, at the same time, emulate the artist's imagination. Since most of the subjects depicted in this work are not real, it is not unreasonable to hope that connoisseurs will overlook their defects.

He then goes on to urge that art be original and explore humanity's darker corners:

> The author has not followed the precedents of any other artist, nor has he been able to copy Nature herself. He who departs entirely from Nature will surely merit high esteem, since he has

to put before the eyes of the public forms and poses which have existed previously in the darkness and confusion of an irrational mind, or one which is beset by uncontrolled passion.

Goya was fifty when he etched the *Caprichos*, a set of eighty aquatint prints that, as Ralph points out, "revealed a philosophy hitherto unreflected in his painting." To say that these acid prints revealed the "foibles and follies" and foolishness of Spanish society is to lapse into cliché and platitude, everything that the *Caprichos* are not, and that Goya fought against.

As Hughes makes clear, although Goya once remarked that his real masters were Velázquez, Rembrandt, and nature, when it came to the *Caprichos*, it was the English caricaturists (Thomas Rowlandson, James Gillray, and, yes, William Hogarth) "whose violent distortions of form and fearlessly scatological humor" informed his caricatures.

And as Hitchens wrote of the *Caprichos*, "Goya could hardly bring himself to represent such people as human. The etchings pullulate with freaks: depraved slobbering bats and goblins and ghouls." Coincidentally, when we first lured Hitchens to leave his native UK and come to *The Nation*, it had been our idea to apprentice him to Palmer Weber. But he quickly realized that Wall Street was not for him, given his interest in politics and the arts. So it was no accident that Christopher saw that for Goya "the Spanish mob was at least as often an instrument of reaction as it was a cry of the oppressed. The frenzies of superstition and the occult, the great carnivals of cruelty that attended the trials of the Inquisition, were frequently the demonstration of . . . popular feeling."

Goya, wrote Christopher, was a "radical pessimist," who used his art to force our attention on savagery and evil "while not surrendering to them or ceasing to protest against [them]."

Charles Philipon

In 1830, three months after King Louis Philippe had replaced Charles X as the last king of France, Charles Philipon (1800–1861), who had taken an active part in the revolution, started the weekly *La Caricature*.

As Ralph Shikes has written, "To the liberty-loving, reform-seeking Republican artist of the day, Louis Philippe was the symbol of dashed hopes, of mediocracy and materialism triumphant, of a detested monarchical form of government."

Philipon—caricaturist, editor, publisher, and gadfly—hit upon the resemblance of Louis Philippe's heavily jowled face to a pear with his "La Poire," which was also slang for "fathead," and he was the first to make it a symbol of the July Monarchy (the liberal constitutional monarchy that held power from 1830 to 1848).

Within months, prosecution followed. Robert Justin Goldstein has reported Louis Philippe's regime had "quickly instituted a massive crackdown on the press, bringing at least 530 prosecutions in Paris alone between 1830 and 1834. . . . A November 29, 1830 law outlawed attacks on the 'royal authority,' the 'inviolability' of the king's person, the order of succession and the throne, the authority of the legislature."

The art critic Ernst Gombrich has written that "the invention of portrait caricature presupposes the theoretical discovery of the difference between likeness and equivalence." And he cited the nineteenth-century critic Filippo Baldinucci as defining the art of mock portraits: "Among painters and sculptors," Baldinucci explains in his *Vocabolario (Dictionary of Artistic Terms)*, which came out in 1681, "caricaturing . . . signifies a method of making of portraits in which they aim at the greatest resemblance of the person portrayed, while yet, for the purposes of fun, and sometimes mockery, they disproportionately increase and emphasize the defects of the features they copy, so that the portrait as a whole appears to be the sitter himself while its component parts are changed."

Gombrich added that "the *locus classicus* for a demonstration of the discovery of like in unlike is the 'Poire,' the pear into which Daumier's employer, Philipon, transformed the head of the *Roi Bourgeois,* Louis Philippe."

Philipon himself artfully and mischievously explained the process in the first of the two trials to which he was subjected. First he drew a face similar to the king's, then he drew three more sketches, and said from the witness stand:

> The first looks like Louis-Philippe, the last looks like the first, yet this last one . . . is a pear! Where are you to draw the line? Would you condemn the first drawing? In that case you would have to condemn the last as well, since this resembles the first and thus the King, too! Can I help it if His Majesty's face is like a pear?
>
> You would sentence a man to two years in jail because he created a pear which demonstrates a certain similarity with the king! In this case you would have to convict all caricatures which depict a head which is narrow at the top and broad at the bottom! In this case, I can promise you will have more than enough to do, as the malice of artists will find a great amount of pleasure in demonstrating this proportion in any variety of broad circumstances. Then see how you will have raised the royal dignity! See what reasonable limits you will have placed on liberty of the crayon, a liberty as sacred as all others, because it supports thousands of artists and printers, a liberty which is my right and which you cannot deprive me of, even if I was the one to use it.

Ultimately, the regime seized his journals, prosecuted him six times (three convictions), fined him over four thousand francs, and jailed him for a year. But his personal travails notwithstanding, the image he had created lived on.* The exiled German journalist and poet Heinrich

* In 1947, in an era of heightening press censorship, the Argentine caricaturist Juan Carlos Colombres began drawing for a new satirical magazine, *Cascabel* ("rattle"). The magazine featured his parodies of President Juan Perón, whom he drew in military regalia with a large pear for a head. What is it with these caricaturists and pears? It wouldn't surprise me if at this very moment, some graduate student is writing his dissertation on "Caricature and the Pear: Philipon and Colombres, a Comparison."

**Opposite:
Charles Philipon, "La Poire" (1831)**

Heine wrote in 1832 that Paris "was festooned with hundreds of caricatures" hanging "everywhere," featuring the pear as "the permanent standing joke of the people," and that "their glory from the king's head hath passed away, and all men see it as but a pear." A journalist at the time reported that the mayor of a town a hundred miles from Paris had added to the Post No Bills sign "nor any pears."

It was 150 years later that my *Nation* colleague the critic Arthur Danto (whom you have already heard from), in his essay "Metaphor and Cognition," explained (citing Philipon's use of "La Poire" by way of example) how metaphors and, in this case, caricatures work. After describing the way Philipon's drawing takes us through the four stages he had elaborated upon at his trial, Danto speculates:

> It is as though Philipon had seen a *poire* inscribed in Louis's head, and taught us to see it through steps—taught us to see what had always been visible to the genius of the caricaturist who has, in Aristotle's words, "an intuitive perception in the similarity of dissimilars." Moralists say we sometimes earn our faces, that our faces have our moral histories inscribed in their shapes, as if each of us displayed a metaphor of our moral reality as a kind of signature. And when we see the pear in Louis's face we instantly see the point Philipon slyly makes.

Although he thinks with a philosopher's precision, Danto's message is not an abstract one, intended for some ideal philosopher's universe. It is, rather, anchored in the world of real, human consequences. It is Danto who reminds us that Philipon's metaphor, which portrays the king as "reprobate and ludicrous at once, like a vicious clown," is "artistic revenge," payback for the king having imprisoned his colleague Daumier, who, as you will see, depicted the king as Gargantua, wallowing in material goods.

Above: William Hogarth, "The Tête à Tête" from *Marriage à la Mode* (1745)
Below: James Gillray, "Fashionable Contrasts" (1792)

FASHIONABLE CONTRASTS;—or—The Duchess's little Shoe yeilding to the Magnitude of the Duke's Foot.

Above:
Ralph Steadman, "Richard M. Nixon" (1974)

Right:
Edward Sorel, "Pass the Lord and Praise the Ammunition" (1967)

Pass the Lord and
PRAISE THE AMMUNITION

Left:
Cover of *New Statesman* (1993)

Below: Qaddafi caricature,
Novinar (2006)

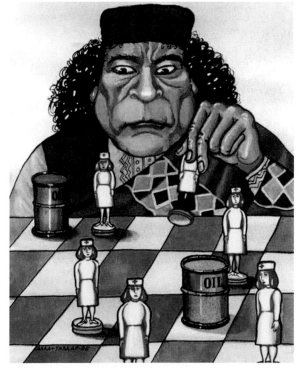

Opposite:
Art Spiegelman, "Valentine's Day," *The New Yorker* (1993)

Right: Art Spiegelman, "41 Shots 10 Cents," *The New Yorker* (1999)

Honoré Daumier

In 1832, two years after King Louis Philippe famously abolished censorship of the press in France, Honoré Daumier (1808–1879) produced his famous caricature of Louis Philippe called "Gargantua." The pear-shaped king sits in front of the National Assembly on a large commode. The poor deliver food and tribute, while he excretes boodle to aristocrats below. Daumier, his publisher, Philipon, and his printer were all indicted for "arousing hatred and contempt of the king's government, and for offending the king's person." Only Daumier went to prison. In 1835, significantly, when the king re-established censorship, it was not for print, but rather for caricature, on the ground that "whereas a pamphlet is no more than a violation of opinion, a caricature amounts to an act of violence." That raises the question of what was/is the scientific evidence for this proposition.

As Robert Justin Goldstein reports in *Censorship of Political Caricature in Nineteenth-Century France,* Philipon sarcastically denied that Daumier had portrayed the king in his drawing, since "far from presenting the air of frankness, liberality and nobility which so eminently distinguishes Louis-Philippe from all other living kings . . . Mr. Gargantua has a repulsive face and an air of voracity that makes the coins shiver in his pocket."

The historian Howard Vincent described Philipon's entourage of caricaturists as "having knives in their brains," and with journals like *La Caricature* (1830–1835) and *Le Charivari* (1832–1906) one understands that this was a period when caricature flourished, which perhaps explains why the regime so feared the power of the crayon. (Over 350 caricature journals were established in France between 1830 and 1920.) Political cartooning had become, in the phrase of Champfleury, art critic and chronicler of caricature, *"le cri des citoyens."*

Philipon and his caricaturists ultimately incurred the hatred of the regime, with Daumier inspiring his fellow caricaturists. Daumier's publisher wrote that he "could no longer count the seizures, the arrest

**Honoré Daumier,
"Gargantua" (1830)**

warrants, the trials, the struggles, the wounds, the attacks, the harassment of all types, any more than could a carriage voyager count the jolts of his trip." But Goldstein, who has carefully researched these matters, could. He reports that the regime indiscriminately seized journals and caricatures, "leading to at least fifteen prosecutions, over a half-dozen convictions, more than two years in jail terms, and fines totaling over 20,000 francs." (On June 15, 1880, the following appeared in the journal of caricature *Le Grelot:* "When future generations learn that the preliminary censorship, abolished for the printed word in 1830, still existed for drawings in 1880 . . . they will not fail to consider us a remarkable race of hydrocephalics.")

Daumier was twenty-two when he began to draw for Philipon's *Caricature,* and in forty years he would produce four thousand lithographs—an average of two a week!—most of them clutter-free and all the more forceful for that, as he used a free-flowing grease pen. He built his monument to the spirit of democracy, it has been said, lithographic stone by lithographic stone.

Daumier did not live to see the fulfillment of the French Revolution's, and his own, ideals of "liberté, egalité, fraternité." However, the astounding counterfactual claim that social critic Ralph Shikes makes on Daumier's behalf sounds awfully plausible: "By suppressing healthy criticism, by creating an atmosphere in which artists had to conform to exist, by failing to grapple with the conditions crying for redress, the rulers of many of Europe's countries made violent upheavals inevitable. If a Daumier had been allowed to exist in the late seventeenth or early eighteenth century, perhaps there might not have been a French revolution."

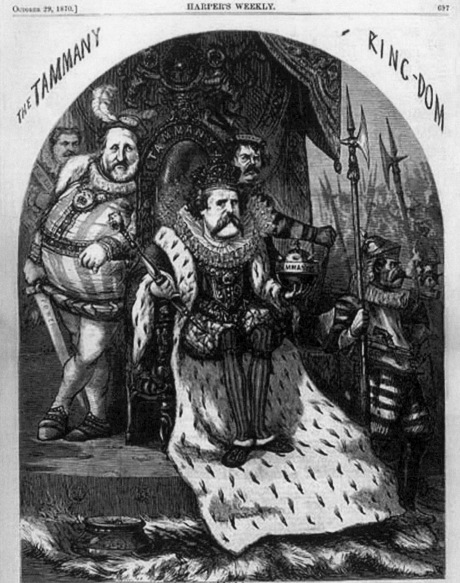

THE TAMMANY RING-DOM

THE POWER BEHIND THE THRONE.

HE CANNOT CALL HIS SOUL HIS OWN.

Thomas Nast

Although most Americans don't know it, they are regularly exposed to Thomas Nast's legacy. It was/is Nast (1840–1902), generally considered the father of American political cartooning, who gave the Democrats their donkey and the Republicans their elephant, not to mention Tammany Hall its tiger.*

On the eve of the municipal elections in New York City in November 1871, *Harper's Weekly* featured a double-page Nast cartoon entitled "The Tammany Tiger Loose—What are you going to do about it?" The cartoon, spread across two pages, shows Boss Tweed and his gang sitting in the Roman Colosseum as the vicious Tammany tiger, fangs bared, is poised to strike the final fatal blow against Justice, her scales

* According to his biographer, Fiona Deans Halloran, Nast only popularized, not invented, the use of the donkey to represent the Democrats; it "was widely used before the Civil War, sometimes in explicit references to Democrats as jackasses, sometimes to connote thickheaded obstinacy."

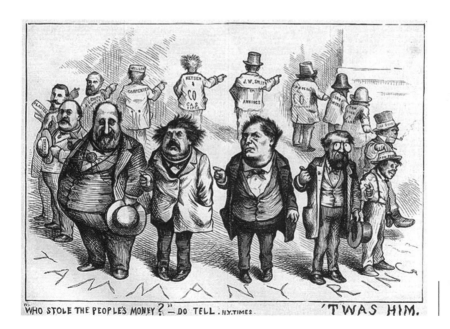

"WHO STOLE THE PEOPLE'S MONEY?"—DO TELL. N.Y.TIMES. 'TWAS HIM.

Thomas Nast, "Who Stole the People's Money?" (1871)

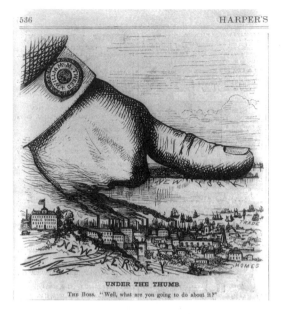

UNDER THE THUMB.

THE BOSS. "Well, what are you going to do about it?"

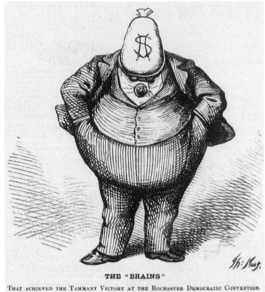

THE "BRAINS"

THAT ACHIEVED THE TAMMANY VICTORY AT THE ROCHESTER DEMOCRATIC CONVENTION.

Left:
Thomas Nast, "Under the Thumb" (1871)

Right:
Thomas Nast, "The 'Brains' " (1871)

already in the dust, her sword broken. Two days later the electorate gave its answer. The Tweed Ring, which the writer J. Chal Vinson, writing in 1967, said had been responsible for what has been called "the most avaricious raid on the public treasury in the history of a city not unfamiliar with graft," was thrown out of office.

As many have observed, Nast had an infallible ability to get swiftly to the heart of an issue. Examples abound:

- "The Tammany Ring-dom," depicting the mayor on the throne with Tweed and his henchmen as the powers behind it.
- "Under the Thumb," a huge thumb pressing down on the city. "Well, what are you going to do about it?" was Tweed's reply (an actual quote) to a mass meeting that had denounced him.
- "The 'Brains,' " a portrait of Tammany with the body of Tweed and the head of a money bag.
- "Who Stole the People's Money?—Do Tell—'Twas Him," showing Tweed and his henchmen standing in a ring, each pointing his finger at his neighbor.
- And when the mayor remarked that "The scandal will soon blow over," Nast did his "A Group of Vultures Waiting for the

Storm to 'Blow Over'—'Let Us *Prey.*' " Tweed and his gang are pictured as vultures, huddled together, and at their feet are their victims—"justice," "law," "the treasury"—as they wait for the storm to pass, while lightning strikes a boulder which is about to crush them.

Boss Tweed himself, who along with his ring, was sentenced to prison in connection with the $200-million fraud they had perpetrated on the citizens of New York, instinctively understood the power of Nast's pen. "Stop them damn pictures," the infamous Tammany chief famously said, in anguish over the unrelenting parade of Nast's savage depictions. "I don't care a straw for your newspaper articles. My constituents can't read. But they can't help seeing them damn pictures!"

It was fitting and proper that

A GROUP OF VULTURES WAITING FOR THE STORM TO "BLOW OVER."—"LET US PREY."

Thomas Nast, "A Group of Vultures Waiting for the Storm to 'Blow Over'—'Let Us *Prey*' " (1871)

Tweed, as I mentioned earlier, was caught and brought to justice by a Spanish customs official who recognized him from Nast's depictions. So, irony of ironies, where cartoonists in other cultures were imprisoned or worse for their artistic assaults on the powerful and corrupt, in Nast's case it was his targets who went to prison; but before they did, they tried to buy him off with an "art scholarship."

As the emissary put it to Nast, who had been forced to drop out of art school at age fifteen to support his family, a group of wealthy benefactors, impressed with Nast's natural talents, wished to put up $100,000 to enable him to take time off from his cartoon labors and study art in Europe. After feigning interest in the proposal, Nast got

Opposite:
Thomas Nast, "Santa
Claus in Camp,"
Harper's Weekly
(1863)

them to raise the offer to $500,000 before telling them thanks, but no thanks.

So famous did Nast become for knocking off Boss Tweed that one of his other great legacies was and is often forgotten, although not by the late Norman Rockwell and the Coca-Cola Company. In 1886, *Harper's Magazine,* unable to keep Nast on retainer, suggested that he draw a book of his Christmas pictures of the previous fifty years, with some new additions. So in 1889 there appeared *Thomas Nast's Christmas Drawings for the Human Race,* which included the modern image of Santa Claus, now stamped on the American consciousness.

As Charles Press concluded in his book *The Political Cartoon,* "Nast was successful in projecting a lasting Santa Claus for the same reason that he was a masterful political artist: he gave imaginative presentation on a subject about which he had something to say. His Santa Claus personified all that one would wish were the official Clausian policy on Christmas joys, and with that policy Nast was in full agreement. He captured and put down on paper the pleasure of Christmas in a single figure."

HARPER'S WEEKLY.

A JOURNAL OF CIVILIZATION

VOL. VII.—No. 314.] NEW YORK, SATURDAY, JANUARY 3, 1863. [SINGLE COPIES SIX CENTS. $2 50 PER YEAR IN ADVANCE.

Entered according to Act of Congress, in the Year 1863, by Harper & Brothers, in the Clerk's Office of the District Court for the Southern District of New York.

SANTA CLAUS IN CAMP.—[SEE PAGE 6.]

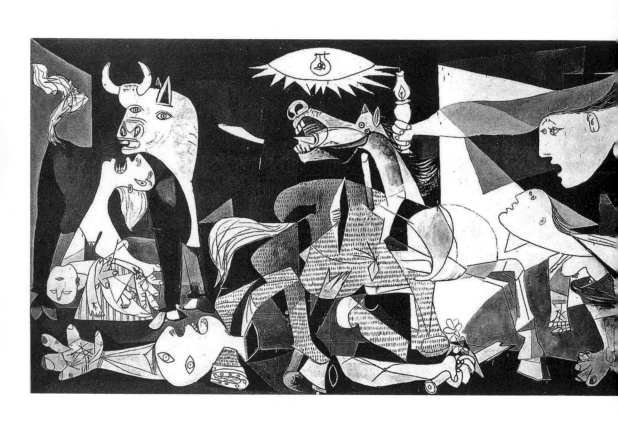

Pablo Picasso

Opposite:
Pablo Picasso,
Guernica (1907)

Was Pablo Picasso a caricaturist? Look at *Masters of Caricature: From Hogarth and Gillray to Scarfe and Levine* by William Feaver, and Picasso's name is nowhere to be found. But turn to page 121

of *The Art of Caricature* by Edward Lucie-Smith and learn that Picasso was a caricaturist of "great brilliance." Actually, he was and he wasn't. Or rather, he started out as one, and became something much more complicated.

"The early portraits . . . of Apollinaire are caricature in the fullest sense of the word. The series of drawings made for the magazine *Verve* in the fifties uses caricature conventions less for satiric than for poetic purposes," writes Lucie-Smith. And then there are the late "transpositions" of masterpieces by other men such as Velázquez and Delacroix, "where it is sometimes doubtful whether a tribute or a satire is intended."

But it is the complicated and complicating Picasso I am thinking about when I ask my question—the Picasso of squares and triangles and cubes, the Picasso of colossal distortions as in the most celebrated Picasso of all, *Guernica*.

I had been struck, moved, and perplexed by this Picasso painting as a young boy, when I used to see *Guernica* on the wall of the Museum of Modern Art every time my father took me to see one of those silent movies they showed on weekends. But it wasn't until the summer of 1951 that I first began to think about Picasso's visual language, as it were. I had just completed my first year in college and taken a job as a bellhop at a resort called Seven Keys on Loon Lake in the Adirondack Mountains of New York.

The owner, Sam Garlin, shared the left-wing politics of his brother

Sender, an editor at the Communist newspaper *Daily Worker*. Many of his guests were in show biz, and most of them were lefties. Sam had the eccentric practice of inviting talented or otherwise specially qualified guests to stay an extra week or two on the house in exchange for cultural or political presentations and performances. For me, the highlight was watching and hearing the slide-show lectures of one of those guests, A. L. (Abe) Chanin, whose subject was Picasso.

Chanin, a softspoken man whom the *Encyclopedia of Biography* would call after his death "perhaps the most influential arts-educator in American history," was on the staff of the Museum of Modern Art, and lectured and wrote widely. As the art critic for *The Daily Compass,* which was the successor to the legendary *PM*, the newspaper "against people who push other people around," as its subtitle put it, he, among other guests, had drawn the attention of anti-Communist witch hunters.

Given the FBI investigators who were buzzing around, Sam Garlin's affinity for political troublemakers, and the man from the allegedly fellow-traveling *Compass* at the lectern, I romantically thought of myself as sitting amidst a hotbed of subversion. Perhaps that's why what I mainly took from Chanin was that Picasso was the ultimate subversive, not because of his politics, but because he challenged so many of the artistic assumptions of the era, of Western visual thought and tradition. I thought, as the Marxists used to say, it is no accident that it was Picasso who said, "All good portraits are, in a way, caricatures" and "Art is a lie that reveals the truth."

Chanin talked, among other things, about Picasso's Blue Period, and how much his canvases from those years owed to Daumier. He also took us through the Rose Period and showed how cubism was a protest against the reigning conventions of what constituted beauty. And so to this day, when I read an essay like the French art historian Michel Melot's on how caricature became "in the eighteenth and nineteenth centuries a symbol of dissent from the established order conveyed through the distorted images created by its exponents," I think of Abe Chanin's Picasso.

And when I read the Austrian art historian Werner Hofmann's essay about how in Picasso's case "caricature was the first step . . . in a series . . . as a protest against art with a capital A," how in his early

drawings the caricatures are "an artist's caricatures" and, as such, they display "a rebelliousness of form," I think of Abe Chanin's Picasso. In Hofmann's telling, as in Chanin's, Picasso's early caricatures are "a protest against traditional norms."

Others with more expertise than I think Picasso's work in caricature, and his preoccupation with the grotesque, continued beyond his youthful efforts. Although I'm not sure I know what Adam Gopnik means when he writes that "as a result of the new language of Cubism, we saw the victory of the notebook over the easel," if he means that Picasso succeeded in making his notebook sketches come alive in his paintings in a way that did nothing less than challenge the old academic, classical conception of the ideal of beauty, I think of Chanin's Picasso.

Would it be too fanciful to suggest that the "lowly" status of caricature (much like our modern graffiti?) provided the creative space that freed Picasso to explore different pasts, and then to point the way forward toward greater abstraction in art? Why not? Max Raphael, the renowned art historian of early modernism, and a contemporary of Picasso, argued in his essay "Proudhon Marx Picasso" for a link between caricature and primitivism: "Without the introduction of caricature, which broke down the European tradition, Picasso would not have been able to approach African art."

The Heilbrun Foundation's Timeline of Art History (prepared for the Metropolitan Museum of Art) notes that Picasso's 1906 portrait of Gertrude Stein reduced her face to a "mask with heavy lidded eyes," and foreshadowed Picasso's "adoption of Cubism."

As I write this, A. L. Chanin, who was born in Lithuania in 1912, would have been one hundred, and for me Picasso will always be Abe Chanin's Picasso.

EDITOR CAPITALIST POLITICIAN MINISTER

The Masses

The Masses: Art Young and Robert Minor

Opposite:
Art Young, "Having
Their Fling" (1917)

My father, Macy Navasky, was a would-be writer who was never able to go to college, because before the U.S. government drafted him into the infantry in World War I, his father drafted him to go to work for Navasky & Sons (later the Sturdybuilt Company), which manufactured "students' and young men's clothing."

But he was an autodidact, a voracious reader of magazines, and a big fan of Art Young, the cartoonist whose work was published in *The Saturday Evening Post, Collier's,* and *Puck.* Then *Life,* when it was a humor magazine, signed him up to do a cartoon against immigration in 1902 and he vowed never again to do work he didn't believe in, and started working for *The Masses,* a leftwing journal.

Art Young, "Gee
Annie, look at
the stars, thick as
bedbugs!" *The Masses*
(1911)

Although *The Masses,* Young's most congenial outlet, ceased publication in 1917, his cartoons survive in anthologies. I still remember two that my father shared with me in my early teens. Neither had to do with his famously revolutionary politics, but both reflected his exquisite sense of irony. One showed a boy and girl of the slums, staring at the heavens. The caption: "Gee, Annie, look at the stars, thick as bedbugs!" The other was a Wanted poster headlined "Reward," with a picture of Jesus Christ, under which it said, "Wanted—for sedition, criminal anarchy—vagrancy . . ." and went on from there.

Over the years I had bought and seen anthologies of Young's work, as well as that of other *Masses* artists and anthologies of *The Masses* itself, most recently, *Echoes of Revolt: The Masses, 1911–1917,* edited by William O'Neil

REWARD

For Information Leading to the Apprehension of —

JESUS CHRIST

Wanted — for Sedition, Criminal Anarchy - Vagrancy, and Conspiring to Overthrow the Established Government

Dresses Poorly. Said to be a Carpenter by Trade, Ill— Nourished, Has Visionary Ideas, Associates with Common Working People the Unemployed and Bums. Alien — Beleived to be a Jew Alias : 'Prince of Peace, Son of Man'-'Light of the World' &c &c Professional Agitator Red Beard, Marks on Hands and Feet The Result of Injuries Inflicted by an Angry Mob Led by Respectable Citizens and Legal Authorities .

Art Young, "Jesus Christ Wanted." *The Masses* (1917)

(1966), with an introduction by Irving Howe, who wrote of the *Masses* staff that "they regarded themselves as soldiers in an irregular army which would triumph through the power of truth, the power of beauty, the power of laughter."

I loved its manifesto: "a revolutionary and not a reform magazine, a magazine with a sense of humor and no respect for the respectable; frank, arrogant, impertinent, searching for true causes; a magazine directed against rigidity and dogma wherever it is found; printing what is too naked for the money-making press; a magazine whose final policy is to do as it pleases and conciliate nobody."

I knew that its contributors included, in addition to Art Young, Carl Sandburg, Amy Lowell, John Reed, and Dorothy Day. I liked that Arturo Giovannitti, the Italian-American union leader, had called it "the recording secretary of Revolution in the making." And I loved that in the words of editor Max Eastman, the magazine was "kicked off the subway stands in New York, suppressed by the Magazine Distribution Committee in Boston, ejected by the United News company of Philadelphia, expelled from the Columbia University library and bookstore, stopped at the borders by Canada, and swept out of college reading rooms from Harvard to San Diego."

I learned that in 1913 Art Young, Max Eastman, and *The Masses* had been sued for criminal libel by the Associated Press after the publication of a cartoon, "Poisoned at the Source," accompanied by a paragraph stating that the Associated Press had suppressed news of a strike in West Virginia, and colored what little reporting it had done in favor

of the employers. The case was dismissed by the municipal court in
New York City.

Then, after the U.S. declared war on the Central Powers in 1917, the
authorities claimed that cartoons by Art Young, Boardman Robinson,
and H. J. Glintenkamp and articles by Eastman and associate editor
Floyd Dell violated the Espionage Act, under which it was an offense to
undermine the war effort. In August 1917 the U.S. Post Office revoked
the magazine's mailing privileges. At trial, the government devoted
more than equal time to the cartoonists. By now I've made clear what
I believe about prosecuting citizens for the exercise of their right to
free expression. But I also believe that once having decided to bring
its case, the government chose the right target in focusing on the art
and artists. The medium, in this case consisting largely of visual lan-
guage, was indeed the message. In Eastman's view (and mine, too), Art
Young, then fifty-two, was the hero of the trial. A typical exchange (as
the prosecutor questioned Young about his cartoon captioned "Having
Their Fling," showing a capitalist, an editor, a politician, and a minis-
ter dancing to the drums of war while the devil directs):

The prosecutor asked him what he meant by the picture.

"Meant? What do you mean by 'meant'? You have the picture in
front of you."

"What did you intend to do when you drew this picture, Mr.
Young?"

"Intend to do? I intended to draw a picture."

"For what purpose?"

Art Young, "Poisoned
at the Source" (1913)

"Why, to make people think—to make them laugh—to express my feelings. It isn't fair to ask an artist to go into the metaphysics of his art."

"Had you intended to obstruct recruiting and enlistment by such pictures?"

"There isn't anything in there about recruiting and enlistment, is there? I don't believe in war, that's all, and I said so."

After three days of deliberation the jury failed to agree on the guilt of the defendants. A second trial, too, resulted in a hung jury. But the legal action forced the magazine to cease publication at the end of 1917. (It was later revived as *The New Masses*, but was never again the same.)

In his preface to his anthology, William O'Neil, who talks about the tension between the artist-employees (unpaid) and the writers (paid, but envious of the artists, who received more public attention), writes that "no one can fully appreciate the visual impact of *The Masses* who has not actually seen a copy. For the total effect produced by its size, quality and composition was far greater than the sum of its parts."

I had no idea of what he was talking about until the spring of 2011, when I visited the Billy Ireland Cartoon Library & Museum at Ohio State University, where I went through the entire file of back issues. Although individual copies were crumbling and falling apart, I realized I had never seen anything quite like it. Here was a magazine where instead of the art "illustrating" the words, it seemed, if anything, to be the other way around. Like a hit musical where the words and music are inseparable, issue after issue made its amalgamated statement. The difference is that with a musical one leaves the theater humming. After reading (viewing) *The Masses* one leaves the library with images in one's head. In his looking-backwards afterword to the O'Neil anthology, Eastman explains how it happened:

> The magazine had one plainly evident superiority, a clean and clear make-up. My contempt for the crazy clutter of type and pictures that is considered popular by American magazine editors was enthusiastically shared by the magazine's artists. We all liked plenty of space. We wanted each object, whether art or literature, presented as a unit, in adequate isolation, unpecked by

editorial sales talk. We wanted the text to read consecutively as a work of art should, not be chopped up and not employed as a lure to jump the reader over to advertising pages in the back. The only clash between me and those artists, and that a brief one, concerned the importance of size in reproducing pictures. The generous dimensions of the drawings in *The Masses,* a notable innovation in American magazinedom, was due entirely to them. I merely yielded to their arguments—and raised the extra money required.

I have included "The Perfect Soldier" by Robert Minor (1884–1952), which appeared in *The Masses* in 1916, to show that Young was not alone. Minor, best

Army Medical Examiner: "At last a perfect soldier!"

Robert Minor, "The Perfect Soldier" (1916)

known for his use of crayon, as exemplified in his headless torso, also drew his war-is-good-for-bankers-and-business cartoons for the *New York Herald,* until the paper switched to support the war, and fired him. Minor, a lifelong Socialist, later joined the Communist Party and ended up as Washington correspondent for the *Daily Worker.*

The Masses was brought to trial twice and its editors were charged with conspiring to obstruct conscription. It is true that the magazine opposed the draft, but the real crime of *The Masses* was that its look, its graphics, and its talented artists made its message impossible to ignore.

DIE LEBENDEN DEM TOTEN . ERINNERUNG AN DEN 15.JANUAR 1919

Käthe Kollwitz

Opposite:
Käthe Kollwitz,
*Memorial to Karl
Liebknecht* (1926)

Although Charles Press in his analytic history of political cartoons from the time of Martin Luther to the present includes the work of Käthe Kollwitz (1867–1945), the German painter, printmaker, and sculptor, most people would not call her a cartoonist: first, because her searing social commentary on the human condition in the first half of the twentieth century so clearly embraced, rather than ridiculed, her subjects, the victims of poverty, hunger, and war; second, because most people don't think of women as cartoonists or caricaturists (indeed there aren't that many); and third, and most important, because her stark, black-and-white woodcuts seem to be so serious.

Like George Grosz, her contemporary, she came of age in Berlin just as Hitler was coming into his prime. Unlike Grosz, Kollwitz didn't leave for the U.S. when Hitler arrived. In fact she stayed and lost a grandson to World War II (fighting in the German army on the Russian front), even as she had lost her son in World War I.

I include her here because her antiwar posters and her prints influenced a long line of Socialist cartoonists like Art Young, and her use of linotype and woodcuts with her simple lines in stark black and white were more appropriate to her message than sensuous colors would have been. Indeed, her work was as acidic, biting, and cutting as any cartoon.

As Ralph Shikes has written, "It is no accident that social criticism has been expressed largely in prints and drawings. The print is the ideal medium for communicating messages to a comparatively wide audience, since multiple copies can reach comparatively wide audiences . . . the dark mass of woodblock accentuates the somberness of a mood, and increases the sting of the attack." He might have added that many cartoons and caricatures are black and white—all-or-nothing, oversimplified exaggerations, and illogical extremes that can take on a grotesque logic of their own.

Although known for her radical politics—she sympathized with

the Spartacus League, the Marxist revolutionary movement founded in Germany during World War I by Rosa Luxemburg and Karl Liebknecht, and belonged to the Berlin Secession, a dissident art collective—Kollwitz poured her real passion into creating antiwar posters for the Workers International Relief, whose members included Otto Dix and George Grosz. Kollwitz was an early contributor to the more liberal than radical *Simplicissimus,* that elegant journal of German political satire born around the turn of the century, whose editors saw that her cutting commentaries belonged in their irreverent magazine. By 1920 she had completed a powerful memorial to Liebknecht (featured here), and had made something like thirty woodcuts.

Kollwitz was the first woman inducted into the Prussian Academy of the Arts, in 1929, but she was kicked out in 1933 when her art along with that of scores of others was found to be "degenerate" because of her anti-Nazi statements (both visual and verbal). In 1936 Kollwitz was arrested by the Gestapo, which asked her to name the names of fellow artists who shared her anti-Nazi beliefs, which she bravely refused to do; she escaped imprisonment because of her age (but she was also extremely popular with the people, having had many streets and parks named after her).

And even as the work of George Grosz came to win the allegiance of and inspire a new generation of troublemakers like that Dadaist manqué Robert Cenedella, I think it is no coincidence that Kollwitz's woodcuts speak so directly to the American caricaturist and illustrator Frances Jetter, who first became aware of Kollwitz when she was all of ten years old; her cousin brought her an art book including the work of Kollwitz and Grosz and she was entranced.

For her, "pictures break language barriers." Ask her why cartoons sometimes have more power than words and she will tell you, "They are more immediate, more symbolic. Art is recognized quickly. I've always thought it registers differently on the brain."

Like Kollwitz, Jetter is a sculptor. She carves the image on the block in reverse, and then inks and prints it. She believes that the technical nature of etching a woodcut imposes a discipline that often adds to the strength of the work. As Ben Shahn once said of the print, "It is to art as the essay is to literature—compact, pointed, intense." Jetter remem-

Frances Jetter, "The Republican Platform Against Choice," *The Reagan/Bush Years* (1992)

bers being struck as a child by the starkness of the black-and-white pictures.

Like Kollwitz, Jetter identifies with the plight of women. For example, see her depiction of the division in the Republican Party over abortion. It was killed by the editors of the *Times* Op-Ed page ("They don't like anything sexual," said Jetter, who had a tamer piece waiting, in case the expected happened), so she used it as the cover for her upcoming book, *The Reagan/Bush Years*.

I asked Jetter why (the biting work of Sue Coe, Signe Wilkinson, Roz Chast, and others notwithstanding) she thinks there are so few women caricaturists. "It's a puzzle," she said. She thinks that part of the reason is "practical": "Women are bringing up the children." But part of it is that "women are supposed to be polite, and caricature is rude." And of course it went without saying that women occupy a lesser share of most hard-to-get jobs (editors, publishers, and journalists included, but also in most other industries). On the other hand, she

optimistically notes that there are plenty of women standup comics, so maybe things will change.

As for herself, besides Kollwitz and Grosz, whose politics appealed to her as well as their style, Jetter says that as far as doing caricatures is concerned, she was influenced by *Mad* magazine ("Who wasn't?"). She went to the Parsons School of Design and found that "I liked type, and got fed up with graphics." She liked the process of printmaking. And far from being polite, she liked the fact that she and her work "irked" people. "They thought that what I did was ugly."

Your subjects or your style? I asked.

"Both."

She doesn't take the turndown of her work personally because she has worked out a pragmatic system. "I always try to make it as strong as possible, and when they don't use it, they take the tamer substitute."

She used to think those turndowns were a form of censorship. Now she says, "I'm not sure 'censored' is the right word. If they pay for it, they own it, right? And it's theirs to do with what they will."

Is this pragmatism, cynicism, or realism? Frances Jetter isn't sure, but looking at Käthe Kollwitz's life and work is still her inspiration. "Her grace and the sense of feeling you get when you see her work—it's beautiful. A lot of her images now seem sentimental. But their quality is always powerful."

George Grosz

I first learned about George Grosz (1893–1959) from my friend the artist Robert Cenedella, who studied under, and revered, Grosz, and later came to occupy the George Grosz Chair at the Art Students League in New York City. We were, if truth be known, co-venturers. *Monocle* agreed to underwrite one of Cenedella's cockamamie business ideas. Little did I know at the time that it was a direct descendant of the spirit of Dada, the precursor to the surrealist movement Grosz had come to embrace and help lead. Cenedella had already established himself as an entrepreneur with his custom-made "Hostility Dart Boards," which consisted of photos of his favorite enemies (J. Edgar Hoover, Nixon, et al.) at the center of a clearly demarcated target. Eventually we commissioned Cenedella to illustrate *The Illustrated Gift Edition of the Communist Manifesto* by Karl Marx. On the back was a one-word blurb—"Revolutionary!"—signed by V. I. Lenin. Now he had a better idea, an Out of Order sticker to be pasted on public telephones. If I remember correctly, *Monocle* agreed to underwrite $250 worth of Cenedella-designed Out of Order stickers, to be pasted on public telephones and other modern inconveniences throughout New York City.*

Although the Nazis denounced Grosz as Germany's "number-one cultural Bolshevist"; although he was charged with obscenity and blasphemy as his drawings depicted prostitution, bloated capitalists, sadistic militarists, and pompous government and church officials; although he and his fellow caricaturist John Heartfield were charged

* I'll never forget the day the long arm of the law in the form of a local policeman tapped Cenedella on the shoulder as he pasted his Out of Order stickers on a series of pay phones on West Fourteenth Street and Sixth Avenue in New York City. "What the fuck do you think you're doing?" asked the cop. "Putting 'Out of Order' stickers on the pay phones so that innocent callers won't lose their money," said Cenedella. "We can't have just anyone who comes down the pike saying which phones are out of order," said the cop. "Why not?" asked Cenedella, volunteering that 75 percent of the pay phones were out of order. The journalist Murray Kempton later wrote a column about it and, if my memory is correct, reported that according to AT&T the figure was only 63 percent.

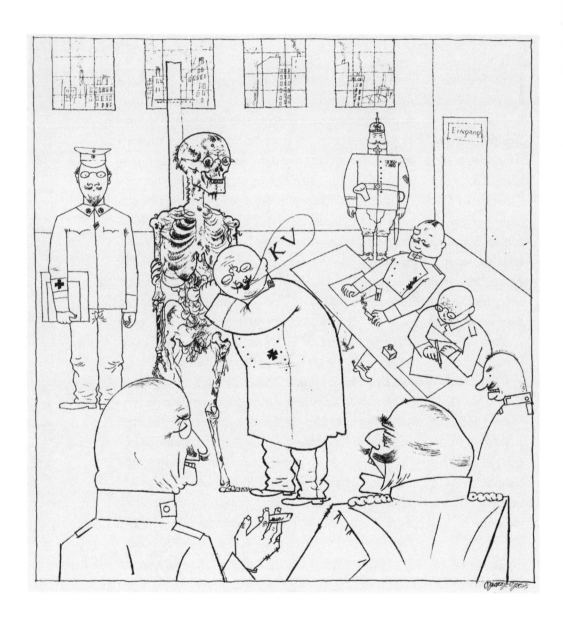

with defaming the military when they stuck a pig's head on top of a uniformed dummy, and were fined 300 marks; and although he landed in court on a number of occasions, when George Grosz left Germany in 1933 it was not because the government deported or banished him but, rather, because he presciently saw fascism coming and wanted none of it. Indeed in 1917 he had anglicized his name—Georg became George—in protest against German nationalism.

How does one measure the impact of a caricaturist? In part, by the yowl of his target subjects; in part, by his influence on contemporary and future artists. For example, Grosz made a great impression on Ralph Steadman, who was born in Britain in 1936, three years after Grosz had fled Germany. "During the last days of the Weimar Republic, when Hitler was rising faster than a bull in heat," observed Steadman, "Georg Grosz, the savage satirical painter, had used human shit as a violent method of coloring his drawings. It is a shade of brown like no other and its use makes an ultimate statement about the subject. Its organic nature lends a powerful presence to the image and no one misses the point."

But despite his strong political commitments, it would be a mistake to see Grosz's influence in political terms only. Yes, he was an anti-militarist, whose 1918 drawing "Fit for Active Service" shows a rotten, skeletal corpse being declared fit to fight on the front lines by a corpulent doctor. Grosz, by the way, had twice been called up, and twice been discharged for being unfit. On the second occasion, only the intervention of a wealthy patron saved him from a firing squad, after attempting desertion following a nervous breakdown.

He was a significant influence on his fellow artists, like Käthe Kollwitz. Grosz watchers still debate whether he lost his energy and gift when he immigrated to the U.S. And indeed he came to America in the aftermath of his disillusion with Russia. Later, Grosz reflected on his return from his trip to the Soviet Union in 1922.

My trip was not a success. The planned book did not materialize. I was not disappointed, but not exactly elated about what I had seen. The mote in my eye with which I saw western capitalist countries was still there, and Russia did not remove it. It was no

Opposite:
George Grosz, "Fit for Active Service" (1918)

Opposite:
George Grosz, "The
Guilty One Remains
Unknown" (1919)

place for me, I felt that clearly. And as I was not a proletariat, I could not be liberated. I can be suppressed, my work can be prohibited, I can be starved and physically punished, but my spirit cannot be suppressed. My ideas cannot be sent to a concentration camp, nor can the pictures in my head, and that eliminates me as a follower of any liberator of the masses. I have a deep suspicion and no love at all for the politics of supermen.

Perhaps Grosz's most significant influence was as a leading exponent of what came to be called the Dada movement. Founded in Zurich in 1915, Dada, which celebrated the absurd, emerged out of the despair felt by many at the pointless destruction of World War I.

So it is appropriate that during pop art's heyday, when the art world was celebrating Andy Warhol's rendering of the Campbell's Soup can, Cenedella, who by now was Grosz's protégé in the best Dada tradition, mounted a show called Yes Art! Everything about Yes Art! was upbeat, including the S & H Green Stamps—a supermarket promotion—which were given away with the paintings. Whereas Warhol had offered his renditions of Brillo boxes, Cenedella offered the Brillo boxes themselves. (Why get an expensive imitation when you can get the real thing?) Cenedella explained, "If a Yes artist folds your Brillo box it will cost $6.75. If you fold it yourself it costs $5.75." The Yes Art! show, held at a chichi Upper East Side gallery, also featured a live statue named Sophia Blickman.

Most recently Cenedella, who has exhibited around the world, had his attorney send a registered letter to leading establishment museums demanding that they set forth the aesthetic criteria based upon which they made their acquisitions so that he could paint to their specifications.*

George Grosz is long gone, but his spirit lives on.

* When last heard from, Cenedella was arranging to reprint his illustrated gift edition of *The Communist Manifesto*, accompanied by a personal affidavit asserting that he is not now and never has been a member of the Communist Party.

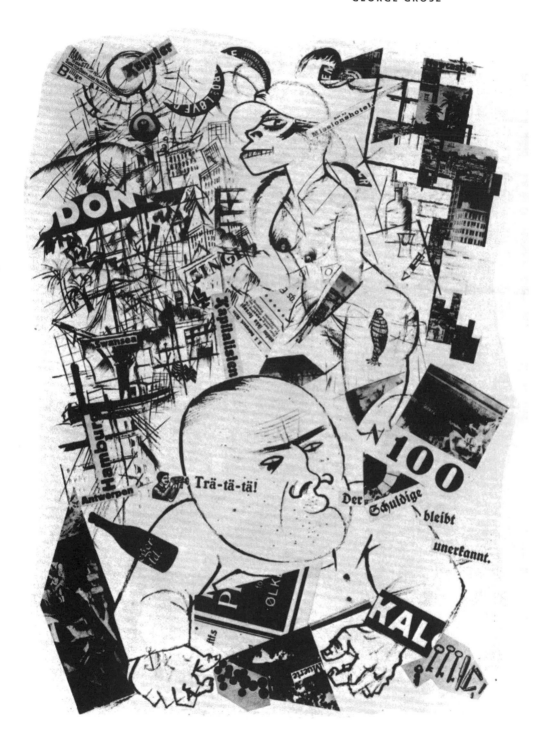

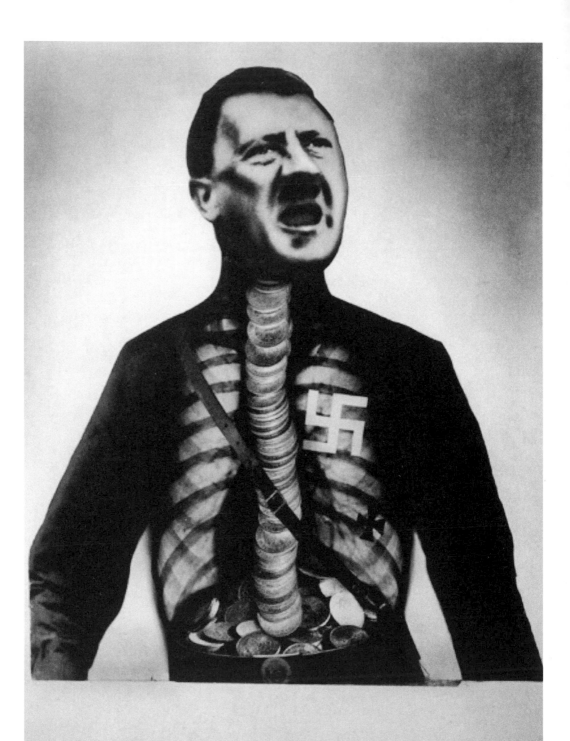

John Heartfield

Opposite:
John Heartfield,
"Adolf the Superman:
Swallows Gold and
Spouts Junk" (1932)

In the 1960s, Richard C. Neuweiler, a refugee from Chicago's Second City comedy club, had a routine in which he would wax nostalgic about the good old days when satirists reigned supreme, in the Berlin cabarets of the 1920s "that prevented the rise of Hitler."

Of course the powerful montages of John Heartfield (1891–1968), along with the caricatures and cartoons of his German buddy and fellow Dadaist George Grosz, did not prevent Hitler and the National Socialists from coming to power. But that doesn't mean that they didn't count, nor that they failed to infuriate.

Satire has its own form of influence. In posters, newspapers, and magazines like *Simplicissimus,* Heartfield and his brother, Wieland Herzfelde, and Grosz, with whom he started the magazine *Die Pleite,* used their art along with other satirists of the day to expose Hitler and his goose-steppers for what they were.

"Although Heartfield was not a caricaturist in any conventional sense," wrote William Feaver, art historian and art critic for London's *Observer,* "he belongs firmly within the tradition of caricature." Like Daumier's "Gargantua," in which King Louis Philippe consumes tribute from the wealthy, Heartfield's "Adolf the Superman Swallows Gold and Spouts Junk" combines a photo of Hitler and an X ray that reveals a spine made of coins, a comment on the financial support the Nazi Party received from the German elite, while pretending to be a socialist, workers' party.

Remember that Heartfield and his colleagues helped pave the way for Walt Disney and his cartoon short *Donald Duck in Nutzi Land* (which included "Der Fuehrer's Face"), in which Donald Duck is forced through so many "Heil Hitler"'s that he eventually wakes up from his nightmare in the arms of the Statue of Liberty. The song became so popular that eventually they retitled the movie and named it after the song. Which calls to mind the question of primacy in different art forms. If a picture is worth ten thousand words, is a song worth ten

thousand pictures? Cartoonists didn't prevent Hitler from coming to power, but they contributed to his undoing.

Heartfield's apartment was sacked, his art looted and destroyed, and eventually, like Grosz, he was forced to go into exile, in his case to Prague (and later to England), one step ahead of the police. In the 1930s, when Prague housed an exhibit of anti-Nazi drawings, Czechoslovakia refused to extradite Heartfield, who had begun doing photomontages for the Communist Party paper, *AIZ*. (He later joined the party.)

Heartfield, who changed his name from Helmut Herzfelde in protest against German anglophobia, invented the technique of the photomontage, "which is one of the most important innovations in the history of caricature," writes Edward Lucie-Smith. He used his terrifying photomontages to attack National Socialism, German militarism, and, of course, Adolf Hitler himself. But in this case the outer face that reveals the inner soul is not a photo but a photomontage.

Although the science of physiognomy has long been widely discredited, perhaps the famous Heartfield photomontage for the cover of journalist Kurt Tucholsky's book *Deutschland, Deutschland Über Alles (Germany, Germany Over All)* gave physiognomy a new meaning.

Tucholsky, editor of the weekly *Die Weltbühne*, a satirist, social critic, and songwriter, rejected especially the idea that faces (or photographs of them) were a way of reading the inner lives of whole races, as the Nazis came to do. But photomontage was something else again. Against a red and gold backdrop (Germany's colors), the montage combined, as Andrea Jeannette Nelson noted:

> a Prussian general's uniform and helmet and a bourgeois businessman's suit and top hat. The soldier/businessman is a visualization of the partnership between German capitalists and the military. The figure's eyes (a German flag and an empty circle) are partially covered by the helmet, but his mouth (a gaping black hole) is wide open as he whole-heartedly, but blindly, sings the national anthem. The book's title, a phrase from the anthem, is written in a traditional German Gothic typeface and comes spilling forth from his mouth.

As Claudia Schmölders, the author of *Hitler's Face: The Biography of an Image*, reports, although the montage was meant to cut through and belie what she calls "the saccharine discourse on the human face," nonetheless the authors took recourse in the physiognomic article of faith, "that the outer says everything there is to say about the inner."

With the invention of Photoshop and other multimedia technologies, the photomontage techniques pioneered by Heartfield, who later became active in the Dada movement, would seem to anticipate the limitless technological potential for caricature in this age of digital apps.

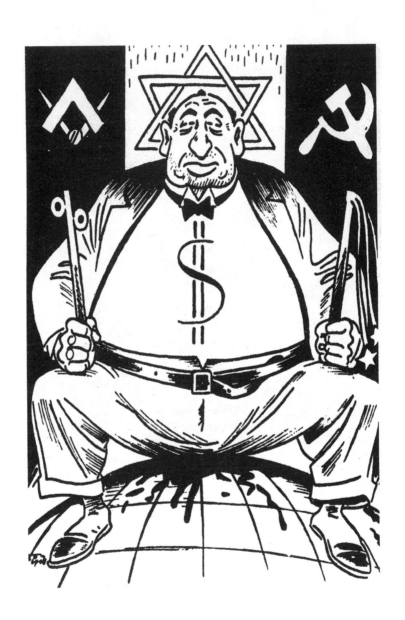

Der Stürmer

Every issue of *Der Stürmer*, the notorious Nazi weekly newspaper published from 1923 to 1945, carried the same slogan on its masthead: "The Jews are our misfortune."

Opposite:
Fips, untitled, *Der Stürmer* (1933)

After the war, the Nuremberg Tribunal indicted twenty-four defendants who represented a cross-section of Nazi leadership—diplomatic, economic, political, and military—on charges of crimes against peace, war crimes, and crimes against humanity (plus an overarching conspiracy count). Julius Streicher, the founder and editor of *Der Stürmer*, was the only editor among them.

Streicher was found guilty, hanged, cremated in Dachau, and his ashes dropped in the Isar River. Although I'm not a believer in capital punishment, it seemed to me that as long as the law was on the books, Streicher, who had become known as "Nazis' number-one Jew-baiter," deserved what he got. And if justice at Nuremberg were truly just, one wonders whether one Philipp Rupprecht, who, starting in 1925 under the pen name Fips, served as *Der Stürmer*'s weekly cover cartoonist and was himself sentenced to only six years, should have been cremated with him.

A reading of the transcript shows that the prosecutor at Streicher's trial asked not one question about *Der Stürmer*'s cartoons, its most famous feature, presumably taking them for granted and sharing the general assumption that hateful words counted more than the pictures that illustrated them. But Randall Bytwerk, a Streicher biographer, observed that Fips, whom he described as "a cartoonist of outstanding crudity . . . became identified with the *Stürmer* almost as closely as Streicher." While his style changed over time the essential characteristics of a Fips Jew were easily recognizable: ugly, unshaven, short, fat, drooling, and hook-nosed. In other words, "a visual embodiment of *Der Stürmer*'s articles," only, I would note, perhaps more insidious, since even the illiterate could see, understand, and be moved by them.

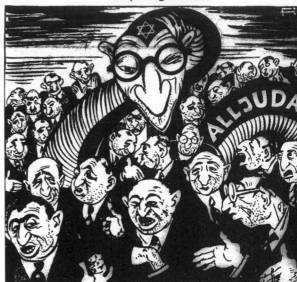

Schlangenbrut

Der Jud führet nicht umsonst den Wurm als Zeichen
Was er erreichen will, das sucht er zu erschleichen

Left:
Fips, "The Bloodbath,"
Der Stürmer (1934)

Right:
Fips, "The Satanic
Serpent Judah," *Der*
Stürmer (1934)

The collective message of the thousands of Fips cartoons that Streicher published, almost all on the front page, was that the Jews were responsible for all of Germany's ills. Typical among them: "The Bloodbath," showing the supposed ritual bloodletting of Christian children, and "The Satanic Serpent Judah," whose title and image speak for themselves.

Over the years, Fips depicted Jews as toads, vampires, vultures, horned monsters, insects, spiders, bacteria, and toadstools. Fips and *Der Stürmer*, of course, did not invent the familiar caricature of the Jew, but they certainly gave it wider circulation.

There were letters from readers who claimed to have seen Jews just like the ones Fips drew—letters that testified, according to Bytwerk, "that the caricatures were not imaginary creatures but unvarnished truth. One soldier wrote that he had been amused by what he thought was the exaggeration in Fips's cartoons, but having seen thousands of such Jews in the flesh, in Poland, he was now a convert."

Der Stürmer, whose circulation went from a few thousand to special

issues with print orders of two million, is a good example not only of the power of the caricature but of the fact that the spurious pseudo-science of physiognomy lives on in people's minds. As Julia Schwarz, who wrote her master's dissertation at the University of Westphalia on *Der Stürmer*'s cartoons, documented, the magazine's covers from 1933 through 1939 featured all of the classic themes of anti-Semitism: ritual murder, Jewish criminality, a Jewish religion that would destroy Christians and Christianity, Jews related to the devil and demons, Jews bent on world conquest as part of a worldwide Jewish conspiracy, the Jew as communist, the Jew as rapist and seducer of Aryan women, the Jew as avaricious capitalist, the Jewish intellectual (abnormal, dishonest, untrustworthy, secretive). And all of the front-page cartoons were on display in specially designed booths in town squares throughout Germany.

Circulation went down only as the war wore on and Jews themselves were no longer visible in their earlier numbers. At this point *Der Stürmer*'s influence in Germany began to wane. But its influence in the world lives on. (The issue is a complicated one because, in the hands of a subtle artist like David Brown, the caricature is not anti-Semitic,

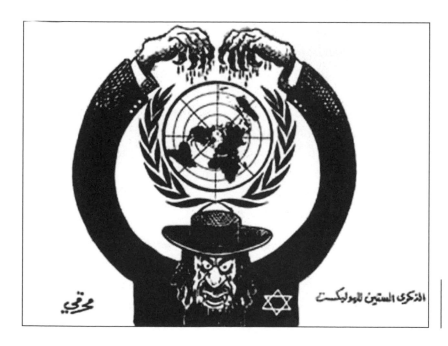

"The Sixtieth Anniversary of the Holocaust," *Akhbar Al Khaleej* (2005)

Dave Brown, "After
Goya" (2003)

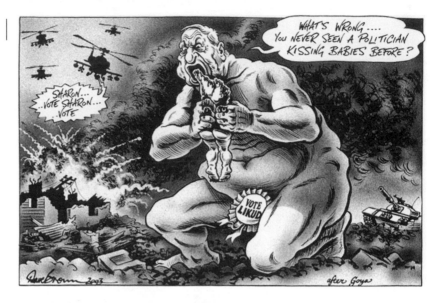

although it gains its emotional resonance at least partly from the history of anti-Semitic caricature.) Consider, for example, Arab cartoonists' depictions of Israeli Jews as conspiratorial demons, drinkers of blood—all with exaggerated "Jewish" characteristics: vide Bahrain's *Akhbar Al Khaleej* cartoon showing a Jew controlling the UN, and Qatar's *Al-Watan* caricature of Ariel Sharon drinking from a cup of Palestinian children's blood.

Its influence can be found in the West too; in 2003, British caricaturist Dave Brown alluded to Goya's painting *Saturn Devouring One of His Children* in his depiction of Ariel Sharon eating a Palestinian child. *Der Stürmer* is dead, but its images and influence live on.

The indictment against Streicher concluded that although he had been "less directly involved in the commission of the crimes against some of the Jews than were his co-conspirators," his propaganda, as Bytwerk put it, "had prepared the way for genocide." As the International Commission at Nuremberg found:

> The crime of Streicher is that he made these crimes [the extermination and annihilation of millions of Jews] possible, which they never would have been had it not been for him and those like him. Without Streicher and his propaganda, the Kaltenbrunners, the Himmlers and General Stroops would have had nobody to carry

out their orders. In its extent Streicher's crime is probably greater and more far-reaching than that of any of the other defendants. The misery which they caused ceased with their capture. The effect of this man's crime, of the poison he poured into the minds of young boys and girls goes on, for he concentrated upon the youth and childhood of Germany. He leaves behind him a legacy of almost a whole people poisoned with hate, sadism and murder, and perverted by him. That people remain a problem, and perhaps a menace to the rest of civilization, for perhaps generations to come.

The thing to remember here is that although Nuremberg didn't focus on them, the cartoons were part of *Der Stürmer*'s woodwork. Mention *Der Stürmer* and the cartoons with their ugly stereotypes are what one remembers.

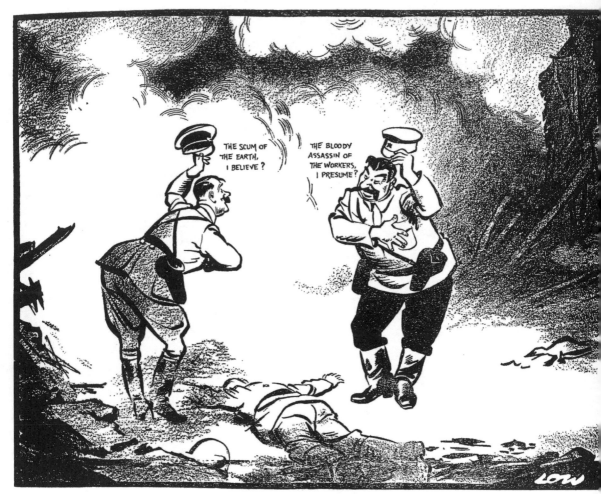

RENDEZVOUS

David Low

David Low (1891–1963), born in New Zealand but working in London from 1919, was generally acclaimed as "the twentieth century's greatest caricaturist." He had two specialties that stood out among his numerous graphic gifts: dictators and fools, which, when you think about it (at least as he thought about it), were actually one specialty, in the sense that in his view all dictators were fools.

Opposite:
David Low,
"Rendezvous" (1941)

Below:
David Low, from
"Low's Topical
Budget," *London
Evening Standard*
(1937)

Colonel Blimp, his best-known fool, is another story. He stood for everything Low despised—pomposity, isolationism, impatience with common people and their concerns, and insufficient enthusiasm for democracy.

Although Colonel Blimp appeared some three hundred times, he represented only 2½ percent of Low's total output. More typical were his cartoons and caricatures of dictators. See, for example, the cartoon that got his newspaper, the *London Evening Standard*, banned in Germany. When Germany withdrew from the League of Nations, Low drew a cartoon depicting Hitler standing near a bonfire outside its headquarters with the inscription: "It worked at the Reichstag—why not here?"*

Lord Beaverbrook, the owner of the *Standard,* especially made a trip to Germany to ask what he had to do to get the ban lifted. "Stop publishing Low," he was informed. The British foreign secretary told Low he was "a factor going against

BIG APPLE BY COL.BLIMP

Gad, sir, Garvin is right. There's only one way to stop these bullying aggressors—find out what they want us to do and then do it.

* It has always been assumed that the Nazis set fire to the Reichstag, Germany's Parliament building.

IT WORKED AT THE REICHSTAG — WHY NOT HERE?

peace" and asked him to modify his cartoons because they irritated the Nazi leaders personally. Low declined the honor, though, as we have seen, he withdrew his refusal later on. After the war, it turned out that Low's name, along with a number of other British cartoonists, had found its way high on Hitler's death list, the "Black Book." Although I believe that Michael Foot, acting editor of the *Standard*, was right when he observed in 1938 that "Low more than any other single figure changed the atmosphere in the way people saw Hitler," others differ.

Thus Timothy Benson, who earned his Ph.D. at the University of Kent and curated the first major show of Low's work, wrote: "By depicting Hitler and Mussolini as figures of fun, Low may have inadvertently, to Beaverbrook's possible relief, made them less threatening to those that saw them in his cartoons, compared to, say, other left-wing cartoonists." The scholar W. A. Coupe in his book *Observations on a Theory of Caricature* (1969) wrote that "by representing serious political problems in humorous allegorical guise," Low invited us "to laugh at our political predicaments, thereby in a way robbing them of their reality, or at least cocooning us from the horror in a web of gallows' humour."

That of course is not the way Hitler, Mussolini (who banned Low's paper from Italy), or Franco (whose emissaries petitioned the British government to use its influence to get Low to lay off) saw it. I prefer Sir David Low's own personal theory on why his cartoons were so effective in penetrating Hitler's skin: because he showed Hitler less as a monster than as an idiot.

SUEZCIDE ?

David Low,
"Suezcide?" (1935)

Interestingly, Timothy Benson believed that "if Low had the opportunity to choose a caricature of a Nazi leader, it would certainly not have been Hitler," who was clearly an inferior physical subject when compared with other leading Nazis such as Göring (known for his garish clothing) and Goebbels (with his double chin). According to Low himself, the problem was partly a technical one: "One of my difficulties about Hitler is that I have to use fine lines to draw his eye[s], and when I send cartoons by radiogram to foreign countries the transmission process cannot pick up all those lines and my Hitler arrives at the other end with the lines lost on the way. Goebbels, on the other hand, is good to draw—dark, sharp lines."

Of course Hitler was not the only dictator he mocked. He drew Mussolini as a Caesar wannabe. In "Suezcide?" he drew a granite-jawed Mussolini in Roman armor testing the temperature of the Suez Canal by dipping his big toe in the water. When the British foreign office put pressure on him to tone down his cartoon strip *Hit and Muzz* because his caricatures of Hitler and Mussolini were incurring the wrath of both of them, his solution was an aesthetic one. "I dropped Hitler and Mussolini," he said, "and to take their places created Muzzler, a composite character fusing well-known features of both dictators without being identifiable to either."

Low died in 1963. No wonder he inspired so many members of the next generation of cartoonists to take up their craft.

Philip Zec

Opposite:
Philip Zec, " 'The
price of petrol has
been increased by
one penny.' –Official"
(1942)

B y the time he died in 1983, Philip Zec (born 1909) was generally
acclaimed as Great Britain's most important cartoonist of World
War II. From 1939 to 1945 he provided 1,529 cartoons to London's
Daily Mirror, which in 1939 was selling 1.4 million copies a day (by
the late forties that was up to 5 million). During the war the paper
had abandoned its Conservative roots and had positioned itself as the
paper of the ordinary soldier and civilian.

In 2002, when BBC's *History Magazine* invited newspaper editors
and political figures to nominate their all-time favorite political car-
toons, both Lord Callaghan (prime minister, 1976–79) and Charles
Wilson, former editor of *The Times*, chose a Zec cartoon that had
appeared on January 8, 1942. It showed an exhausted, torpedoed Brit-
ish sailor adrift on a raft in the Atlantic. The caption: " 'The price of
petrol has been increased by one penny.'—Official." Wilson declared:
"In fifty years in Fleet Street I can recall no cartoon that had greater
impact. No wonder Churchill's War Cabinet went berserk."

The original caption for the cartoon had read "Petrol is dearer
now." But since the government had just increased the price of petrol,
a colleague persuaded Zec that the other caption would be stronger.
There quickly followed an intense and explosive hurricane of con-
troversy and government condemnation. The home secretary, Her-
bert Morrison, described the cartoon as worthy of "Goebbels at his
best . . . plainly meant to tell seamen not to go to war to put money in
the pockets of the petrol owners." The *Daily Mirror* was deluged with
requests for copies. Zec himself recalled: "I had hundreds and hun-
dreds of letters from readers who understood what I was saying. . . .
Many of them said that they were going to put their car away for the
duration."

Winston Churchill believed that the cartoon, which he interpreted
as saying that lives were being put at risk to increase the profits of
the oil barons, would undermine the morale of the merchant marine,

and ordered an investigation to discover who owned the *Daily Mirror*, looking for Nazi sympathizers on its board.

On March 18, 1942, the editor, Cecil Thomas, and the chairman, Guy Bartholomew, were summoned to the office of the home secretary, who produced a dossier of alleged transgressions from which he extracted the Zec cartoon, which, in addition to comparing it to Goebbels's propaganda, he described as "wicked." At the end of question time later that day in the House of Commons, in what Michael Foot would later describe as "one of the stormiest debates the wartime parliament had known," when a Conservative MP asked Morrison if he had seen the cartoon in question, he declared that it was "only one example, but a particularly evil example, of the policy and methods of a newspaper which, intent on exploiting an appetite for sensation and with a reckless indifference to the national interest and to the prejudicial effect on the war effort, had repeatedly published scurrilous misrepresentations and irresponsible generalizations." Morrison concluded by threatening to shut the paper down.

In the end, as Zec's brother Donald later wrote, "Churchill and Morrison went back to fighting the war. Philip Zec went back to [the] drawing board." Three years later there was an interesting postscript to the affair. The war was over, and Zec was asked to produce some posters for Labour's election campaign. The Labour leaders were eager to exploit the power and ingenuity he had brought to his cartoons. Zec produced about a half-dozen posters, all of which were instantly accepted, and Herbert Morrison showered him with the most extravagant praise. Zec commented wryly about that years later:

> Politicians have thick skins. Herbert Morrison used everything I submitted. Finally, when he said "thank you" I did say unto him: I think you've forgotten something. I am the chap you called a saboteur. You thought I was vaguely unpatriotic, and here I am advising you on how to become the Government of the country. Don't you think that's a bit odd? He just laughed and said "Oh, everybody makes mistakes." But I insisted. I really do think you should apologize to me. He said: "My dear fellow, of course I apologize."

Ironically, like other cartoons in these pages (especially Barry Blitt's Obama), the outrage over the cartoon was due at least in part to a mis-interpretation. In most cases when a cartoon is misunderstood, it's because the picture is misinterpreted. But in this case it's the changed words that caused the misinterpretation. Nevertheless it's important to remember that it was the powerful picture, in tandem with the words, that led to the furor; without the image, the probability is that nobody would have noticed.

Here was a case where the absence of words explaining the cartoon images simultaneously gave the cartoon its power but opened it to mul-tiple interpretations.

Victor Weisz (Vicky)

Opposite:
Vicky, "Introducing:
Supermac" (1958)

Victor Weisz (1913–1966), or Vicky, Berlin-born cartoonist for London's *Evening Standard*, "was the best-loved and most fiercely hated political cartoonist of his time," says the unsigned introduction to a book about him by Russell Davies and Liz Ottaway.

Vicky got his cartooning start as a teenager in Berlin. Forced by family tragedy to leave school, he secured a job as the most junior member of the graphics department of *12-Uhr Blatt*, described as "a mildly radical journal which for a time represented a haven for anti-Hitlerians." The only graphics advice he was given was "Big heads, little legs," but studying the cartoonists of *Simplicissimus* and the style of Käthe Kollwitz (a onetime contributor), he gradually began to develop a style of his own when, using his Hungarian passport to avoid disappearance into one of Hitler's concentration camps, he made his way to London.

Generally regarded in the UK as one of the finest political cartoonists of the century, he was a radical, a Socialist, and a passionate opponent of fascism, racism, and, toward the end of his life, nuclear weapons.

On November 6, 1958, he introduced a new character to his readers: Supermac, a takeoff on the Conservative prime minister, Harold Macmillan, dressed as Superman, cloak and all. His drawing was subtitled "How to Try to Continue to Be Top Without Actually Having Been There." "Mac's torso is of course padded," he confided to his readers. Though clearly intended as a mockery of the politician's intentions, Supermac somehow helped counter the image of the aging Edwardian prime minister.

As Michael Foot later wrote, in a small tribute to Vicky published by the Centre for the Study of Cartoons and Caricatures, University of Kent, "His Supermac was intended to reveal how, although he might appear so brilliant in escaping from an unconscionable political mess, Macmillan had been responsible for it in the first place, and how, as sure as anything could be sure in politics, he would land us all back in the

mess or worse in the end. His Supermac was the stunt merchant of all time who could fall flat on his face. What Vicky sought to expose was a note of falsity in that grandiloquence which was there from the start."

But Supermac had taken on a life of its own, and it was not until long after Vicky had died (he committed suicide in 1966, just as his father had years earlier) that a Macmillan biographer, Richard Lamb, in his 1995 book, *The Macmillan Years, 1957–1963,* revealed that Vicky had guessed right about Macmillan's role at Suez, not to mention the Profumo affair and attempted cover-up, which later helped drive him out of office. Foot again: "It was not a pretty spectacle. The unflappable Macmillan became hysterical. Supermac took a nosedive unknown in the history of aeronautics."

And yet, for all that, as it was said, Vicky's creation of Supermac "was an example of how a satirist can set his imprint on a whole epoch, how he can seem to compel the principal actors to conform to his tastes and insights."

Bill Mauldin

It has been said that only somebody who has served as a combat soldier in World War II can truly appreciate what the American Bill Mauldin (1921–2003) achieved in his famous *Up Front* Willie and Joe cartoons, with their flashing black brush lines and sardonic captions.

I disagree. I did not serve as a combat soldier in World War II, but I believe that one experience that my fellow draftees and I had during our first eight weeks of peacetime basic training at Camp Gordon, Georgia, qualifies me to understand how Mauldin, by looking at war through the skeptical and idiomatic humor of the troops themselves, was able to tell the truth not just about World War II but about war itself.

There's nothing like basic training to capture the existential absurdity and comic potential intrinsic in preparing otherwise peaceful young men to undertake the necessities of military brutality. The year was 1954. The subject was bayonet training. The drill sergeant explained how to affix the blade to the rifle, how to hold the rifle, how to slash and smash, how to deploy the rifle's butt to the enemy's groin. The exercise, as he described it, would require us, when he blew his whistle, to race however many yards toward the dummies with the targets painted on their bodies, our bayonets held high, our adrenaline pumping; then we were to repeatedly plunge the bayonet blade into the dummy's heart, yelling "Kill! Kill! Kill!"

The sergeant then paused, and put his hands on his hips and said, "Now I have a special message for you and it is from the base commander himself. So listen carefully:

"Some of your parents object to your being asked to yell 'Kill! Kill! Kill!' In fact some of them object so much that they have called members of Congress. And these members of Congress have called the base commander. And the base commander has called me. They think it's offensive. So we are no longer allowed to require you to yell 'Kill! Kill! Kill!' As a result, those of you whose mommies don't

"Joe, yestiddy ya saved my life an' I swore I'd pay ya back. Here's my last pair of dry socks."

want you to yell 'Kill! Kill! Kill!' are allowed to say—" here he paused, then smiled his smile as he drew out the first syllable and said, derisively—" 'Lollipop!' "

"Oh, yes. One more thing," he added. "We are no longer allowed to call you 'knuckleheads.' But you are knuckleheads and don't you ever forget it."

My fellow knucklehead and buddy Huey Thurschwell, who possessed a law degree from the University of Chicago, and I promptly proceeded to do exactly that. "Lollipop! Lollipop! Lollipop!" we yelled with a vengeance, as we raced down the field and slaughtered the dummies before us. Years later I read a *Christian Science Monitor* interview with one Richard C. Kohn, a University of North Carolina professor of military history, who explained that in Western society, "where we have such reverence for the individual, where we socialize people to believe in the rule of law and all that," bayonet training was used to undo socialization, "essentially to try to mitigate or eradicate the reluctance of human beings to kill each other."

Well, to me, *Up Front* was Bill Mauldin's way of resocializing, as it were, not just Willie and Joe, but all infantrymen and all of those who identified with the characters in the cartoons, so that they were individuals once again, soiled uniform or no uniform. David Levine said, "I think of Mauldin as one of the great antiwar artists, like Goya." Mauldin later came to espouse controversial and progressive politics, but his Willie and Joe cartoons, although they never expressed antifascist sentiments or talked loftily about democratic ideals, were of, by, and for Everyman.

So what you see is Willie offering his mud bath to Joe, who says, "No thanks, Willie. I'll go look for some mud wot ain't been used."

It could be either Joe or Willie saying to the medal dispenser (wearing a medic's cross), "Just gimme th' aspirin, I already got a Purple Heart."

Or Willie saying to Joe, "I'm beginnin' to feel like a fugitive from the law of averages."

Or the drawing featured here.

World War II was a censored war, and no one had seen soldiers quite like his. Mauldin concentrated exclusively on what he liked to

call "the benevolent and protective brotherhood of them what has been shot at." Todd DePastino, Mauldin's biographer, notes that in the "fugitive" cartoon that appeared November 2, 1944, Willie expresses a terrible realization that dawned on every combat soldier: "They were victims of forces they could neither control nor escape. At this time casualty rates in Europe had soared to a point where the army virtually ran out of trained replacements." Mauldin achieved his impact through repetition, making the most of the comics form.

After the war, Mauldin, whose politics, as I have already mentioned, had taken a turn toward the radical, said of Willie and Joe, "I should have killed them. The dogfaces they were based on were really dead anyway, why not kill them?" (Indeed, he had earlier told the head of his syndicate that he would draw a panel of a blasted foxhole with their gear scattered about. "Don't do it," said his syndicator. "We won't print it.")

It wasn't as if Mauldin was exposing the dirtiest underside of war: He never depicted Americans dying ignobly, committing war crimes, insulting their officers, forgetting their own names, smiling as they were carried from combat on a stretcher. He never depicted blood, body parts, or corpses. But he nevertheless managed to convey war's reality. For example, one cartoon showed an unbandaged Willie sitting in a hospital bed with a "thousand yard stare." The rest was left to the reader's imagination. He also found ways of obliquely commenting on American propaganda. American troops never "invaded" or "conquered," they "liberated." Ergo, Willie says to Joe, as they look at their next target, "Must be a tough objective. Th' old man says we're gonna have th' honor of liberatin' it."

And when, in 1944, Mauldin found himself at Supreme Allied Headquarters in France, he resisted suggestions that he clean up his characters, whose appearance, he was told, was affecting replacement troops. At a famous meeting with General George Patton, Patton objected to a cartoon that showed grubby enlisted men lined up outside the front door of a USO show, while well-groomed officers stood at the stage door waiting for the chorus girls to emerge.

Patton asked him where the caption was. Bill explained that it had no

caption. It meant what it showed, Bill said, that enlisted men can only look at the girls, but officers get to wine and dine them.

"Why did you draw this picture if it wasn't to create disrespect for officers?" asked Patton. Mauldin's response: "Soldiers who see a cartoon that expresses their gripes are less rather than more likely to cause problems in the ranks." (He was resorting to the "letting off steam" theory, which hardly did him credit, but helps explain the popularity of his work.)

Not that all readers accepted Willie and Joe the way Mauldin presented them. One reader complained to the cartoonist: "Our boys don't look like the way you draw them. They're not bearded and horrible looking. They're clean, fine Americans." Most readers, however, were probably like the man who told a reporter, "It took me some time and study to catch on to Bill's humor, but now I feel I know him and the men over there."

After the war, he went from top to bottom. He had published over six hundred cartoons against war. Out of 246 cartoons he submitted to his syndicate in 1946, more than forty were censored. The *New York World-Telegram,* the flagship of the Scripps-Howard chain, unceremoniously dumped "Willie and Joe." Publisher Roy Howard wrongly accused him of "following the Communist Party line" because of his attacks on red-baiting politicians. As Mauldin put it at the time, "I set two records in a very short period of time. I rolled up more papers than anybody had, and I think I lost more than anybody had."

His third feat was not a record, but is his most impressive: He had showed how the visual language of cartoons, with their singular capacity to combine and compress humor, commentary, and insight into a single image, could illuminate the contradictions, absurdities, and realities of one of mankind's most baffling institutions—war itself.

"Carry On, Lads"

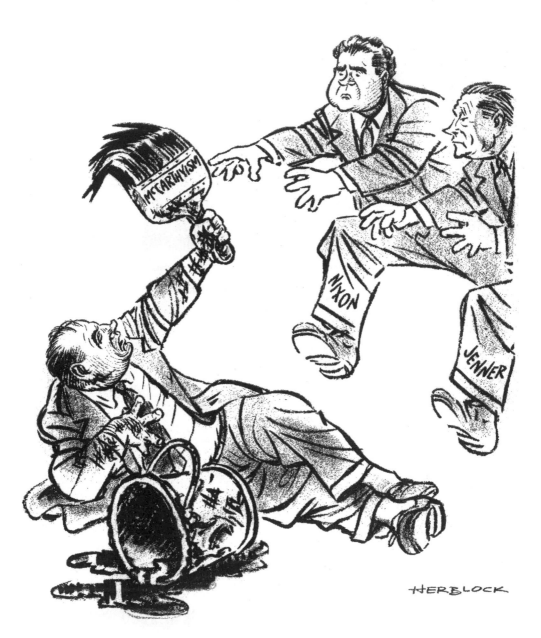

HERBLOCK

Herbert Block (Herblock)

In the fall of 1953, in my last year of college, I was privileged to be able to participate in a new experiment, the Washington Semester, under the aegis of American University. The idea was that a small group of students from around the country would take up residence in the nation's capital, where, to supplement their classroom studies, they would constitute a roving seminar, meeting with members of Congress, Supreme Court justices, the Librarian of Congress, and other members of the Washington establishment, to see how our government really worked.

Opposite: Herblock, "Carry On, Lads" (1954)

As a premature civil libertarian, I looked forward to a heady experience. The cold war was anything but cold. The Supreme Court was on the brink of declaring school segregation unconstitutional. And with Richard ("Tricky Dick") Nixon serving as Dwight D. Eisenhower's vice-president, "Tailgunner Joe" McCarthy riding high in the Senate in his hate-filled search for Communists and traitors under every mattress, and the House Committee on Un-American Activities moving from smear to smear, I expected to be in the red-hot center of American politics.

Our seminars were lively, but somehow it seemed what we were getting were live elaborations on textbook accounts of how the three branches "really worked," rather than a sense of the urgent issues dividing the country. Then, almost by accident, everything changed. One day a classified ad appeared in *The Washington Post* for a tour guide for the paper, and since I could use the extra money, I applied for and got the job.

Along with the other tour guides, I was given a script. The tour was supposed to start on the top floor and proceed downward, where floor-by-floor the guide would explain what went on. I thought I had a better idea and got permission to try it. I would start the tour out on the street where the story took place, then try to follow it from the rewrite man to the copy desk to the production department, ending

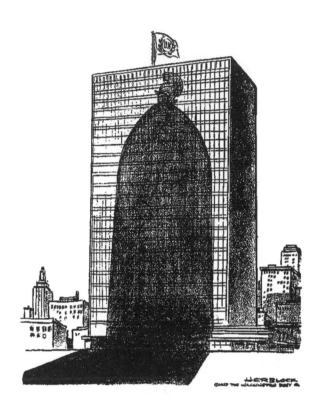

up in the basement where the presses rolled. Then I would take the bedraggled tourists back up to the editorial floor, where they could see the editors discussing or writing editorials commenting on the news, and then the pièce de résistance—Herblock, working on his next day's cartoon.

No matter the time of day, deadlines that he always somehow met be damned, he had time to come out of his glassed-in office and talk. Unlike some of the other artists whose work is depicted here, no single Herblock cartoon ignited a national or international explosion, yet I would argue that his influence—although there is no consensus on how to measure the impact of pictures (whether versus words or not)—was beyond incalculable. His images were indelible and are with us to this day.

Herblock, "Untitled, 12/8/1953"

The previous year, 1952, Herblock had incurred the wrath of Phil Graham, the *Post*'s publisher, who was supporting the Republican candidate for President, Dwight D. Eisenhower, against his Democratic opponent, Adlai E. Stevenson. In the final weeks of the campaign, Graham asked Herblock to stop submitting his anti-Ike cartoons. Herblock, who was nationally syndicated, agreed, but as a result, readers saw Herblock cartoons portraying Ike as insufficiently intolerant of McCarthy's and Nixon's red-baiting of Stevenson elsewhere, and angrily accused the *Post* of censoring their own cartoonist. Graham relented, and ever after, as Katharine Graham, who succeeded her husband as publisher, later recalled, Herblock "earned a unique position on the paper; one of complete independence of anybody and anything."

Thus was Herblock syndicated and vindicated—a unique position not only at the *Post* but in the country, since editorial cartoonists are

expected to follow the editorial line of the papers in which their work appears. Here, perhaps, we have implicit recognition of the fact that the impact of visual propositions is "different" from verbal ones.

Who will ever forget McCarthy with his tar brush, or "Here He Comes Now," as the crowd of Republicans awaiting his arrival see the five-o'clock-shadowed Nixon emerge from the sewers with his suitcase? As renowned journalist and author Haynes Johnson noted in *Herblock: The Life and Work of the Great Political Cartoonist* on the occasion of his centenary, that cartoon "would stick with Nixon throughout his career." Or think of Herblock's hysterical citizen, rushing up the ladder carrying a pail of water with which he seems intent on dousing the flame in the Statue of Liberty's torch at the height of the Red Scare.

It is fitting that Herblock, who invented the term "McCarthyism," showed McCarthy, at the end of his career, fallen in the gutter, under the caption "Carry On, Lads," as he passes on his McCarthyism tar brush to Nixon and fellow red hunter Senator William Jenner of Indiana.

On one of my last days at the *Post,* December 8, 1953, Dwight D. Eisenhower eloquently (according to all accounts) spoke before the United Nations General Assembly proposing "Atoms for Peace," whereby America would extend aid to countries using nuclear power for peaceful purposes. I can't remember a word he said, but Herblock's rendition of the bomb casting its shadow on the UN Building is still with us.

Al Hirschfeld

Like so many New Yorkers, I grew up counting the "Nina"s in Al Hirschfeld's theatrical caricatures in the Sunday *New York Times*. For those unfamiliar with Hirschfeld's work, he would camouflage his daughter Nina's name in his drawings, and print the number of "Nina"s after his signature, so you would know when your search was done.

In the 1920s, Hirschfeld lived on the Left Bank in Paris where he tried painting, sculpture, and printing. Early in life he had done drawings for *The New Masses*. His lines were unlike the bold protest brushstrokes of such *Masses* contributors as Robert Minor and other artists of the social-realist or "ashcan" school. He also co-edited with Alexander King the short-lived satiric magazine *Americana*, which gave employment to George Grosz and other dissident free spirits. Its editorial stance: "Many things are evil and all things are funny." Although a self-described antifascist, and passionate supporter of trade unions, Hirschfeld was not a member of any political party. Disillusionment with politics came when *The New Masses* censored one of his drawings, a caricature of Father Coughlin, the racist, anti-Semitic, fascist American nationalist. They, too, disapproved of Coughlin, but were courting Catholic trade union leaders and were fearful that Hirschfeld's caricature would alienate them.

For Hirschfeld the distinction between a cartoon and a caricature was profound. He once told Steve Heller that he never wanted to be a cartoonist. "A cartoon doesn't depend on the quality of the drawing so much as the idea. If it's a good idea anyone can do it. But a caricature has another quality. The word 'abstract,' I suppose, is the only one I can use. Are Picasso, Lautrec and Hokusai caricaturists, graphic artists or painters? They were all caricaturists in my view."

He credited a trip to Bali in 1931 as marking the beginning of his love affair with the lines which made his work so recognizable, given his uncanny talent for capturing what one critic called "the essential stage presence of his subject." But his style, as he explained, was defi-

Opposite:
Al Hirschfeld, "Famous Feuds: Strasberg vs. Kazan" (1963)

nitely a response to the constraints of the media. "I discovered that the safest way to reproduce on the toilet paper that newspapers are printed on, which they haven't improved since the process was invented, was to stick with pure line. I kept eliminating and eliminating and eliminating and getting down to bare essentials." He did that until the end, and as Heller explained, "in so doing, his caricatures became ever more distinctive, owing to the elegant complexity of his line." Over lunch, Heller told me, "You begged to be in an Al Hirschfeld caricature. It was enjoyable—an honor even."

His portrait here of Elia Kazan, the legendary director, and Lee Strasberg, the legendary acting teacher, which originally appeared in *Show* magazine's "Famous Feuds" series, is notable for its success in capturing not merely the characteristic expressions of the protagonists, but the psychodynamics of their relationship. Although it did not win a Pulitzer Prize (unlike other Hirschfeld caricatures), it speaks to me personally on a number of levels. When I set out to write what became the book *Naming Names,* I inherited the one-room sixth-floor office of a friend in Manhattan. By coincidence, on the second floor of the building were the offices of none other than Elia Kazan, the prominent director and a key and controversial figure in the blacklist story I hoped to tell.*

Kazan, who had directed Arthur Miller's prize-winning *Death of a Salesman* and Tennessee Williams's *A Streetcar Named Desire*, became a lightning rod for criticism, because he had not only named names in his testimony before the House of Representatives Committee on

* In fact, although the book I eventually wrote told the story of the blacklist with special attention to the role of the informer, originally I had thought I might be able to tell that story through the interrelated lives of Kazan, who had named names of people who had joined the Communist Party, and Arthur Miller, who had refused to do so, at risk of imprisonment. Kazan went on to direct the film *On the Waterfront*, in which the Marlon Brando character, Terry Malloy, realizes his obligation to fink on fellow waterfront hoodlums, whereas Miller wrote *The Crucible*, a condemnation of McCarthyite hysteria seen through the prism of the Salem witch trials, and *A View from the Bridge*, a one-act play depicting the devastation that informing can cause. Eventually Kazan and Miller got together again under the auspices of the new Repertory Theatre of Lincoln Center, where Kazan ended up directing Miller's *After the Fall*, which included an informer character based on Kazan himself. Not only that, but Kazan had had an affair with Marilyn Monroe before Miller married her. (Kazan's second wife, Barbara Loden, played the Monroe character in Miller's play.) The only reason I didn't write that book was that neither Kazan nor Miller was willing to talk about the other, and the blacklist story could be told in other ways.

Un-American Activities, but had taken a full-page ad in *The New York Times* urging other ex-Communists to do likewise. His action was particularly resented by many on the left who believed that since the blacklist didn't apply on Broadway and he was the director most in demand, he could always get work in the theater; therefore, his decision to name names was a gratuitous betrayal of former comrades. When I asked for an interview, after some resistance he agreed to talk with me about anything but his testimony (which, of course, is what I wanted to talk with him about), because he planned to write about it himself.

But when he finally saw me, it was when Richard Nixon's former lawyer John Dean was testifying before the U.S. Senate Watergate Committee. Kazan asked me if I would mind watching with him, and after providing me with a chair, he unforgettably reclined on a couch not unlike the one in Hirschfeld's caricature, whereupon we both watched John Dean on TV play the role of "good" informer as he reported on the misdeeds of the Nixon White House, which I took to be Kazan's way of letting me know that the issue of naming names was a complex one.

As you can see in Hirschfeld's rendition, Strasberg is sitting in the therapist's chair while Kazan lies in the position of analysand. Their feud had a long history, going back to the days of the Group Theater in the 1930s, but its latest manifestation had to do with Kazan's allegedly "betraying" Strasberg by quitting the Actors Studio (which he and Strasberg, along with Cheryl Crawford, had co-directed) to take a position as lead director of the new Repertory Theatre of Lincoln Center. The beauty of Hirschfeld's metaphor was that under Strasberg's leadership, the Actors Studio was the foremost proponent of the so-called Stanislavsky Method (the idea, named after Konstantin Stanislavsky, that an actor needed to take his own "emotional memory" and personality onto the stage when he played a character). Psychoanalysis and the Method were thought to go hand in hand.

I later discovered that Kazan, who had been in analysis five days a week, used to write up his sessions after the fact, and deposited these diaries with his other papers at Wesleyan University. Putting Kazan on the couch, Hirschfeld knew not how prescient he was.

But in the guise of an innocent caricature of two show-biz bigshots, his line-drawing captured an enduring truth about the relationship between the two men whose measure he had taken.

Raymond Jackson (Jak)

Raymond Jackson (1927–1997), better known as Jak, cartoonist for London's *Evening Standard* and *The Mail on Sunday* for something like thirty years, was, according to Mark Bryant's obituary in *The Independent,* one of "Britain's best-loved cartoonists." This did not mean that he did not have his share of enemies and critics, nor that he was easy to get along with. Ever since his first job, retouching pubic hairs on photographs for the naturist magazine *Health and Efficiency,* from which he was sacked, he went his own way.

Laughter rather than apologetics was his way of dealing with those he offended. He once said, "I'll laugh all the way right up to the execution chamber."

Relations between him and Vicky (Victor Weisz), the *Standard*'s other great cartoonist, were so dicey that they didn't speak for years, and indeed Vicky took the back stairs to his office so that they need not meet. When Vicky, whose politics were far to the left of Jak's, committed suicide, and Jak was hired as his replacement, the *New Statesman*'s maverick investigative reporter Duncan Campbell observed, "It is ironic that Jak should have inherited the cartoonist's job from Vicky, who killed himself in despair at the proliferation of the sort of attitudes that Jak encourages."

It was not merely his politics that made him enemies. His work often featured stereotypes rather than recognizable individuals, and as a result, as his biographer at the British Cartoon Archive pointed out, "he managed to offend large numbers of people." Not least among them were the targets of the cartoon he published on December 9, 1970, attacking the power workers, which is featured here.

The cartoon, drawn during the strikes that led to blackouts in hospitals, so infuriated the power workers that they threatened to shut down the *Evening Standard.* This cartoon, called "Homo-Electrical Sapiens Britannicus circa 1970," was a savage caricature that depicted

Opposite:
Jak, "Homo-Electrical Sapiens Britannicus circa 1970" (1970)

a cloth-capped man holding out a permanently open right hand, a hole where his heart should be, eyes green with envy, ears deaf to reason, and a solid-bone head.

By way of protest, the *Evening Standard*'s printers stopped the presses and threatened to keep the paper shut down until it agreed to carry a letter next to Jackson's cartoon, giving the printers' opinion: "The Federated House Chapel most strongly deprecates the cartoon and feels that it goes above and beyond the bounds of humour and fair comment. However, to show that we are not boneheaded as portrayed and because we firmly believe in the freedom of the Press, we have not refused to print, once given this opportunity to express our opinion."

The line between racist and nonracist stereotypes is elusive. This ambiguity often gives them their power. The trick for the wounded (or those who identify with the cartoon's target population) is not to nurse their wounds; rather they may use the occasion to kick off a round of discussion, debate, argument.

Because Jak's use of stereotypes on occasion went over the line, his cartoons sharply raise the question of the relationship of caricature to group defamation. His October 29, 1982 cartoon in the *Evening Stan-*

Jak, "The Irish" (1982)

dard, "The Irish," which caused heated controversy in both Britain and Ireland, is a good case in point.

As always, context is critical: it appeared at a moment when IRA bombs in London had recently killed eight people, and Anglo-Irish relations were strained over the Irish government's attitude toward Britain during the Falklands war. The consensus, according to Roy Douglas, Liam Harte, and Jim O'Hara, joint authors of *Drawing Conclusions: A Cartoon History of Anglo-Irish Relations, 1798–1998,* was that Jak's drawing "represents one of the most appalling examples of anti-Irish cartoon racism since the Victorian era."

As you can see, it depicts a man walking past a poster advertising a quadruple-X-rated film from Emerald Isle Snuff Movies, "The Ultimate in Psychopathic Horror—*The Irish,*" featuring paramilitary and loyalist groups whose initials appear at the bottom, thereby reducing the Irish, in the nonsmiling eyes of those who objected, to murderers and thugs.

Critics noted that "the cartoon does not take into account Irish political complexities or distinguish between different paramilitary groups," and instead "homogenizes the Irish as a race of psychopathic monsters." But isn't that what cartoons, by definition, do and don't do?

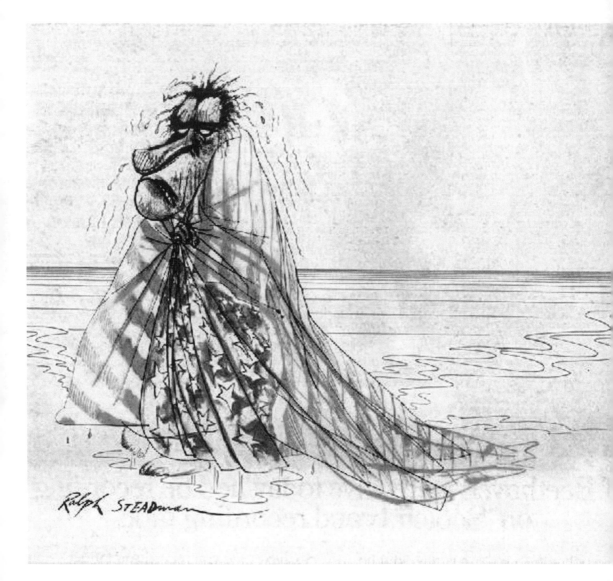

Ralph Steadman

Before he quit *The New York Times* to start *Scanlan's Monthly* with a colleague, Sidney Zion was summoned to a meeting by James Reston, the quintessential, ultra-connected establishment journalist then running the *Times*. The purpose of the meeting was for Reston to explain why it would be needlessly cruel and inappropriate for the *Times* to run Sidney's latest exposé, even though he had gotten the goods on his subject.

Opposite:
Ralph Steadman,
Richard M. Nixon
(1974)

"The difference between you and me, Mr. Zion," Reston said from behind his imposing desk, "is that you were brought up as a Jew on the scrappy streets of Passaic, New Jersey, whereas I was brought up in the Church of England, outside of Glasgow." At which point Sidney said, "I thought the difference between us is that you are sitting there, and I am sitting here."

The idea behind *Scanlan's* was to publish an antiestablishmentarian exposé magazine, a journal that would be cruel when necessary, thumbing its nose at establishment figures and niceties, a magazine that would make verbal and visual trouble. So it was altogether fitting and proper that I first became aware of Ralph Steadman, who now bills himself as a gonzo artist, in the pages of *Scanlan's*, for which its then art director, J. C. Suares, had recruited him to cover the Kentucky Derby, America's premier horse race, with the prince of gonzo, Hunter Thompson. (Steadman later said that "Suares greeted me with some caution, as I recall, treating me like a hired hitman.")

It has been written that Steadman (born 1936) "works as a moral and social commentator," but I much prefer his own description of how he works, because I think the process he describes applies not just to himself. Here he is talking about the first time he met Hunter Thompson's brother Davison, whom he promptly started to draw:

Not a very kind drawing as I recall, but it was only for fun, anyway. However, you could see he was visibly shocked and it took

me quite awhile—many drawings in fact—to realize that Kentuckians and many other Americans for that matter, take things like that as a personal comment and even, in some cases, an insult, comparable to a smack in the mouth. Hunter was shocked and then horrified as I persisted in adding to the drawing, making it darker and darker and more hideous as lines covered lines. It is at a point like this that the drawing can take over and I am completely immersed in its development. It is no longer merely a personal insult, but a battle between the drawing and my desire to mold and twist it. The drawing becomes more important than the subject. Other people were watching now. . . . I was smiling as I stabbed one last violent stroke across the page and signed it with a flourish. I handed it over. My subject had become a victim and his dark features blackened, resembling my drawing even more.

Of all the cartoonists out there, none is more his own man than Steadman. Nonetheless one would think that collaborating with the larger-than-life Hunter Thompson might take its toll. Not so. The collaboration endured well beyond the life of *Scanlan's* itself, which lasted all of seven issues; and if anything, Steadman became more Steadmanish. In his memories of life with Thompson, he writes: "Working with Hunter was always a challenge and he had infected me with an aggressive edge—or sharpened the one I already had." The drawing on page 140 is an illustration for Thompson's 1974 book on Richard M. Nixon, *The Scum Also Rises*—note the blank, demonic eyes, which recall the eyes of Levine's Kissinger, possessed and frenzied.

Alan Mumford observed in his book *Stabbed in the Front: Post-war General Elections Through Political Cartoons* that "it's perhaps most difficult to imagine politicians seeking to buy originals of Ralph Steadman's cartoons." This was certainly true during the decades when he would regularly rip the guts out of his political prey. Indeed, Steve Heller wrote, "There was a period during Ralph Steadman's career when he found the anticipation of drawing a politician almost like sitting down to enjoy a good meal." It was even truer as he ceaselessly pushed the limits of facial distortion—as was and is his wont—to the point where the faces were no longer recognizable.

What I hadn't realized when I went to visit Steadman in his home in Kent, as I mentioned earlier, was that for a period he had stopped caricaturing politicians. I should have figured that out when he took me on a tour of his studio and spent the first half hour going through his latest portfolio—a brilliant, hilarious, beautiful, and scarifying series of birds, real and imagined.

But it all came into focus when he gave me a copy of an article I had been searching for in vain—he had written it in 1988 for *The Observer Magazine*—called "The Cabinet of the Mind." The article is in the form of a manifesto aimed at his fellow cartoonists around the world, encouraging them to follow his example and to stop drawing politicians, period, to take the pledge he had taken. "I have sworn darkly to avoid drawing real, live, politicians at all costs," he wrote. His theory, as I related earlier, was that if all cartoonists did that, even for one year, politicians, as we know them, would "disappear from the face of the earth," because, as I quoted Steadman earlier, "by giving them the benefit of our attention and portraying them daily in the world's press we are contributing endlessly to their already inflated sense of self-worth. If we denied them the benefit of our attention, insight and wit, they would suffer withdrawal symptoms of such withering magnitude that the effect on their egos could only be guessed at. Not even a tyrant can survive the whiplash of indifference."

On one level, Steadman, who wrote a book on Freud, sees cartooning as a form of therapy. For example, he admitted to one interviewer that in the days when he was still skewering pols, he actually wanted to shoot Reagan before he drew him, but never after. "It's a form of assassination," he has said. "What you want to do is to cause that person damage. But not lethal, physical damage. If you can psychologically damage someone then you are really doing something. I'm all for that. It's the story of every serious satirist."

He says he believes that most cartoonists in newspapers depend on their style rather than the content of what they have to say. "It doesn't impress me in any way," he told me. "My style has evolved out of my lack of ability to draw." (As an art student he hadn't gotten along with his teacher and was sure he was going to flunk. "Then this fellow gave me a grade of 100 percent only to show he didn't hold a

grudge . . . But it might have been a grudge, you see, expressed as 100 percent. Nobody gets 100 percent of anything.")

Steadman's ink-splattered work, easily identifiable, like poetry, resists paraphrase. In fact, when asked whence he thinks cartoons derive their power, he says, "The only thing of value is that thing that you cannot say. That's where drawing is so important, that is the value of drawing. You could do something with a drawing that you couldn't say in words."

"Whereof one cannot speak, thereof one must be silent," is the famous last sentence in the philosopher Ludwig Wittgenstein's book *Philosophical Investigations* (in which he also wrote, "Don't think, look!"). Maybe Steadman took up where Wittgenstein left off.

It's not just that Steadman's art resists paraphrase. Somehow his splatters simultaneously express his discontent with the world and his satiric take on it. When I think of the way during the Watergate years he pushed his caricatures almost beyond facial recognition, I think of Nixon's widow's peak, which in Steadman remains intact, while all Tricky Dick's other features explode in chaos, and the splatters remind us of the unintended consequences of his subject's actions, and the widow's peak reminds us who his subject is.

Lucky for us, on the date Steadman resumed caricaturing real pols (in the *New Statesman*), he didn't make a big deal about it. There were no manifestos or apologias to mark the occasion. But then, as he has already explained: the art says it all.

"All authority is a mask for violence," were Steadman's parting words to me. From a man who has spent his life resisting, exposing, and attacking authorities, enough said.

Robert Edwards

As a Yale University law student in the late 1950s I was privileged to take the first political and civil liberties law school seminar in the United States, taught by Professor Thomas Emerson. Although he was known affectionately to his students as "Tommy the Commie," Emerson was probably the country's leading authority on free-speech issues, and as fair and judicious a teacher as one could hope to have. If I had any doubts before I took Emerson's course, I had none after, and bought into his careful analysis of the speech-action continuum (which provided the greatest legal protection for that which most closely resembled expression).

As a Jewish boy growing up in New York City, my first job had been to pass the contributions basket at the Ben Hecht play *A Flag Is Born*, calling for the establishment of an independent Jewish state in Palestine. I remain a strong believer in the establishment of the state of Israel, although in recent decades I have come to believe that Israeli policies, especially with regard to the Palestinians and the West Bank settlements, are ill advised and self-defeating.

In 1978, when I had the opportunity to join *The Nation* as its editor in chief, I was proud to accept the appointment not least because I was aware that in 1947, *The Nation*, under the leadership of its editor Freda Kirchwey, had played a key role in revealing the behind-the-scenes World War II ties between the Grand Mufti of Jerusalem, living in exile in Egypt, and the Nazis.

This is all by way of background to explain my reaction when I learned that the last Westerner to be put in prison for drawing a cartoon was one Robert Hamilton Edwards. Edwards (1928–), the son of a Kent miner (from South Wales), was a professional cartoonist with a history of involvement in racist politics. In the 1960s he was dishonorably discharged from the army (where he held the rank of private) for attending a Mosleyite meeting in uniform (Sir Oswald Mosley was the founder of the English Union of Fascists). During the 1970s he lived in

West London and was active in the British National Party (which split from the National Front in 1975), drawing cartoons for its publications.

He had gotten in trouble for his cartoons in the late 1970s when he was an active member of something called the League of St. George (a neo-Nazi political club which broke away from Mosley's British Union of Fascists) and took part in bitter and violent factional infighting. He was beaten up after he did a cartoon suggesting an opponent was Jewish.

In 1981 he joined the National Front Constitutional Movement, a more moderate offshoot of the National Front, becoming deputy editor of its newspaper, *Frontline News,* but was forced out for drawing unflattering cartoons of his superiors. What landed him in prison was his conviction in 1982 for publishing cartoons "likely to incite racial hatred."

The incriminating cartoons appeared in a strip he called *The Stormer* (you can guess what it was named after or, if you can't, go back to pages 107–112 and read about *Der Stürmer*), which was distributed outside schools and was described by *Times* journalist Paul Hoggart as a perverse twist on *Green Cross Man,* a popular British educational comic: "*Green Cross Man* instills road prudence, birth-control advice for teenage girls is given in picture-strip stories, and at the sick end of the scale, a racist organization recently circulated a comic called *Stormer* about burning a black boy."

The Stormer's characters included "Billy the Yid, the Kosher Cowboy," "Li the Paki," and "Sambo, the Chocolate Colored Coon." There were strips denying the Holocaust and invoking the blood libel, the ancient anti-Semitic myth that was used to banish Jews from England in 1290. Another strip told "The Real Menachem Begin Story," purporting to document his involvement in terrorism, specifically the murder of dozens of English people at the King David Hotel in Jerusalem on July 22, 1946.

Shortly after Edwards left prison he claimed in a newspaper interview and to *Searchlight* magazine that he had repented for his racist past. He said he had been made a scapegoat while more senior neo-Nazis got away scot-free, and he moved to Ramsgate, where he said he converted to conservatism.

Robert Edwards, "The Real Menachem Begin Story" (1981)

Jonathan Aitken, the defense procurement minister and MP for Thanet South, which includes Kent County in the southeast, wrote a glowing preface for a book of Edwards's cartoons called *Thanet Life and Times* in which he said, "Robert Edwards has a quintessentially English sense of humor so gentle in his jibes that even his victims enjoy being lampooned."

But in 2006, in the aftermath of the Danish Muhammads cartoon conflagration, when the Iranians announced an International Holocaust Cartoon Competition, the first entry submitted from Europe came from none other than Robert Edwards. He wrote in a letter to the editor of *Hamshahri,* the newspaper that sponsored the contest: "I am in agreement with the position of the President of the Islamic Republic of Iran on issues such as the Holocaust and welcome his holding a conference on the subject. It proves that there is more freedom of expression in Iran than in America or Israel."

His cartoon showed Iranian President Ahmadinejad popping a hot-air balloon labeled "Zionist Lies" and carrying George W. Bush, Tony Blair, and Dick Cheney, who are busy dropping bombs on Iraq, Afghanistan, and Pakistan.

Three years later, on April 5, 2009, Edwards gave an interview to *Blood and Honor,* which describes itself as a "white power music zine," in which he said of his imprisonment: "I was given a twelve months prison sentence at Snaresbrook Crown Court in East London and I served just over nine months. I remember the wording of the original summons—'material likely to incite racial hatred.' There was never any evidence that these comics incited anyone to harm or injured others, but I do admit the cartoons were a bit over the top. I tend to avoid depicting Jews or black people in caricature. The risks are too great and sitting in a prison cell is a complete waste of time. Martyrdom is often short-lived in the memory of others, besides. As a cartoonist I do find myself severely restricted."

I reprint Edwards's Begin cartoon here not because of its artistic power. (As an artist, he is not without talent, but on that score, in my view, he ranks near the bottom among those represented in this book.) But the Emersonian civil libertarian in me thinks that Edwards, who would be entitled to legal protection in the U.S. on free-speech grounds,

should not have been put in prison. The anti-anti-Semite in me is deeply offended by his casually provocative flirtation with *Der Stürmer* and all that it represents (including the stereotypical Jewish noses in the Begin and other strips). The Israel-watcher in me acknowledges that he got Begin's activities as a member of the Stern Gang right, but feels that Edwards undercuts his own observation by the hatefulness of the message implicit in his visual language. The citizen in me finds his ideas repugnant, yet the sociologist in me wonders why the authorities find his work, which itself is a caricature of conventional bigotry, sufficiently threatening to earn him imprisonment.

Naji al-Ali

O n Wednesday, July 22, 1987, at five in the afternoon, the most respected cartoonist in the Arab world, Naji al-Ali, was walking in the Chelsea area of London toward the offices of the Kuwaiti newspaper *Al-Qabas,* where he worked, when he was shot in the head by a lone gunman, who walked calmly away and vanished.

Opposite Top:
Naji al-Ali, Hanthala
(1983)

Opposite Bottom:
Naji al-Ali, Hanthala
(1981)

By that time, the cartoons of al-Ali—who was born in 1936 and grew up in a Palestinian refugee camp in Lebanon, where his artistic talents were discovered by the Palestinian writer Ghassan Kanafani in the early 1960s—had appeared on the last pages of Arab dailies from Cairo to Beirut, and in London and Paris, and long lines of people waited impatiently every morning to see his drawings.

Newspaper reports quoted a "friend" of al-Ali saying that two weeks before the murder he had received a phone call from a senior member of the PLO in Tunis complaining about a cartoon attacking a female friend of a high Palestinian leader (presumably Yasser Arafat), which was published across the Arab world. The caller said, "You must correct your attitude." Apparently, al-Ali ignored the warning and promptly published a cartoon lambasting Arafat and his henchmen.

Two streams of rumor immediately began to flow. According to one, Arafat had ordered his assassination. Rumor number two had it that the Mossad, the Israeli secret service, which had long had al-Ali on its hit list because of his unceasing production of devastating anti-Israeli cartoons, finally got around to ordering his liquidation.

Eventually the police arrested two suspects, each said to be a double agent employed by the Mossad, but working for London-based PLO hit teams. The Brits expelled one Israeli diplomat, barred another from the country, and Margaret Thatcher threatened the Mossad with further action, but as of this writing there have been no indictments, no trials, no convictions, and as al-Ali himself predicted, although he is dead, the cartoon character he created, Hanthala, lives on.

Actually, very few Middle Eastern regimes and groups had escaped his highly personal condemnations, exposés, and commentaries on everything from the brutality of the Israeli army to the hypocrisy of the PLO. He had been detained by police, frequently censored, and expelled from Kuwait in 1985, when he moved to London.

As seen in the images on page 150, nearly every cartoon that al-Ali drew included his signature character, a barefooted little boy, Hanthala, seen only from the back since, with his wispy hair, he had turned his back on the world. Al-Ali wrote of Hanthala, "I drew him as a child who is not beautiful; his hair is like the hair of a hedgehog who uses his thorns as a weapon. Hanthala is not a fat, happy, relaxed, or pampered child. He is barefooted like the refugee camp children, and he is an icon that protects me from making mistakes. . . . His hands are clasped behind his back as a sign of rejection at a time when solutions are presented to us the American way."

Before he was murdered, Naji al-Ali had received more than a hundred death threats from an unprecedented range of would-be assassins. Clearly, whoever commissioned the actual hit job—Arafat, the Mossad, or a third party unnamed?—had been driven to ordering the lethal action by Naji al-Ali's cartoons. And the international media that covered the murder never got around to the question of motive, focusing only on who committed the crime.

His style has been described as stark and symbolic. Specific politicians did not appear in any of the more than forty thousand cartoons he drew in the course of his life as a political cartoonist. His explanation: "I have a class outlook. That is why my reactions take their form. What is important is drawing situation and realities, not drawing leaders."

Thus one cartoon might feature a thin, miserable-looking man throwing stones representing Palestinian defiance of Israeli oppression; another a fat man representing Arab regimes and Palestinian leaders leading the life as they engaged in the compromises al-Ali abhorred. During his lifetime he was elected president of the League of Arab Cartoonists. In 1988, after his death, the International Federation of Newspaper Publishers awarded him the Golden Pen of Freedom.

A statue of al-Ali, erected at the Ain al-Hilweh refugee camp in Lebanon, where he grew up, was damaged by an explosion and, like al-Ali, shot in the head. The statue soon disappeared.

Despite the reams of brilliant and fair-minded reported analyses, probably no subject has been written about with more passion, bitterness, and bias than the Palestinians and the Israelis, the Arabs and the Jews. Yet it's hard to think of a single print journalist who has covered that conflict who was assassinated or assaulted for his prose. Cartoons, I repeat, are totems, which once unleashed are not merely uncontrollable themselves but can have uncontrollable and in this case deadly consequences for their creators.

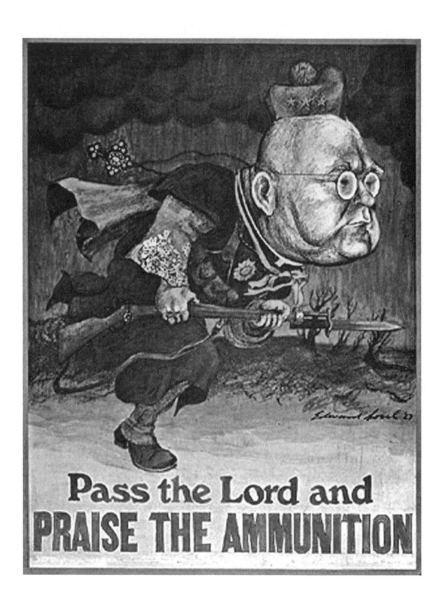

Pass the Lord and
PRAISE THE AMMUNITION

Edward Sorel

I first met Edward Sorel (born March 26, 1929) in 1961 in the pages of *Caterpillar*, a satire magazine that appeared briefly in the early sixties and soon disappeared. At about the same time his marriage to his first wife was disappearing, and so he proposed a deal: if he could sleep in the *Monocle* office, in place of rent he would become our art director. It was the best deal I ever made.

Since then, Ed has come to fame as an artist, muralist, and moralist and especially, as I've said, a critic of religion. His works may be found in the National Portrait Gallery in Washington DC, the Wilhelm Busch Museum in Hanover, Germany, the Canadian Museum of Caricature in Ottawa, and countless other venues. For Sorel, organized religion had no better symbol in 1967 than Catholic cardinal Francis Spellman, a dedicated anti-Communist, Vietnam War hawk, and military vice-general of the U.S. Armed Forces. His poster "Pass the Lord and Praise the Ammunition" did not bring down Spellman and the church's wrath on him only because the cardinal died just as the poster was finished. So instead of putting it on sale, Sorel used the image for his 1972 book, *Making the World Safe for Hypocrisy*.

As you already know, Ed Sorel's Frances Lear, like Levine's Kissinger, fell afoul of *The Nation*'s political-correctness police. You already know that once again the issue had to do with what used to be called "the war between the sexes" (although most men in the office, including myself, thought of themselves as on the woman's side of the so-called war). This time, the staff was upset because of the words. But once again, it was the pictures that brought the words into sharp focus (see page 8).

The following notice appeared in the same issue as Sorel's cartoon. (Had I not been away because of a family emergency, I would have held the letter off until the following week, so that the cartoon was not seen through its filter.)

Opposite:
Edward Sorel, "Pass the Lord and Praise the Ammunition" (1967)

ENTER SEXISM, VINDICTIVE

Readers should know that Edward Sorel's cartoon in this issue appears despite the strong protest of thirty-four staff members. We are outraged that sexism is still a respectable prejudice, especially in a left magazine.

Had one of the magazine's male-chauvinist contributors written an article making the same argument as Sorel, it undoubtedly would have drawn some negative mail, but not the outraged group denunciation his panel had incited. As it was, the following week, the letters pages featured a gracious, good-humored note from Frances Lear. "I am thrilled with [the letter] and send everyone my gratitude for being right-on. I wonder about Sorel. I fail to see why he failed to see my still-steamy good looks." A constructively emotional letter to the editor from the gifted artist Jules Feiffer also appeared:

What has made the left so traditionally condescending to its artists? Edward Sorel is one of the great cartoonists and caricaturists of this century. Whether one agrees with his every cartoon or not, it seems to me that after thirty years of work on a level that is simply extraordinary, he shouldn't have to pass an ideological means test to get in *The Nation*'s pages. That thirty-four staff members tried to suppress Sorel when they disagreed with him reveals a contempt for the right of free expression that is not only shortsighted but, as Sorel's colleagues well know, predictable.

Letters from fellow cartoonists Robert Grossman and Arnold Roth and others are worth pondering, but I guess it shows my inability to learn from experience that I still believe even more strongly what I wrote in my editor's comment—which follows others' comments below—only more so.

Just because a drawing is mean and stupid is no excuse not to run it. What is it about Frances Lear that makes Sorel angry? Is it that she is buying into the magazine business? Is it that she might be desperately vain? Certainly she is entitled to these things and could hardly hurt anyone in the process.

What Sorel should have focused on is the mediocrity of *Lear's*. It has been packaged the same way television series are, bland formulas to "*épater la bourgeoisie.*"

—J. C. Suares

· · ·

Sorel does come on like a loose cannon. But then again, he's so often on target.

I'd call it a good shot. ***Bill Charmatz***

Bill Charmatz, Letter to the Editor

· · ·

One rule I live by is: If a person has under $111 million, I observe certain niceties—above that amount he/she is fair game. Go Sorel!

—Robert Grossman

· · ·

Edward Sorel is a superb cartoonist. His work aligns contemporary politics with deep structures, philosophy, myth and psychology. As an artist in this society, he is probably very isolated and does not receive much input, positive or negative.

Sorel's work is critical realism. He attacks corruption and hypocrisy wherever he sees it—just as George Grosz attacked militarism in Weimar Germany, subsequently aligning his work with the left. Attacking the right does not mean that one is ideologically of the left. Grosz's work contained many negative depictions of women, which I am sure he did not see as a contradiction.

Political art, a male domain, historically has been subject to

negative stereotyping, as the language is one of limited artistic formulas. Left artists are not immune from or separate from the cultural language and thinking of the dominant class. It is an ideological question as to whether one has the luxury to expose a legitimate contradiction, if in turn that criticism reflects negatively on forces of social change.

The image in art is final, but the growth and development of the artist is not a fixed commodity, and perhaps it would have been a good idea for thirty-four objectors of the cartoon to explain to Sorel why the content was sexist and offer suggestions on how he could tinker with the idea of bourgeois feminism without attacking women—before publication.

As the crisis in capitalism worsens, precious newsprint becomes an important weapon to combat this rise in brutality. We must break down manufactured isolation and distorted thinking, to help cultural workers become more effective.

—Sue Coe

. . .

I wasn't overly offended. That a member of a discriminated-against group with lots and lots of money should have little trouble overcoming that discrimination seems a legitimately funny idea. That a woman should be stereotyped as ditzy isn't very nice but shouldn't be censored; we need to get a little bit thicker skin. Lampooning a displaced homemaker, however, bugs me. Often discarded after their children are raised and possessing few job skills, women face many obstacles upon re-entering the work force; ridicule is just one of them.

Frances Lear is no ordinary displaced homemaker, though rich people have always made good targets. But why be selective? Are Martin Peretz or Eric Utne scrutinized for marrying wealth or are they judged by the quality of *The New Republic* or the *Utne Reader?* [Peretz and Utne respectively were the heads of these publications.]

Speaking of big bucks, I was more irritated by Sorel's satire last year of Bill Cosby for Cosby's endorsements, since Sorel promotes at least one big corporation himself. I remember that at a New York Public Library lecture Sorel was asked how he reconciled his illustrations for Manufacturers Hanover [bank] with his left political beliefs. He turned on his questioner, saying that when he became an illustrator it was a noble profession for the son of an immigrant to aspire to, whereas today middle-class children become illustrators when they're too lazy to become doctors or lawyers. The implication that if one's background is working-class any flirtation with wealth is excusable is a leniency Sorel doesn't allow his victims. But then, he probably hasn't made as much as Bill Cosby or Frances Lear. Surely those aren't sour grapes?

—Lisa Blackshear

. . .

As a professional critic of the news media who frequently takes them to task in print for, among other sins, sexist messages spread, unwittingly and otherwise, through headlines, captions, commentary and reports, I confess to being somewhat mystified by the charge of sexism leveled at Edward Sorel's cartoon featuring Frances Lear. Maybe it would help if those thirty-four members of staff who protested its publication would specify just what it is about the piece that suggests a gender-related bias. The vanities of men—self-indulgence, self-glorification, self-delusion and the rest—get plenty of attention from Sorel. Surely women who exhibit similar tendencies are equally worthy targets.

—Gloria Cooper
Columbia Journalism Review

. . .

SOREL REPLIES

Ed Sorel stayed above the fray with a short, witty rejoinder which skirted all the issues.

Lisa Blackshear recalls my talk incorrectly. My diatribe against lazy, unmotivated students was in response to a question about why I no longer teach. I've never tried to justify working for banks to my Politically Correct friends, any more than I've tried to justify working for *The Nation* to my accountant.

. . .

My Editor's Response went on and on, but since you already know that, rather than reprint it *in toto*, I quote only the following:

> Sorel, in a gracious private letter to "the Unfriendly 34," wrote that his cartoon about Frances Lear is about hypocrisy. "I show a very rich woman who advises other women to be as enterprising as she has been, ignoring the fact that other women don't have the options that come with wealth."
>
> Sorel, it seems to me, has accurately identified the main thrust of his cartoon, and the objectors have accurately identified its most troubling political assumption. Indeed, many of them would argue further that the assumption is sufficiently insidious to disqualify it from publication in *The Nation*.

Looking back, I believe that the exchange raises a meta-question: If one assumes that art can accomplish something that prose cannot, ought a political journal subject art to a different set of standards than prose, and if so what might they be? Or to put it differently, are editors (including myself) hired primarily to make news judgments about politics and prose, ipso facto competent to make editorial decisions about art?

Robert Grossman

Robert Grossman (born March 1, 1940) is best known for his airbrushed caricatures which have appeared on more than 500 covers of periodicals including *Time*, *Newsweek*, *Rolling Stone*, *The New Republic*, *Sports Illustrated*, *New York*, and *The New York Observer*. Although widely imitated, as Steve Heller once observed, his "mordant wit" is never duplicated.

An early *Monocle* contributor, he came up with an intermittent comic strip satirizing the Central Intelligence Agency, "Roger Ruthless," CIA operative extraordinaire, and, during Lyndon Johnson's presidency, "Animal Ranch," featuring such anthropomorphic beasts as "Mutton Luther King" and "Chairman Meow." When in 2005, one C. A. Tripp posthumously published *The Intimate World of Abraham Lincoln*, a book suggesting that Lincoln might have been gay, Grossman produced a (nonairbrushed) cartoon for *The Nation* that he called "Babe Lincoln." Drawn to resemble a daguerreotype (a process invented in France in the early nineteenth century), as you can see, it portrayed Lincoln as a fishnet-stockinged buxom babe.

Left:
Robert Grossman, "Mutton Luther King" (1966)

Right:
Robert Grossman, "Chairman Meow" (1966)

Lincoln's sexuality had long been the subject of speculation. For example, in Carl Sandburg's 1926 biography, he wrote of Lincoln's relationship with a male friend as "having a faint scent of lavender, and spots as soft as May violets."

The question of what is and what isn't funny, especially when it involves images, is arguably always a matter of taste—although as Ed Sorel remarked to me, "To work, a cartoon not only has to be funny, but you don't pick on people smaller than you."

Once again *The Nation* was drowned in a sea of accusatory, outraged, and indignant letters. I cite a personal letter to me (no matter that by this time I was emeritus and had not seen the offending cartoon until I received my copy of the magazine) from a former editor in chief of *Esquire*, who wrote, "I'm sure I'm not the only person who finds your Abe Lincoln cartoon deeply and painfully insulting. What you mistake for humor is nothing more than virulent and blatant homophobic garbage, utterly unworthy of the 140-year-old magazine that has been entrusted to your care. It's this kind of ignorant stereotyping that fuels and perpetuates hatred, disgust and violence against homosexuals."

A more perplexed reader wrote:

Bethesda, Md.

I'm having a problem understanding the "Babe Lincoln" cartoon. The drawing shows a recognizable Lincoln head atop a voluptuous Victorian postcard-porn female body. The text states that the "newly discovered" image lends credence to the suggestion that Lincoln was gay.

Was Lincoln transgendered—a male "trapped" in a female body? Or was he a transvestite, a man who likes to dress up in female clothing (but those cartoon breasts look pretty real, no padding there)? Could he actually have been a hermaphrodite with characteristics of both sexes (although I can't be sure what those pantaloons are really hiding)? Of course, none of these things necessarily equates with homosexuality.

I've been racking my brain trying to figure out how the cartoonist could have visually indicated "gayness" in some other

BABE LINCOLN

Newly discovered daguerreotype lends support to theory in a recent book that the sixteenth president was gay. Log Cabin Republicans take note.

ROBERT GROSSMAN 12/04

less confusing way. Undoubtedly, however, it too would have been inaccurate and stereotypical. So, can you help me figure this out? Who's confused here—me, Lincoln or the cartoonist?

—L. E. Martinez

Grossman responded:

When I read the review in *The New York Times* of C. A. Tripp's *The Intimate World of Abraham Lincoln,* the words "Babe Lincoln" suddenly ran through my mind rendering me helpless. In the impoverished mental landscape of a cartoonist this is what passes for true inspiration. I knew that gay men were not necessarily effeminate, cross-dressers or bearded ladies but I couldn't let that prevent me from having my laugh. Better a cheap infantile joke than no joke at all, or so I thought. Now I hereby apologize to anyone I have offended. . . .

Somebody asked me about the ax in the picture. It was a contemporary symbol of Lincoln. Although now I've read that he may not have split any rails. Somehow I thought it would make my picture a little more edgy.

Grossman's response seemed to me to be funny, classy, and appropriate, but whether one agrees with the objecting letters or not, "Babe Lincoln" does raise a number of questions: Is it homophobic (and therefore verboten)—i.e., is it so offensive to a disempowered minority that one ought to defer and not run it? Or would that be leaning so far over backward as to miss the bigger picture? And what ever happened to our sense of play, which I take to be Grossman's point? I abhor homophobia and gratuitously hurting people's feelings, but I vote to encourage nonsense as much as sense and to have a presumption (rebuttable though it may be) against killing any cartoon that is on its face funny, although again one has to ask, to whom?

Not all, of course, agreed, and some even came to his defense.

As . . . an admirer of Bob Grossman and a collector of his work, I felt deeply offended by the letters on your website from some of your readers about Bob's "Babe Lincoln" cartoon. Their impli-

cation that an artist—especially in his case a political, social and cultural critic—should be constrained by rules of taste, political correctness and propriety is offensive to common sense and damaging to freedom.

And what's even worse, it seems that those advocates of censorship see themselves as "liberals." It's worrisome that a mild, sweetly funny and even affectionate take on Lincoln's alleged gayness should cause such a rabid response.

—Jorge Pontual

Doug Ireland, the gay activist, saw it differently. "[That] cartoon is like something out of a time warp," he wrote, "the long-ago disproven notion that a man who loves a man really wants to be a woman is truly from another era. And by letting Grossman's reply stand as the only real response by the magazine the editors have simply magnified their insensitive error. To put it simply . . . they just don't get it."

I think I get it, but whatever one thinks about Grossman's "Babe Lincoln" and the decision to run it, it seems to me inarguable that the fact that Grossman's caricature was an image rather than words (how could it have been otherwise?) is what raised the temperature of the offended to scalding.

NEW

80th ANNIVERSARY YEAR 1913-1993

STATESMAN

29 JANUARY 1993 £1.50 & SOCIETY

The curious
case of
John Major's
'mistress'

Tony Blair: Why crime is a socialist issue
Apocalypse tomorrow: Ten disasters waiting to happen
John Cole James Lovelock Jaci Stephen John Pilger

Steve Platt and the *New Statesman*

Opposite:
cover of *New
Statesman* (1993)

In the 1920s, the *New Statesman,* although its circulation was only ten thousand, was said to be the most influential of the British weeklies, founded by Fabian Socialists Beatrice and Sidney Webb (with an assist from George Bernard Shaw, who talked them into putting up the money). Anybody on the left who was anybody wrote for it. When John Maynard Keynes couldn't persuade T. S. Eliot to leave Lloyd's bank for the literary editorship, he hired Leonard Woolf instead.

Despite its left-wing politics, and a close relationship with the Labour Party, over the years it followed no dogmatic party line. Indeed, like its American counterpart, *The Nation,* under Freda Kirchwey, the *New Statesman,* under Kingsley Martin, managed to accommodate literary contributors in deep disagreement with the more pro-Soviet writers in the front of the magazine (see H. G. Wells's famously deferential 1934 interview with Joseph Stalin). Like a pantomime horse, it was said, "the front half knoweth not what the back half doeth—and vice versa."

To protect the independence of "Staggers and Naggers," as the *New Statesman* was quaintly known ("Staggers" for their perpetual funding crises, "Naggers" because that's what they were), George Bernard Shaw and the Webbs had set up an ornate ownership structure. By the early 1990s it had evolved into four separate but overlapping companies, each with three classes of shareholders; all of this supplemented by five "E" (for editorial) shareholders. I mention this only because in June of 1990, Stuart Weir, the then-editor, called and told me that under the terms of their charter, the "chapel" (the union) got to name one of the five E's. My name had been proposed, and would I agree to serve? To make an already too-long story no longer, I said yes, which is how I got a ringside seat at the events I am about to describe.

On January 20, 1993, the *New Statesman* published "The Curious Case of John Major's 'Mistress'" by Steve Platt, its editor, with a cover photo-cartoon of Prime Minister John Major in mid-repast, and his caterer, Clare Latimer, in the background. The tabloid press had, for

months, been printing blind items—planted by Major's enemies in the Thatcherite right wing of his own party—about Major's alleged affair with his caterer. Nobody had bothered to check whether it was true.

The *New Statesman* checked, decided it wasn't (or at least that there was no evidence that it was), documented its case, and wrote an article denouncing the tabloid culture of carelessness and prurience. "At the time, we didn't pay much attention to the cover," said Platt when I talked to him in the spring of 2012. "I didn't even remember the person who designed it. It was a last-minute thing." The prime minister, who was flying home from India at the time, not yet having read the article, was told by an advisor that he should be offended by the cartoon cover and headline. He denounced the article, and eventually, used Britain's draconian libel laws to sue Platt, his co-author, the *New Statesman,* its publisher, printers, distributors, and its major retail outlets. As *The Economist* put it that July, "John Major sued a down-at-the-heels British weekly" for an article which said "he was not sleeping with his cook." "One of the ironies," Platt told me, "was that some of the people I spoke with at the time told us we named the wrong person. We didn't want to pursue that."

Because of a quirk in the British libel laws, although the case never came to trial and Major settled, the suit cost the *New Statesman* £250,000. (It had, as is the UK custom, indemnified its printers and distributors against libel suits.) The *New Statesman* went, temporarily, into bankruptcy. Platt eventually lost his job. And ten years later it came out that Major indeed had conducted a four-year clandestine love affair, though not with Clare Latimer.

In October of 2002, Platt came to a retrospective conclusion. Since the *New Statesman* at the time had never accused Major of being an adulterer,

> it had been something of a puzzle as to why he did what he did. In hurling writs at not only myself and the magazine, but the printers, distributors, and anyone [who] showed the slightest inclination to produce, stock or sell the offending issue, he seemed to have gone entirely over the top. Now it becomes clear. Major was deliberately, shamelessly, kicking the weakest kid in

the playground—a magazine that could not afford to go to court to cover a case it felt sure it could win—in an attempt to keep the bigger bullies of the press from kicking him around instead. . . . I found it difficult to comprehend why, other than for reasons of deep personal distress, he should have responded to its appearance with such seemingly irrational vehemence. I was naive. I should have realized that no one protests so loudly as the crook who is rightly accused, but can claim innocence in particular circumstances.

Surely, Platt is right. Although he later discovered that "the plan was already in place pre-publication" to sue whoever charged that Major was having an affair, it is also true that had it not been for the cover, which, as the cliché goes, spoke louder than words, it is inconceivable that Major would have brought the suit he brought.

Whatever the words in the article, or however the reader interpreted the headline ("The Curious Case of . . ."), the photo-cartoon, even if only by virtue of its placement on the cover, became the visual equivalent of, the surrogate for, an accusation. As Kiku Adatto, author of *Picture Perfect,* has written, "To frame an issue is to exercise some 'interpretive power.'" When a photo is in effect a caricature, a joke, a lie with a narrative implication, then we may be in the presence of a double whammy.

It wasn't the artist's (or the designer's) artistry that caused the problem; the visual statement overrode the words that appeared in the magazine, and that made the difference. In an age of photoshop, animation, and innumerable other technological advances in visual communication, it's hard to overstate the importance of what happened here.

As Platt now puts it, "The picture provided the context for reading the article, but the article didn't provide the context for reading the picture."

Like Barry Blitt's *New Yorker* cover satirizing the right wing's view of the Obamas, the *New Statesman*'s story satirizing the gossip press's false charges fell victim to its own visual joke—albeit with greater consequences for those involved.

The New Yorker Images

Art Spiegelman, who, incidentally, says that David Levine was one of his main inspirations "especially when he challenged himself to go beyond facial recognition," is best known for his two-volume graphic novel, *Maus* (winner of a special Pulitzer Prize in 1992), which tells the story of his father's experience during the Holocaust. In the novels, Jews are famously represented as mice and Nazis as cats.

Opposite:
Art Spiegelman,
"Valentine's Day," *The New Yorker* (1993)

Spiegelman's approach came out of an early attempt to draw a series about race in America called *Ku Klux Kats*. It gave him the idea that the cat-mouse metaphor could actually apply to his more immediate experience, which included nightmares about Nazis chasing Jews. So, as he tells it, he collected drawings by concentration camp survivors, and these turned out to be "essential" for him; unlike photographs, "they were a kind of commemorating, witnessing, and recording of information—what Goya referred to when he says 'This I saw.' "

Spiegelman is also known, among many other things, for two *New Yorker*–cover imbroglios caused by less anthropomorphic stimuli: The first was his St. Valentine's Day celebration showing a Lubavitcher Hasid kissing a Caribbean-American woman (at a moment when violence between the two groups had erupted in the Crown Heights section of Brooklyn). Perhaps anticipating a negative reader reaction—but not the angry protests the magazine received—then-editor Tina Brown ran an unprecedented editorial paragraph inside the magazine, explaining the cover:

> About the painting, which is Mr. Spiegelman's first work for the magazine's cover, the artist writes, "This metaphoric embrace is my Valentine card to New York, a wish for the reconciliation of seemingly unbridgeable differences in the form of a symbolic kiss. It is a dream, of course, in no way intended as any kind of programmatic solution. The rendering of my dream is intentionally, knowingly naïve, as is, perhaps, the underlying wish that

people closed off from one another by anger and fear—Serbs and Croats, Hindus and Muslims, Arabs and Israelis, West Indians and Hasidic Jews—could somehow just kiss and make up. Though I'm a maker of graven images by profession, I respect the fact that in the real world, the world beyond the borders of my picture, a Hasidic Jew is proscribed from embracing a woman from outside his sect and his family. (I won't disingenuously attempt to claim that the woman in my painting is his wife, an Ethiopian Jew.) I'm also painfully aware that the calamities facing black communities in New York cannot be kissed away. But once a year, perhaps, it's permissible, even if just for a moment, to close one's eyes, see beyond the tragic complexities of modern life, and imagine that it might really be true that 'all you need is love.'"

"Tina held the Valentine kiss drawing in her drawer," remembered Spiegelman. "It was on again, off again. The genteel *New Yorker* tradition argued against having anything to do with it." But after they ran with it, "everybody was frightened about what Tina would do next."

As Spiegelman later explained, he had considered his cover ironic and in the Valentine's Day spirit because instead of showing two groups that were at each other's throats, he showed them "at each other's lips." But when Crown Heights's black activist minister the Reverend Herbert Daughtry denounced the cover as yet another white man oppressing a black woman and asked the cartoonist why he didn't have a black man and a Hasidic woman, Spiegelman said, "Maybe he's a good Reverend, but he's a rotten art director. A Hasidic man is a lot easier to recognize than a woman with a handkerchief on her head." The imagery aside, he was probably right when he added, "In terms of signs, if I had used a black man and a Hasidic woman he'd have complained that I was once again showing a black man defiling a white woman." All of which led him to conclude that "the problem has nothing to do with the signs being shown, but the reverberations in people's heads," or, as the visual culture people might put it, "the relationship between the image and the viewer of the image" rather than a translation of the image into a static, unchanging verbal message.

**Art Spiegelman,
"41 Shots 10 Cents,"
The New Yorker (1999)**

What is also interesting about the "Valentine's Day Kiss," as Spiegelman pointed out, is that "it is not out of *Der Stürmer*. To be a cartoonist you have to be ready to deal in stereotypes. Inside every well-meaning West Side liberal there is a stereotype buried deep in the brain. You have to not follow the recipe, you have to be cagey." He once did an O. J. Simpson caricature, but "I didn't show him with thick, rubbery Al Jolson minstrel lips, but rather with white lips."

And then there was the Spiegelman cartoon set in a shooting gallery, which mocked the New York policemen who had fired forty-one bullets into Amadou Diallo, an unarmed (and as it turned out, innocent) Guinean immigrant. The mayor denounced it. The governor denounced it. Two hundred fifty police officers picketed *The New Yorker*. A *New York Post* editorial advised the cartoonist: "If you're burglarized or your family is menaced by thugs, you should be consis-

tent. Call Al Sharpton instead of 911. See where that gets you, Spiegelman, you creep."

If the upset over his Valentine's Day kiss was the result of a misunderstanding, the objectors to his shooting gallery understood his captionless cartoon only too well. The image of a shooting gallery set off far more noise than a *New Yorker* written piece might have.

Doug Marlette

Doug Marlette (1949–2007) arrived at *The Charlotte Observer* in 1973, and within a month, a petition had arrived from readers demanding that he be fired because of an antiwar cartoon that Marlette, who had applied for and received conscientious-objector status, had created.

Over the years he also received more than his share of hate mail. North Carolina senator Jesse Helms, a frequent target, who started out by asking for the originals, which he would frame and hang on his walls, stopped asking and instead would complain to the publisher. ("Democrats," wrote Marlette, "complain to the cartoonist. Republicans, I have noticed, go straight to the publisher.")

A particularly bitter example: In 1984, Helms came from behind to retain his Senate seat, defeating Governor James B. Hunt Jr. by linking his opponent to high taxes, blacks, homosexuals, unions, and liberals. It was a hard-fought and dirty campaign which a Harvard case study called "the country's most expensive Senate race ever and arguably the meanest." Afterwards, Marlette published a cartoon that depicted Helms with his trousers dropped, smiling at the reader, sitting on his windowsill and mooning the Capitol. The caption, surrounded by musical notes: "Carolina Moon Keeps Smiling. . . ."

Helms's response was to instruct his office to stop returning phone calls from the *Observer*'s Washington correspondent. Helms said he would never talk to anyone on the paper again until he received "an official apology from the publisher." Marlette later wrote, "I don't know if he ever got one, but of course, the Senator resumed speaking to our reporters as soon as he had something he wanted to appear in the paper."

Like many cartoonists, Marlette took pride in being an equal-opportunity offender. Of particular interest, when Jewish groups complained to his editors that his cartoon of Israel's Menachem Begin was anti-Semitic, comparing it to the ugly anti-Semitic Nazi cartoons

Doug Marlette, "What Would Mohammed Drive?" (2009)

of the 1930s because he drew Begin with a big nose, Marlette was quick to respond: "I drew Begin's nose big because it was, in fact, big," he said, and suggested that "these critics focused on Begin's nose because it was easier to defend his nose than his policies."

Speaking of noses, it was Marlette, as I noted earlier, who observed of Richard M. Nixon that "his nose told you he was going to invade Cambodia." But it was probably his *Newsday* cartoon called "What Would Mohammed Drive?" that prompted the greatest firestorm of outrage—more than twenty thousand complaints, fueled in part by CAIR, an acronym for the Council on American-Islamic Relations, a lobbying group. It's worth considering that Marlette responded to the complaints in some detail, if only because he was such an articulate free-speech defender of the cartoonist's trade.

The cartoon, as you can see, showed a man in Middle Eastern dress driving a Ryder truck carrying a nuke. It was a takeoff on a recent controversy among Christian evangelicals over the morality of driving gas-guzzling SUVs. ("What would Jesus drive?") Marlette's response to critics:

> The truth, like it or not, is that Muslim fundamentalists have committed devastating acts of terrorism against our country in the name of their prophet. CAIR reprinted my cartoon in their newsletter and encouraged its subscribers to e-mail and call me, my newspaper and syndicate to complain. During the past few days we have received 5,500 e-mails and counting all saying more or less the same thing about me and my drawing: Blasphemy. Ignorant. Bigoted. Disrespectful to our Prophet Mohammed. Hateful. "DONKEY"? They all demanded an apology. Quite a few threatening mutilation and death. My only regret is that the thousands who e-mailed me complaining felt that my drawing was an assault upon their religion and its founder. It was not. It was an assault on the distortion of their religion by murderous fanatics and zealots. In fact, I have received death threats and hate mail throughout the years for standing up for the rights of minorities in my drawings, including Muslims and Arab-Americans. Just as Christianity and Judaism and probably Zoroastrianism are dis-

torted by murderous fanatics and zealots, so too is the religion of Islam.

Citing his record of having "outraged fundamentalist Christians by skewering TV preacher Jerry Falwell, Roman Catholics by needling the Pope, and Jews by criticizing Israel," Marlette continued:

> What I have learned from this experience is that those who rise up against the expression of ideas are strikingly similar. No one is less tolerant than those demanding tolerance. A certain humorlessness binds them. Despite differences of culture and creed, they all seem to share the egocentric notion that there is only one way of looking at things, their way and others have no right to see things differently. . . . Here is my answer to them: In this country, we do not apologize for our opinions. Free speech is the linchpin of our republic. All other freedoms flow from it.

So far so good. "This is why we have the First Amendment." Hallelujah! "We don't need constitutional protection to run boring, inoffensive cartoons. We don't need constitutional protection to tell our readers exactly what they want to hear. We need constitutional protection for our right to express unpopular views." Amen. "The point of opinion pages is to focus attention, stimulate, debate, provoke argument." Yes, but since cartoons don't deal in verbal logic, but in visual logic, visual emotion, aren't they somehow always unfair?

Marlette persuasively argues, with words, not his cartoons, that it's a bad idea to censor ideas. But the question raised by the many examples of cartoons that have incited attempts to suppress them or otherwise penalize their perpetrators is whether a cartoon or a caricature that contains an idea is the idea itself. And the answer is yes: the cartoon embodies the idea, is in some way inseparable from it.

But this raises a trickier question. If cartoons are to be viewed as different from speech, and are really closer to art, then we must ask: Are they art in the sense that painting, sculpture, and music are art—are they art in the sense of "artful," skillful or clever—or, rather, are they art in the same way that propaganda art is art, the sort of art Hitler had in mind when he wrote in chapter 6 of *Mein Kampf* on the importance

of propaganda? He called it "a weapon of the first order" in focusing people's attention on certain facts and opinions. And of course the Nazis used posters, cartoons, and caricatures to get their point across. Needless to say, the civil libertarian Marlette was as far away from Nazi ideology as one can possibly be. And it's not his fault that the Nazis used his genre of art to get their points across. But if indeed effective propaganda deals in simple messages that appeal to the emotions rather than the intellect, aren't cartoons in the same genre as propaganda? Although this question is raised by Marlette's otherwise persuasive essay, it applies not just to his work but to that of most of the cartoons and cartoonists in this book.

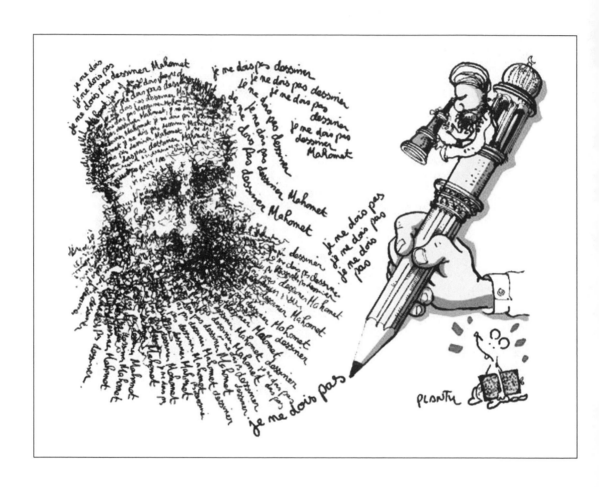

Plantu and the Danish Muhammads

I n the introduction I say I have had some second thoughts on whether or not *The New York Times* and others (including yours truly) should have reproduced the Danish newspaper *Jyllands-Posten*'s depictions of Muhammad, which caused a worldwide furor when they were first published in 2005.

Opposite:
Plantu, "I Must Not Draw Muhammad" (2006)

Before I tell you about them, let me share with you what happened eighty years earlier when David Low published his August 17, 1925, cartoon about cricketer Jack Hobbs on the occasion of his record-breaking season.

The cartoon showed Hobbs, at the time the UK's numero-uno celeb, being installed in the "Gallery of the Most Important Celebrities." The larger-than-life Hobbs was surrounded by smaller figures looking up at him in admiration. They included Adam, Julius Caesar, Muhammad, Christopher Columbus, and Lloyd George. The caption stated that compared to others, Hobbs was "IT," the center of attention and only topic of conversation.

His cartoon drew nothing but praise from the cricketing world, but as Dr. Nicholas Hiley, head of the British Cartoon Archive based at the University of Kent has documented, Low was surprised when an "indignantly worded protest" arrived from the Ahmadiyya Mission in London, which took offense at the inclusion of Muhammad as one of the admiring statues. By the fall, outrage over the cartoon had spread as far as the mission's branch in Calcutta, India. On November 3, 1925, the correspondent of *The London Morning Post* reported that "an Urdu poster has been widely circulated throughout the city, calling on Moslems to give unmistakable proof of their love of Islam by asking the Government of India to compel the British Government to submit the ill-mannered editor of the newspaper to such an ear-twisting that it may be an object-lesson to other newspapers." The correspondent further reported: "There is no doubt whatever that quite unwittingly the cartoon has committed a serious offense which, had it taken place in

this country, would almost certainly have led to bloodshed. What was obviously intended as a harmless joke has convulsed many Moslems to speechless rage for while there is some laxity among them as regards the religious law against the making of pictures, no one has ever dared attempt to depict Mohamed. When a picture of the Prophet appears in a cartoon, no explanation will suffice; it is an insult."

Perhaps the decades-old umbrageous Muslim response to David Low's depiction of Muhammad still resides somewhere in the British subconscious. This would help explain why Brits, like the militant cartoonist Ralph Steadman, inveterate protester against attempts to suppress visual images as intrusions on free speech, immediately saw the publication of the Danish Muhammads as a blatant provocation. For many other non-Muslims around the world, however, the issue of whether or not to reproduce the Danish Muhammads posed a profound dilemma.

In a case study of the dilemma facing *Le Monde* that Kirsten Lundberg prepared for Columbia University's Graduate School of Journalism, she identifies the issue that most preoccupied journalists at any number of papers in the aftermath of the episode: "With the appearance of the cartoons across Europe, it was time to bite the bullet. Should *Le Monde* reproduce the cartoons—which could be seen as support of free speech and media colleagues? Or should it not—out of respect for the large Muslim population in its readership area, and to avoid fanning the sectarian embers still smoldering in Paris?"

Or, to put it another way, let's stipulate that of course the Danes had the right to draw what they drew. But violence aside, the moral issue—as distinguished from the civil liberties one—has to do with what sort of deference, if any, we in the West owe a people who have been discriminated against, disrespected, insulted, marginalized, and misunderstood, but who would have their injunctions (no images, graven or otherwise) applied to and enforced against nonbelievers. And questions of deference aside, how does one weigh the presumption against gratuitously insulting groups who define themselves by race, religion, or whatever, against presumptions on behalf of letting visual language speak for itself?

The question came up again when the Yale University Press declined

to publish the cartoons in connection with Jytte Klausen's study, *The Cartoons That Shook the World*, mentioned earlier. But here the issue had to do with fear of violent retaliation and intimidation. Prior to publication, against the author's wishes, Yale University Press's officials removed all images of Muhammad from the book, including the controversial cartoons and other images of Muhammad from Muslim and non-Muslim sources.

Each time the Danish cartoons were reproduced they set off a chain reaction of protests and counterprotests. Most U.S. and British dailies and weeklies, as well as the Associated Press, didn't republish them. As you know, *The New York Times* didn't reproduce them, and they explained why it didn't matter. *The Washington Post* didn't reproduce them but ran an article by Flemming Rose, the culture editor of *Jyllands-Posten*, entitled "Why I Published Those Cartoons." *Le Monde*, which eventually published some of them, at first punted, asking its leading cartoonist, Jean Plantureux (known as Plantu), to do an illustration about the controversy.

I believe one of the most significant comments on the affair was made by Plantu, in what he called "a graphic sentence." A peace activist but a militant cartoonist, Plantu took *Le Monde*'s assignment and subsequently explained his philosophy on the cartoonist's role to Columbia's Kirsten Lundberg: "We have to think about the graphic responsibility of our cartoons. We have a responsibility. We have to use that responsibility. We have to goad, we have to disturb, we have to exacerbate. We have to be violent." Plantu's cartoon (his "graphic sentence") appeared on *Le Monde*'s front page, and as Lundberg describes it, it "showed a mammoth hand gripping a huge pencil, writing over and over the words . . . 'I must not draw Muhammad.' " As you can see, the words spiraled into a portrait of a turbaned man with a flowing beard. At the top of the pencil, shaped like a minaret, a small turbaned figure trains his telescope on the trail of words.

Collectively, Lundberg, Plantu, and Klausen help us understand what happened, each from a different perspective. But since most of the protesters never saw the cartoons, one must ask whether it's the *idea* of Muhammad's image being represented that upsets people? Would prohibited (blasphemous) words have been as incendiary as the

idea of a prohibited image? I asked Professor Klausen, partly because her book makes it clear that Danish editorials and newspaper stories were on their face more inflammatory than the cartoons. "A number of people observed during the conflict that the caricatures only expressed things and views that were daily published in the newspaper," she replied. She also said that depiction inflames the mind in ways words do not. The question is why.

> An easy answer is that the editors set out to break a taboo, the power of which they did not comprehend. For sure the taboo-breaking aspect played a role but it did not explain all. The taboo has been broken many times before, is not really a fixed taboo, etc. The prevalence of a new Islamic Puritanism cum nationalism promoted by a growing international Muslim middle class with international viewing habits and no reliable education in the history of their own faith also played a part.
>
> In my book I suggested that Muslims around the world were primed to be angry about the Danes; the Clash of Civilizations perception, the belief that Christians are imperialists and [Samuel] Huntington's book [*The Clash of Civilizations and the Remaking of the World Order*] was a prescription for the West to suppress Muslims. . . .
>
> Cartoon/caricatures are wordless and the reader/viewer brings the interpretive frame to the picture. But much like the way Clifford Geertz describes how a wink can be understood as an insult, a friendly gesture, or simply a twitch, cartoon/caricatures are understood only by the meaning the viewer/reader brings to the picture. And people saw very different things when confronted with the Danish pictorial representation of various meanings of "Muhammad."

Since most of those who took to the streets in protest had never seen the cartoons, what took place was not a clash of civilizations, as it was portrayed at the time, but a politically orchestrated campaign, a campaign supplemented by the idea of a taboo image (unseen) and the fabrication of objectionable images (seen); and the real objection was not that Muhammad was depicted so much as that the depictions

were seen as racist stereotypes. Nevertheless, I believe that a campaign against them would probably not have been possible had the offense been a verbal rather than a visual one.

My second thoughts: When I encounter suppression, whether by Jytte Klausen's publisher or any of the papers that declined to reproduce the Danish Muhammads, a part of me yearns to condemn these cowards for not damning the torpedoes and proceeding full speed ahead. But after some reflection the better part of me reminds myself that especially since one never knows what one would do in a similar situation, it is not up to me to put other people's lives (or for that matter, real estate) at risk.

Two other factors contributed to the decision I made (in consultation with my editor and publisher) not to reproduce the Danish Muhammad cartoons in this book. I have looked at the cartoons and they lack distinction. There are no hidden Daumiers or Herblocks here. If you don't believe me, see for yourself.

Assignment: Answer the multiple-choice question that follows:
Why haven't I republished the Danish Muhammads?

a Fear of retaliation by Muslim extremists.
b Fear of booksellers wanting to avoid controversy.
c Respect for Muslim sensibilities and desire to avoid needless provocation.
d The cartoons are available for all to see on the Internet, only a Google away.
e Plantu's cartoon is better.
f All of the above.

Correct answer: f.

БЛАГОДАРЯ ВИ ЗА ВЪНШНАТА ПОЛИТИКА И ЗА ТИХАТА ДИПЛОМАЦИЯ.

Qaddafi and the Bulgarians

Opposite: Qaddafi caricatures, *Novinar* (2006). The bottom cartoon reads "Thank you for your quiet diplomacy."

Let's stipulate that Muammar Qaddafi was mad; that the Libyan system of justice is/was by and large a farce when the trial and retrial of the Bulgarian nurses accused of intentionally infecting 426 Libyan children with HIV occurred; and that the cartoons published by the Bulgarian daily *Novinar* lacked the inventive genius of many of the other artists represented here.

Nevertheless, the Libyan response to the cartoons is worth noting, because here is yet another case where cartoons ignited an international diplomatic conflagration, whereas a straightforward recitation of what did or didn't happen would, based on the evidence, have done no such thing.

What happened: In 1998 five Bulgarian nurses and a Palestinian medical intern were charged with "conspiring to deliberately infect" 426 children with HIV, causing an epidemic at El-Fatih Children's Hospital in Benghazi. They were arrested, tortured, and forced to confess. After eight years in prison and a series of trials that culminated in a seven-minute hearing before Libya's highest court, they were sentenced to death by firing squad.

The defendants' lawyers claimed that most of the children had been infected before the Bulgarians had arrived, and that the nurses' alleged confessions had been obtained only after the Libyan investigators had tortured them with electric shocks and threatened to target their families.

On May 3, 2006, on the eve of their second trial, this one in Tripoli, *Novinar,* impatient with Bulgaria's "quiet diplomacy" on behalf of the nurses, and angry at Libya's stalling of the retrial of the nurses, published twelve cartoons mocking Qaddafi. Among them was a cartoon showing Qaddafi holding a devil's trident, standing over a boiling cauldron of soup, nurses' caps floating in it; another depicted him calculating his next move over a chess board with nurse-shaped chess

**Qaddafi caricature,
Novinar (2006)**

figures (actually modeled after the five jailed nurses) and barrels of oil thrown in for good measure.

The Libyan foreign minister summoned Bulgaria's ambassador, Zdravko Velev, and informed him that in the opinion of the Libyan government, the caricatures slandered the dignity of Muammar Qaddafi, discredited the country's justice system, and offended the Libyan people. He added that the cartoons could hurt Bulgaria's interests, and expressed the hope that "the issue won't escalate to other Bulgarian media." Velev responded that Bulgaria's state institutions had already distanced themselves from the cartoons; but a few days later, a *New York Times* headline read: "Bulgaria Tries to Contain New Cartoon Uproar" and Matthew Brunwasser's story, datelined Sofia, went on to report that "Bulgarian officials have expressed 'deep concern and worry' " over the " 'offensive' " cartoons.

The foreign ministry in Sofia quickly issued a statement expressing concern about "the offensive cartoons": "The Ministry of Foreign Affairs firmly distances itself from such press items, which can only harm bilateral relations between Bulgaria and Libya at a sensitive moment when efforts are directed at bringing the case of the Bulgarian medical workers to a prompt and favorable end." The Arab ambassador in Sofia met with Deputy Foreign Minister Fair Chaushev and together they expressed their gratitude for the "categorical position" of the Bulgarian authorities in response to the "anti-Libyan and anti-Islamic" caricatures.

A Bulgarian foreign ministry spokesman said he hoped the cartoons would not be reprinted, but *Novinar* had already sent the drawings

to the hundred newspapers worldwide that had reprinted the Danish Muhammad cartoons. *Novinar*'s publisher, Miroslav Borshosh, was unapologetic, as the cartoons were printed in France, Turkey, and elsewhere.

The *Times* report quoted Isabelle Werenfels, a researcher on North Africa affiliated with the Institute for International and Security Affairs in Berlin. "The cartoons are pretty devastating" for the trial, she said, because for seven years Libyans had been told that the nurses were guilty, and "at this point it's very important for Qaddafi to save face."

In my view, the Libyan embassy, representing a regime that framed and tortured the nurses before sentencing them to death, was at least right about the impact of cartoons. Speaking in visual rather than verbal language, the cartoons and caricatures constituted a public visual event, humiliating in ways that a verbal event would not have been.

In the end, the captives were extradited to Bulgaria, where they were freed by president Georgi Parvanov. I have already shared my reservations about neuroaesthetics, but if there is such a thing as a superstimulus, the image of devil Qaddafi stirring innocent nurses in a boiling cauldron should qualify.

Jonathan Shapiro (Zapiro)

Zapiro, born Jonathan Shapiro in Cape Town in 1958, is perhaps South Africa's most controversial cartoonist. Typically, Zapiro, whose work over the years has appeared in the South African newspapers *South* (1987), *Soweto* (1994–2005), *Sunday Times* (since 1998), *Cape Times, The Star, The Mercury,* and *Pretoria News* (three times a week since 2005), made international news in 2003 when three of his cartoons (one showed President George W. Bush with a raised middle finger in a comment on American unilateralism) appearing at an exhibition for visiting American congressmen were denounced by the exhibition's sponsors, members of the Faith and Politics Institute.

Opposite:
Zapiro, "Lady Justice" (2008)

But it was this September 7, 2008 Zapiro cartoon, which appeared in the *Sunday Times,* that caused South African president Jacob Zuma, at the time contending with fallout from charges against him of rape and corruption, to sue Zapiro and the *Times* media group for defamation by cartoon, alleging damages of five million rand ($600,000).

Over the years, cartoons that have gotten him in trouble include one he did protesting a secrecy bill, which essentially outlawed whistle-blowing and investigative journalism and called for jail sentences up to twenty-five years; it shows ANC head Jacob Zuma with a can of black paint (reading "Secrecy") as he paints out the word "Democracy" on a white wall which is becoming all black. Then there is the cartoon titled "Whites Who Never Benefited from Apartheid," which consists of a big, blank white space. And after news broke that (now-President) Zuma had fathered a child out of wedlock, Zapiro replaced a tower at Zuma's presidential office with a giant penis to mock his stance on AIDS.

Oh, yes. Ever since Zuma stood trial for raping a family friend (his successful defense was that the sex they had was consensual), and mentioned in passing that after having sex with this HIV-positive woman he took a shower as a way of protecting himself from contracting

her disease, Zapiro depicted Zuma in his cartoons with a showerhead attached to his noggin.

At his trial, by the way, Zuma had argued that he was "a successful lover" and not in need of raping to get sexual satisfaction. Invoking the Zulu culture, he had stated that it was culturally inappropriate to leave the woman "in a state of desire."

Happily for Zuma, the court bought his argument. Nevertheless, Stephen Grootes, a radio reporter in South Africa, writing in the *Daily Maverick,* noted that at the time it seemed the ANC was really ganging up on the judiciary. "The wagons were being circled." He went on to write:

> It was a pretty normal Sunday when I first saw the cartoon. It literally took my breath away. It was so good, so funny, hit the nail on the head, and yes, it was offensive. In a way, that was probably the point. At the time, it seemed as if something offensive was imminent and Zapiro had found a way to capture that. But I couldn't resist calling the ANC and asking what they felt. Jessie Duarte was their spokeswoman at the time. I remember the conversation clearly—she was a little angry about it, and hell, yes, she'd say something about it, on tape. As always she gave a good sound-bite, and I filed for the next morning's Eyewitness News bulletins. It seemed a minor story.
>
> The next morning it ran on the 6 a.m. bulletin and suddenly the world went into overdrive. Callers, outrage, laughter, frustration, the usual stuff of talk radio, just at a much higher level, [and became the talk of] ANC branch meetings. Those meetings are not occupied by people who worry too much about the legal definition of offense. They are more likely to be angered afresh by the cartoon.

As you can see, the cartoon published in the South African *Sunday Times* depicts ANC President Jacob Zuma (with the ever-present showerhead) unbuckling his pants and being urged to "Go for it, boss!" by ANC Secretary General Gwede Mantashe, who—along with three other Zuma allies—is shown pinning Lady Justice (in the cartoon identified as "Justice System") to the ground.

South Africa's Human Rights Commission exonerated Zapiro from criminal liability because it found that his cartoon was not intended to incite others to commit illegal acts, but rather "it was a metaphor about what Zuma was doing to the judiciary" (even as Levine's Kissinger was a metaphor for what he was doing to the world). Zapiro nevertheless still faced a $600,000 libel suit and was on the receiving end of multiple death threats.

It was the content of Zapiro's cartoon—its charge that Zuma and his cronies had corrupted the justice system—that gave rise to the libel suit. And it was the image—the rape of Lady Justice—that made the cartoon a high-visibility subject of national debate, fueling Zuma's and his allies' outrage. Zapiro once told an interviewer from *Playboy* that "cartoons are eighty percent ideas, and twenty percent drawing." But what he didn't say, because it went without saying, was that the idea itself is a visual metaphor.

South African political observers have pointed out that Zuma, who had already been exonerated of the rape charge, had nothing political to gain from going forward with his libel suit. Hypothesis: the suit is best explained by Zuma's psychology. More than that, as two South African social scientists, Thomas A. Koelble of the University of Cape Town and Steven L. Robins of the University of Stellenbosch, wrote at the time, the rape trial "provided the stage for an enactment of an extraordinary national drama about sex, gender, and HIV/AIDS, and a lens onto the authoritarian culture of patriarchy, misogyny, and sexual violence in the new South Africa."

The circumstances surrounding the case of the rape of Lady Justice are clearly too idiosyncratic to draw any universal conclusions (although I would argue that that is probably true of most cartoons that cause controversy) but Zapiro himself has a theory: that the cartoonist is the equivalent of the old court jester and as such he is licensed to rudely confront those in power. In that way he serves as "a kind of pressure valve," but he also sparks debate that can lead to outrage and other uncontrollable and unpredictable consequences.

So far I have not mentioned race. But the fact that Zapiro, a white cartoonist, had depicted the black Zuma (a Zulu who, by the way, had four wives, multiple girlfriends, and twenty children), as a sexual pred-

ator, both complicated and intensified black South African responses to the episode.

A subsequent furor over another depiction of Zuma by another white artist helps put the matter in context. On May 10, 2012, the Goodman Gallery in Johannesburg mounted a show called "Hail to the Thief II." It included a painting by white artist Brett Murray called *The Spear*, featuring President Zuma posing as Lenin but with his penis exposed.

Secretary General Gwede Mantashe of the African National Congress announced that "We have not outgrown racism in our eighteen years of democracy." A week after the show opened the ANC announced its intention to sue the artist for defamation and to force the gallery to remove the painting from the exhibition and its Web site. One church leader demanded that Murray be "stoned to death." On May 22 two men walked into the Goodman Gallery and were caught on camera with pots of paint as they defaced *The Spear*.

After threats of boycotts and violence, Mark Gevisser wrote in *City Press* that "Mantashe and his henchmen won on the street what they were manifestly unable to achieve in the courts. . . . In the process, however, the ruling party revealed its own nakedness." The political editor of the *Sunday Times*, S'Thembiso Msomi, wrote a column filling in some of the background history: how black people had been stripped naked by white overlords, and how workers of his father's generation were compelled to expose their genitals in public "for city officials to decide if they were healthy enough to work."

No wonder *The Spear* was a profound affront to many black South Africans' sense of dignity, once again raising the difficult question of how to reconcile the tension between the sometimes conflicting values of free expression and human dignity (especially given the history of apartheid, when the target was black and the cartoonist was white).

Wherever one comes down on that perplexing issue, for what it's worth, I share the sentiment of Gevisser, a (white) writer born in South Africa, who had served as a *Nation* intern: "Wouldn't it be great," he wrote, "if Jacob Zuma and his mandarins wore the vestments of their very real power with confidence and responsibility, rather than claiming that they have been stripped naked by a white man's paintbrush

and then seeking to clothe themselves in the revolutionary garb of the street?"

In solidarity, Zapiro turned over a page of his blog to Murray, who explained that his painting was "both a work of protest or resistance art and it is a satirical piece," a description which might well apply to many of the cartoons and caricatures in these pages.*

* On Friday, October 26, Zuma and his legal team withdrew all charges against Zapiro and the *Sunday Times*.

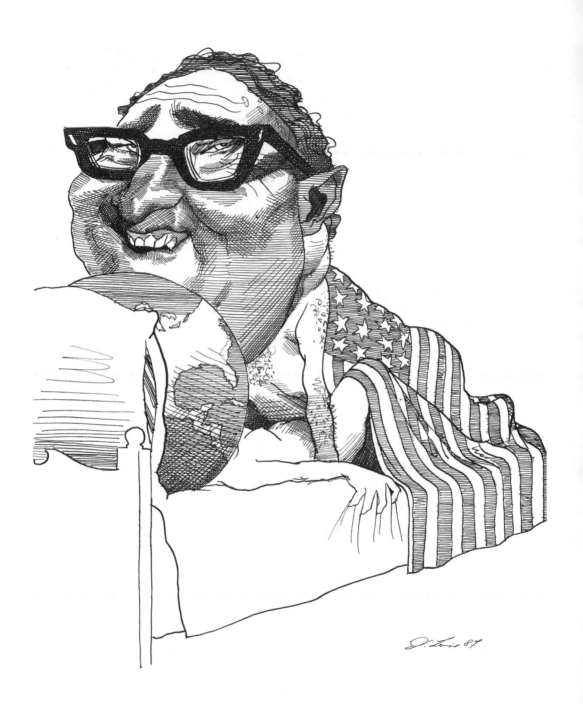

David Levine

I began by describing David Levine's caricature-commentary on Henry Kissinger, which prompted *The Nation*'s staff to revolt, thereby raising many of the questions explored in these pages, so it's appropriate that I end with him. The angry response of the staff, whose letter accurately captures the content and tone of their objections, appears below, along with some other correspondence. I have already dealt with the substance of the staff's complaints. But here I want to think out loud about some of the nonpolitical issues involved in the decision to publish.

Opposite:
David Levine,
"Screwing the World"
(1984)

First, there is a question that rightly belongs in the realm of aesthetics. Can a cartoon without words make a statement—and does that statement have the same ontological status as a proposition stated in words alone?

Second, when an artist of David Levine's talent and seriousness (never mind his stature) submits a cartoon or a caricature for publication, is it appropriate for the publication to "edit" (or suggest revisions in the work of art, the image) in the same way it would deal with a proposed signed article? Would the answer be different if the periodical had commissioned the caricature in the first place? (By way of reminder, *The New York Review of Books* originally commissioned the Levine caricature.)

Third, suppose that the "message" of the cartoon (if cartoons can contain messages, which I believe they can) was different from the message of the essay it was meant to accompany. Does that give the publication the right to turn it down? (I am not talking legal rights here, but rather best editorial practices.) Another way of asking this question would be to ask: When a periodical commissions an artist to render an image to accompany an essay, is the image meant to illustrate the writer's point of view or to be the artist's own statement?

Fourth, the thrust of what has gone before is that there are times when images are more powerful than words. Let's assume that this is

one of those times—that Levine's image, whether or not it is sexist and politically incorrect—makes a more powerful statement against Kissinger and his policies than the more meditative essay it was meant to accompany. Should that make a difference?

Fifth, is it possible to deconstruct a cartoon like Levine's, saying that one agrees with the political message—that, in Levine's words, Kissinger (and our imperial policies) are "screwing" the world—yet simultaneously condemning the image as sexist or whatever, and if so, which set of values should prevail?

Sixth, nobody is claiming that in the absence of artistic or, for that matter, literary merit, artists ought to be immune from traditional editorial concerns and judgments. That being the case, if an artist's regular outlet turns down his submission because it is politically "too strong," does that deserve to be called censorship, or is it simply the exercise of the editorial prerogative?

Seventh, take a look at Gillray's "Fashionable Contrasts" (page 63) and note that judging from the position of the legs, the man appears to be on top. Would the same objections ("sexist!") apply to Gillray's painting as were leveled at Levine's Kissinger?

My purpose in raising these issues, and sharing some of the letters *The Nation* printed about Levine's Kissinger and my decision to run it, has to do more with the questions than with my answers (which I think I've made clear already), because I think that they apply to many of the cartoons and caricatures that appear in these pages.

The letter from the staff, signed by seventeen women and nine men:

> As workers at *The Nation,* we protest the publication of David Levine's cartoon in the February 25 issue. The problem is not that the drawing is sexually frank; it is that a progressive magazine has no business using rape jokes and sexist imagery (he screws, she is screwed) to make the point that Kissinger revels in international dominance. Kissinger is a man, but the globe is not a woman. The artist's intention may have been to dramatize the confusion between sex and power in the mind of a powerful white, middle-aged man. But the publication of his drawing

shows that *The Nation* itself is imbued with that mentality. No wonder seven out of ten of our subscribers are men.

Christopher Hitchens wrote:

How depressing that so many *Nation* colleagues should confuse the use of a stereotype, even as an artistic satire, with the reinforcement of a stereotype. The only safeguard against such a literal mentality would be the adoption of the Islamic code which, in order to be on the safe side, forbids all depictions of the human body as profane. The last sentence of their letter is just silly.

Debra C. Rosenthal wrote:

Although I suspect that you would prefer not to receive a humorless feminist letter, I feel compelled to comment on David Levine's drawing. Here we have the image of Henry Kissinger in bed, his backside covered by the American flag, hovering happily atop a female body with the globe for her head.

The Western hemisphere faces us; "she" clutches the sheet beneath her. In short, we see Kissinger fucking the world. What's wrong with this picture? Only its misogyny: the direct and "natural" equation of women with the earth and the assumption that the portrayal of sexual intercourse will be automatically interpreted as an image of exploitation and oppression. Levine's illustration makes its point only because it exploits the vision of a dominated female sexuality.

Many contemporary caricaturists are pleased to sell their originals to their subjects. But David was different. When a New York state senator wanted to buy a copy of David's caricature of him, David took it as an insult. What I like about this story is what it says about values—both the moral values of the artist and the commercial value of his art.

A not entirely unrelated phenomenon has been remarked upon by the critic John Berger. In his *Ways of Seeing*, he notes, "The National Gallery sells more reproductions of Leonardo's cartoon of *The Virgin*

and Child with St. Anne and St. John the Baptist than any other picture in their collection. A few years ago it was known only to scholars. It became famous because an American wanted to buy it for two and a half million pounds.

"Now it hangs in a room by itself . . . It has become impressive, mysterious, because of its market value."

Coda: On August 24, 1967, the headline on the front page of *The New York Review of Books* read "Violence and the Negro." In large type, the cover announced Andrew Kopkind's piece on Martin Luther King and Black Power and Tom Hayden's report on recent riots in Newark, New Jersey, which he called "The Occupation of Newark."

Underneath was a large do-it-yourself diagram of how to make a Molotov cocktail. (It was based on a sketch Hayden had made on the back of a napkin when Kopkind had asked, at a diner in Newark, if he knew how to make one.) The diagram incited its own firestorm of outrage and later became the centerpiece of a conservative campaign against the *Review*. Many also believed it marked a turning point in the *Review*'s previously radical politics—Kopkind, a regular contributor who had written ten *Review* essays, became an irregular. My own suspicion is that if there had been no diagram and Kopkind's essay (including his observation that "morality, like politics, starts with the barrel of a gun") had simply described the recipe for a Molotov cocktail, the moment might have passed except in the irresistible letters columns of the *Review*.

I mention it now because what went relatively unremarked at the time was that Kopkind brought the napkin back to New York and showed it to his editors, and they decided that it would make a splendid cover image—but when they asked their "staff artist," one David Levine, to draw it, he refused.

Think about that. And think about David Levine.

Timeline

This chronology pretends to be neither definitive nor exhaustive but provides a context for all that has come before.

1831, France
Charles Philipon depicts King Louis Philippe as a pear in his caricature "La Poire," which also stands for "buffoon." He is charged with defamation and acquitted after showing in a series of drawings how the king did, in fact, resemble a pear. Drawings of pears are subsequently banned.

1832, France
Honoré Daumier is sentenced to six months in prison for drawing "Gargantua," published in the journal *La Caricature*.

1917, Holland
Under pressure from the German government, Louis Raemaekers, whose cartoons attack German militarism, is charged with "endangering Dutch neutrality." Although he is acquitted, Raemaekers later flees to England with a 12,000-guilder bounty on his head.

1917–1918, United States
Art Young of *The Masses* is tried twice under the Espionage Act for conspiracy to obstruct enlistment. Young, who naps through much of the second trial, is given a pen and paper by his attorney to keep him awake, with which he draws "Art Young on Trial for His Life." All charges are dropped.

1929, Germany
George Grosz and his publisher, Wieland Herzfelde, are tried for blasphemy for Grosz's drawing "Shut Up and Obey," which depicts Christ

on the cross wearing a gas mask and army boots. A guilty verdict is overturned on appellate court by Judge Siegert, a conservative jurist, whom the Nazis later dismiss for having made this decision. In 1933, Grosz and Herzefelde are forced to flee Germany.

1940, United Kingdom
Cartoonist David Low is put on a hit list by Adolf Hitler for his depictions of Der Führer.

1944, Poland
A group of Polish cartoonists is executed on May 27, 1944, for drawing caricatures that mock Nazi fascism.

1964, Greece
The Greek newspaper *I Avgi* publishes Chrysanthos Mentis Bostant-zoglou's cartoon "St. George Triumphant and the Prophet Iliou," depicting the newly elected prime minister George Papandreou as St. George, beset by Ilias Iliou, the parliamentary leader, carrying a screed calling for 500,000 more jobs. When a military junta seizes power in 1967, they seize Iliou as well as his copy of the cartoon.

1970, Turkey
Cartoonist Turhan Selçuk is tortured by the military junta.

1973, Israel
Sheikh Muhammad Ali al-Jabari, the powerful mayor of Hebron, is depicted in an *Al Fajr* cartoon with a house slipper in his mouth. Soon after, the newspaper's publisher, Yusuf (Joe) Nasser disappears, never to be found.

1976, Argentina
Héctor Oesterheld, a comic-book author, and his four daughters and their husbands are kidnapped and never seen again. Oesterheld's work depicted that country's military leaders as extraterrestrials.

1978, Turkey
Islamic fundamentalists attack an exhibition of work by Sema Ünde-
ger, a cartoonist for the socialist newspaper *Politika*, destroy her work,
and threaten her life.

1982, United Kingdom
Robert Edwards is sentenced to prison for a year for drawing cartoons
"likely to incite racial hatred."

1984, Liberia
Harrison Jiedueh, pen name "Black Baby," pursued by death squads,
is forced to flee to the United States after drawing cartoons critical of
Samuel K. Doe, Liberia's ruler.

1985, United States
Following the burning of the MOVE headquarters, the *Philadelphia
Daily News* censors work by its cartoonist, Joe Szabo, saying it would
"incite the city's black population."

1987, India
S. Balasubramaniam, a newspaper editor, is sentenced to three months'
imprisonment for publishing an anonymous caricature of members
of the Legislative Assembly. Two days later, the chief minister of
the Indian state Tamil Nadu, under government pressure, orders his
release.

1987, United Kingdom
The Palestinian caricaturist Naji al-Ali, famous for his child charac-
ter, Hanthala, a symbol of Palestinian defiance, is shot and killed in
London after drawing a caricature poking fun at Yasser Arafat. Police
arrest Ismail Sowan, who claims to work for both the PLO and the
Mossad, which knew about the plot to kill the cartoonist. In response,
Margaret Thatcher expels an Israeli diplomat.

1990, Turkey
Ismail Pehlivan, editor of *Girgir,* is sentenced to sixteen months in prison by a Turkish court for printing a caricature of former prime minister Yildirim Akbulut in front of a mirror, saying: "Mirror, mirror, tell me, is there a better prime minister than me?" The response shows Prime Minister Turgut Özal giving Akbulut the finger.

1992, Sri Lanka
Because he draws a series of cartoons critical of then-president Ranasinghe Primadas, Jiffry Yoonoos is beaten and stabbed, his family terrorized, forcing his wife and children to go into hiding.

1992, Russia
Mikhail Zlatkovsky is forced to flee to the United States after drawing a cover for *Sobesednik,* a Russian weekly, titled "Russian Coat-of-Arms," that shows a plucked peacock in uniform. The cartoonist is threatened, and the magazine investigated by the Russian parliament. Zlatkovsky reaches the United States in 1993, but returns to Russia in 1998.

1992, China
Communist authorities suppress a riot in Xining, Qinghai province, caused by *Swiftly Turning Mind,* a comic book first published in Taiwan, which depicts Muslims praying next to a pig.

1992, Iran
Manouchehr Karimzadeh, a cartoonist for the magazine *Farad,* draws a cartoon on the poor state of Iranian soccer. The authorities rule that the character depicted bears an unacceptable resemblance to the late Ayatollah Khomeini in his youth. Zadeh is sentenced to fifty lashes, one year in prison, and a fine. After he serves the one-year prison sentence, the Supreme Court of Iran rules that he is to be retried and another arbitrary prison sentence is imposed, this time for ten years.

1993, Israel

The Israeli cartoonist Oleg Schwarzburg is charged with drawing an anti-Semitic cartoon likening *kashrut*—Jewish dietary laws—to imprisonment. He is released on bail after being held for two days. The charge is later dropped.

1994, Cambodia

The Ministry of Information issues an advisory to the press prohibiting the use of animals in cartoons to depict members of the government.

1995, Yemen

Cartoonist Saleh Ali is arrested after publishing his anti-censorship cartoon showing a Yemeni "common man" with his hands tied behind his back, his mouth locked, as the arresting officer explains "Democracy is what I say."

1996, Croatia

The Croatian parliament passes legislation on March 29 criminalizing satirical commentary of the president, the prime minister, the speaker of parliament, and the chief magistrates of the supreme and constitutional courts.

1996, Argentina

Political satirist Cristian (Nik) Dzwonik, who regularly made fun of President Carlos Menem's toupee, is abducted, kidnapped, pistol-whipped, and admonished to "stop messing around and behave." He is robbed and left alongside a road outside Buenos Aires.

1996, Algeria

On July 4, *La Tribune* publishes a cartoon by Chawki Amari criticizing Algeria's political elite. The newspaper is shut down and Amari is arrested, detained, and charged with "insulting the national emblem." Hundreds of Algerians peacefully protest the government's treatment of Amari and its attack on free speech.

1996, Nigeria
Owei Lakemfa, the editor of *Today's News Today,* is arrested for publishing cartoons by Adenle Adewale criticizing the regime of General Sanai Abacha. Adewale goes into hiding and is later forced to resign.

1998, Turkey
Dogan Guzel is charged with "insulting the state" for his cartoons criticizing Turkey's treatment of ethnic Kurds. He serves a year in jail in Istanbul's Bayrampasa Prison.

1999, Cameroon
Cartoonist Popoli is dragged from his car, beaten by security officers, and arrested for his cartoon referring to the first lady's past as a prostitute.

2002, Greece
Gerhard Haderer, an Austrian cartoonist, is given a six-month jail term in absentia for portraying Jesus Christ as a pot-smoking hippie crossing the Sea of Galilee on a surfboard. Haderer's book *Das Leben des Jesus (The Life of Jesus)* prompts the Bishop of Salzburg to demand he be jailed under the blasphemy paragraph in the Austrian penal code.

2004, Turkey
Cartoonist Musa Kart and the newspaper *Cumhuriyet* are sued by Turkish prime minister Recep Tayyip Erdogan for depicting him as a kitten entangled in a ball of yarn. In his suit, the prime minister asserted emotional distress. Kart is fined 5,000 Turkish lire (around $2,785).

2005, Belarus
Cartoonist Oleg Minich is charged with defaming President Alexander Lukashenko of Belarus and then forced to choose between serving five years in prison or permanent exile.

2005, Denmark
The Danish newspaper *Jyllands-Posten* publishes a dozen cartoons depicting the prophet Muhammad. Hundreds of thousands of Muslims across the world take to the streets to protest. Worldwide, more than a hundred people are killed, another five hundred injured. Danish goods are boycotted. The cartoonists themselves are forced to go into hiding, with million-dollar price tags put on their heads.

2006, Sweden
Swedish foreign minister Laila Freivalds resigns after lying about her involvement in suppressing a Web site that has posted cartoons of the prophet Muhammad.

2006, Iran
Seeking to quell massive unrest among its minority Azeri population following the publication of a drawing many Azeris find offensive, the Iranian government jails cartoonist Mana Neyestani in Tehran's Evin prison and threatens him with death. In 2012 he publishes a graphic novel, *An Iranian Metamorphosis,* which recounts his imprisonment.

2008, South Africa
Jonathan Shapiro (Zapiro) is sued by President Jacob Zuma for his cartoon "The Rape of Lady Justice."

2009, Mexico
Mario Robles Patiño is beaten and his life is threatened following the publication of his cartoons criticizing the local Institutional Revolutionary Party (PRI) and the PRI governor of the Mexican state of Oaxaca.

2009, Malaysia
Zulkiflee Anwar Ulhaque (aka Zunar) is arrested for sedition by the Malaysian government. The government also seizes the inaugural issue of *Gedung Kartun (Cartoon Store),* which features the work of Zunar and others.

2010, Denmark
A Somali man with links to the terrorist group al-Shabab breaks into the home of Kurt Westergaard, one of the twelve famous Danish cartoonists, armed with a knife and an axe, but is arrested before he is able to harm the cartoonist. (A 2008 conspiracy to murder Westergaard also failed.) Westergaard continues to live under police protection.

2010, United States
American cartoonist Molly Norris is threatened with death by Muslim cleric Anwar al-Awlaki after she creates a poster and Web site announcing an "Everybody Draw Muhammad Day." She is now in a witness protection program.

2010, Sri Lanka
Prageeth Eknaligoda, an investigative reporter and cartoonist, is abducted on his way home from work. He has not been seen or heard of since. At the time of his disappearance, Prageeth was preparing an exhibition of his cartoons with the United States Embassy.

2010, Belgium
A Belgian court refuses to ban the sale of the iconic comic book *Tintin in the Congo* by Hergé after hearing charges first brought in 2007 by a Congolese man, Bienvenu Mbutu Mondondo, who argued it propagates racist stereotypes about Africans.

2011, India
Indian cartoonist Harish Yadav (aka Mussveer) is arrested for a cartoon poking fun at Chief Minister Narendra Modi's refusal to wear a skull cap given to him by a Muslim cleric, under a section of the penal code that prohibits acts "intended to outrage religious feelings of any class by insulting its religion or religious beliefs."

2011, Turkey
Bahadir Baruter is charged with "insulting the religious values adopted by a part of the population" and tried for a caricature he drew in which he renounces God.

2011, France
The offices of *Charlie Hebdo,* the satirical magazine, are bombed as a protest against its issue "guest-edited" by the prophet Muhammad.

2011, Syria
The Syrian cartoonist Ali Ferzat is abducted and has his fingers broken in retaliation for his cartoons attacking Syria's president, Bashar al-Assad.

2012, Morocco
Eighteen-year-old Walid Bahomane, who posted caricatures of King Mohammed VI on Facebook, is sentenced to one year of prison, and the newspaper *El País* is banned for disseminating a caricature of the king, originally drawn for *Le Monde,* by Damien Giez of Burkina-Faso.

2012, Iran
Mahmoud Shokraye, a cartoonist for the Iranian newspaper *Nameye Amir,* is sentenced to twenty-five lashes for depicting an MP, Ahmad Lotfi Ashtiani, as a soccer player. The mild satire, which an Iranian "press court" deemed "insulting," was a reference to Ashtiani's populist proposal to transfer a Tehran soccer team, Naft, to his constituency in the central-western city of Arak.

2012, India
Cartoonist Aseem Trivedi is charged with sedition after drawing cartoons that allegedly mocked the national emblem, replacing its lions with bloodthirsty wolves, with the caption "Long live corruption."

Acknowledgments

First, I want to thank Ben Waltzer, without whom this book would not be a book. He was my indefatigable sidekick in assembling, checking, editing, tracking down, critiquing, and rights-clearing. And I want to thank Mary Schilling, my long-suffering assistant (her title), for sticking with this and me. As always, I am grateful for the support of my wife, Annie, and children, Bruno, Miri, and Jenny, but in this case I give special thanks to Bruno for his careful readings and helpful editorial suggestions, and to Miri and Jenny for joining him in keeping my laptop, my Hillsdale printer, and me in sync. I am indebted to Katrina vanden Heuvel and my colleagues at *The Nation* for their ideas and collegiality, and then there is Richard R. Lingeman, who has been there for me since before the beginning. I owe him. Special gratitude to Steven Heller, who read an early draft of the introduction, but all mistakes (of fact, judgment, or whatever) are my own. I also owe a special debt to Kate Murphy, who as my intern assisted me in getting this project off the ground. Other interns who were particularly helpful include Uzma Kolsy, Lis Bocov-Ellen, Karl Cornejo Villavicencio, Eli Epstein-Deutsch (a demon memo-writer), Connor Guy, Andrea Jones, and Richard Kreitner. At Columbia's Graduate School of Journalism I owe special thanks to Dean Nicholas Lemann and such colleagues as David Hajdu, Marguerite Holloway, Todd Gitlin, and Jonathan Weiner, whose minds I have picked. I have benefited from conversations with Arthur Danto, *The Nation*'s longtime art critic, and going way back, the late Monroe C. Beardsley, who first introduced me to aesthetics when I was his student in his unforgettable honors seminar at Swarthmore College. I have learned from conversations with my friends Marshall Arisman, David Freedberg, W. J. T. Mitchell, Mark Green, Adam Gopnik, Floyd Abrams, Carroll Janis, Richard Sennett, Richard Goldberg, Edward Jay Epstein, and Mort Gerberg; and I want to give particular thanks to Ike Kitman, *Columbia Journalism Review* intern, for introducing me to physiognomy, and to Maria Konnikova

and Vivian Pana-Hazadi, who helped educate me on neuroscience. Of course none of this would have been possible without the cooperation of artists like Edward Sorel, Robert Grossman, Ralph Steadman, Art Spiegelman, Frances Jetter, Steve Brodner, Steve Bell, and Ted Harrison.

I owe a special debt (as do we all) to the Billy Ireland Collection at Ohio State University, and to the British Cartoon Archive at Templeton Library, University of Kent (whose director, Nicholas Hiley, went out of his way to be helpful), for making their collections so easily available. I can't list all of the great cartoonists whose work, although not represented here, belongs in the pantheon that makes a book like this possible, but a few who have had such an indelible impact on me include the late Lou Myers, Jules Feiffer, R. Crumb, and Tom Tomorrow. And finally, I thank my editor Jonathan Segal and his team at Knopf, notably Joey McGarvey, Meghan Houser, Kevin Bourke, and copy editor Patrick Dillon, who have saved me from myself, and designer Peter Andersen, who deserves credit for the look of this book.

Selected Bibliography

Adatto, Kiku. *Picture Perfect: The Art and Artifice of Public Image Making*. New York: Basic Books, 1993.

Arendt, Hannah. *Eichmann in Jerusalem: A Report on the Banality of Evil*. New York: Viking Press, 1963.

Atherton, Herbert M. "George Townshend Revisited: The Politician as Caricaturist." *Oxford Art Journal* 8, no. 1 (1985).

Baldinucci, Filippo. *Vocabulario toscano dell'arte del disegno*. Milano, 1809.

Beck, Stefan. "Art Spiegelman: In the Shadow of No Towers." *New Criterion*, October 1, 2004.

Benson, Timothy S. *The Cartoon Century: Modern Britain through the Eyes of Its Cartoonists*. London: Random House, 2007.

———. *Low and Lord Beaverbrook: The Case of a Cartoonist's Autonomy*. Canterbuy, UK: University of Kent, 1998.

Berger, John. *Ways of Seeing*. London: Penguin, 2008.

Block, Herbert. *Herblock: A Cartoonist's Life*. New York: Macmillan, 1993.

Bozal, Fernández Valeriano. *Picasso, from Caricature to Metamorphosis of Style*. Aldershot, Hampshire, UK: Lund Humphries, 2003.

Brecht, Bertolt. Trans. by Desmond Vesey and Eric Bentley. *The Threepenny Opera*. New York: Grove Press, 1964.

Brooks, Cleanth. *The Well Wrought Urn: Studies in the Structure of Poetry*. New York: Reynal & Hitchcock, 1947.

Brown, Roland E. "The Ayatollah Is No Joke." *Foreign Policy*. June 1, 2012. Accessed June 10, 2012. http://www.foreignpolicy.com/articles/2012/06/01/the_aya tollah_is_no_joke.

Brown, Tina. Editor's Note. *The New Yorker*, February 15, 1993.

Brunwasser, Matthew. "Bulgaria Tries to Contain New Cartoon Uproar." *New York Times*, May 11, 2006.

Bryant, Mark. *World War II in Cartoons*. London: Grub Street, 2005.

Bytwerk, Randall L. *Bending Spines: The Propagandas of Nazi Germany and the German Democratic Republic*. East Lansing, MI: Michigan State University Press, 2004.

———. *Julius Streicher*. New York: Stein and Day, 1983.

Chute, Hillary. "Why Mice?" *The New York Review of Books*, October 20, 2011. Accessed April 30, 2012. http://www.nybooks.com/blogs/nyrblog/2011/oct/20/why-mice/.

Collini, Stefan. *That's Offensive!: Criticism, Identity, Respect*. London: Seagull Books, 2010.

Coupe, W. A. "The German Cartoon and the Revolution of 1848." *Comparative Studies in Society and History* 9, no. 2 (January 1967).

———. "Observations of a Theory of Political Caricature." *Comparative Studies in Society and History* 11, no. 1 (January 1969).

Danto, Arthur C. *After the End of Art: Contemporary Art and the Pale of History.* Princeton, NJ: Princeton University Press, 1997.

———. *Beyond the Brillo Box: The Visual Arts in Post-Historical Perspective.* New York: Farrar Straus Giroux, 1992.

Davies, Russell, Liz Ottaway, and Michael Foot. *Vicky.* London: Secker & Warburg, 1987.

Donald, Diana. *The Age of Caricature: Satirical Prints in the Reign of George III.* New Haven: Paul Mellon Centre for Studies in British Art and Yale University Press, 1996.

Douglas, Roy, Liam Harte, and Jim O'Hara. *Drawing Conclusions: A Cartoon History of Anglo–Irish Relations, 1798–1998.* Belfast: Blackstaff, 1998.

Dror, Itiel E., Sarah V. Stevenage, and Alan R. S. Ashworth. "Helping the Cognitive System Learn: Exaggerating Distinctiveness and Uniqueness." *Applied Cognitive Psychology* 22, no. 4 (2008).

Dworkin, Ronald. "The Right to Ridicule." *New York Review of Books*, March 23, 2006.

Edwards, Robert, ed. *A Sense of Permanence?: Essays on the Art of the Cartoon.* Canterbury, UK: University of Kent, 1997.

"Exchange: On Sorel, Lear and Sexism." *The Nation*, April 30, 1988.

Fauconnier, Gilles, and Mark Turner. *The Way We Think: Conceptual Blending and the Mind's Hidden Complexities.* New York: Basic Books, 2002.

Feaver, William, and Ann Gould. *Masters of Caricature: From Hogarth and Gillray to Scarfe and Levine.* New York: Knopf, 1981.

Freedberg, David. *Iconoclasts and Their Motives / David Freedberg.* Maarssen, The Netherlands: G. Schwartz, 1985.

———. *The Power of Images: Studies in the History and Theory of Response.* Chicago: University of Chicago Press, 1989.

Freeland, Cynthia A. *But Is It Art?: An Introduction to Art Theory.* Oxford: Oxford University Press, 2001.

Fultz, Barbara. *The Naked Emperor: An Anthology of International Political Satire.* New York: Pegasus, 1970.

Gay, John. *The Beggar's Opera.* Lincoln: University of Nebraska Press, 1969.

Gerberg, Mort. *Cartooning: The Art and the Business.* New York: Morrow, 1989.

Gierych, Ewa, Rafa Milner, and Andrzej Michalski. "ERP Responses to Smile-Provoking Pictures." *Journal of Psychophysiology* 19, no. 2 (2005).

Goguen, Joseph, and Erik Myin. *Art and the Brain: Investigations into the Science of Art.* Tucson, AZ: Imprint Academic, 2000.

Goldstein, Robert Justin. *Censorship of Political Caricature in Nineteenth-Century France.* Kent, OH: Kent State University Press, 1989.

————. *Fighting French Caricature Censorship: The Forgotten Story of André Gill (1840–1885)*. Ann Arbor, MI: University of Michigan Library, 1992.

Goldstone, Robert L., Brian J. Rogosky, and Mark Steyvers. "Conceptual Interrelatedness and Caricatures." *Memory and Cognition* 2, no. 31 (2003).

Gombrich, E. H. "The Cartoonist's Armory" in *Meditations on a Hobby Horse*. London: Phaidon Press, 1963.

————. "The Wit of Saul Steinberg." *Art Journal* 43, no. 4 (Winter 1983).

Goodwin, George M. "More Than a Laughing Matter: Cartoons and Jews." *Modern Judaism* 21, no. 2 (May 2001).

Gopnik, Adam. "High and Low: Caricature, Primitivism, and the Cubist Portrait." *Art Journal* 43, no. 4 (Winter 1983).

Habermas, Jürgen. *The Structural Transformation of the Public Sphere: An Inquiry into a Category of Bourgeois Society*. Cambridge, MA: MIT Press, 1989.

Habermas, Jürgen, and Ciaran Cronin. *The Divided West*. Cambridge, MA: Polity, 2006.

Halloran, Fiona Deans. *Thomas Nast: The Father of Modern Political Cartoons*. Chapel Hill, NC: University of North Carolina Press, 2013.

Hanfstaengl, Ernst. *Hitler in Der Karikatur Der Welt: Tat Gegen Tinte: Ein Bildsammelwerk*. Berlin: Verlag Braune Bücher, Carl Rentsch, 1933.

Hecht, Ben. *A Flag Is Born*. [New York]: American League for a Free Palestine, 1946.

Herzog, Rudolph. *Dead Funny: Humor in Hitler's Germany*. Brooklyn, NY: Melville House, 2011.

Historicus. *Lines and Battlelines: Cartoons of World War II*. N.p.

Hitler, Adolf. Trans. by Ralph Manheim. *Mein Kampf*. Boston: Houghton Mifflin Company, 1943.

Hoffmann, Werner. *Goya: Traum, Wahnsinn, Vernunft*. München: Deutscher Taschenbuch Verlag, 1981.

————. *Caricature from Leonardo to Picasso*. New York: Crown, 1957.

Hughes, Robert. *Goya*. New York: Knopf, 2003.

Hustler Magazine and Larry C. Flynt, Petitioners v. Jerry Falwell, 485 US 46 (1988).

Ian Haywood. "The Transformation of Caricature: A Reading of Gillray's *The Liberty of the Subject*." *Eighteenth-Century Studies* 43, no. 2 (2009).

Jetter, Frances. *The Reagan/Bush Years*. New York: F. Jetter, 1992.

Johnson, Haynes, Herbert Block, and Harry L. Katz. *Herblock: The Life and Work of the Great Political Cartoonist*. [Washington, D.C.]: Herb Block Foundation, 2009.

Johnson, Isabel S. "Cartoons." *The Public Opinion Quarterly* 1, no. 3 (July 1937).

Justice, Benjamin. "Thomas Nast and the Public School of the 1870s." *History of Education Quarterly* 45, no. 2 (2005).

Kahneman, Daniel. *Thinking, Fast and Slow*. New York: Farrar Straus Giroux, 2011.

Kandel, Eric R. *The Age of Insight: The Quest to Understand the Unconscious in Art,*

Mind, and Brain: From Vienna 1900 to the Present. New York: Random House, 2012.

Kemnitz, Thomas M. "The Cartoon as a Historical Source." *Journal of Interdisciplinary History* 4, no. 1 (Summer 1973).

Klausen, Jytte. *The Cartoons That Shook the World.* New Haven: Yale University Press, 2009.

Koestler, Arthur. *The Act of Creation.* New York: Macmillan, 1964.

Kotek, Joël. *Cartoons and Extremism: Israel and the Jews in Arab and Western Media.* Edgware, UK: Vallentine Mitchell, 2009.

Kraus, Jerelle. *All the Art That's Fit to Print (and Some That Wasn't): Inside the* New York Times *Op-Ed Page.* New York: Columbia University Press, 2009.

Kris, Ernst, and Gombrich E. H. "The Principles of Caricature." *British Journal Of Medical Psychology* 17, no. 119 (1938).

Lakoff, George. *The Political Mind: Why You Can't Understand 21st-Century Politics with an 18th-Century Brain.* New York: Viking, 2008.

Lamb, Richard. *The Macmillan Years, 1957–1963: The Emerging Truth.* London: John Murray, 1995.

Laqueur, Thomas W. "Roy Porter, 1946–2002: A Critical Appreciation." *Social History* 29, no. 1 (2004).

Lee, Kieran, Graham Byatt, and Gillian Rhodes. "Caricature Effects, Distinctiveness, and Identification: Testing the Face-Space Framework." *Psychological Science* 11, no. 5 (2000).

Levine, David. *The Arts of David Levine.* New York: Knopf, 1978.

Low, David, and Sinclair Hitchings. *David Low.* [Boston]: Sinclair Hitchings, 2009.

Lucie-Smith, Edward. *The Art of Caricature.* Ithaca, NY: Cornell University Press, 1981.

Lundberg, Kirsten. "Caricatured: *Le Monde* and the Mohammed Cartoons." *Columbia Graduate School of Journalism Knight Case Studies Initiative,* 2011.

MacKinnon, Catharine A. *Only Words.* Cambridge, MA: Harvard University Press, 1993.

Marlette, Doug. "Journalism's Wild Man." *American Journalism Review,* January 1992.

McCloud, Scott. *Understanding Comics.* [Northampton, MA]: Kitchen Sink Press, 1993.

McLaren, I. P. L., C. H. Bennett, T. Guttman-Nahir, K. Kim, et al. "Prototype Effects and Peak Shift in Categorization." *Journal of Experimental Psychology: Learning, Memory, and Cognition* 21, no. 3 (1995).

McLees, Ainslie Armstrong. *Baudelaire's "Argot Plastique": Poetic Caricature and Modernism.* Athens: University of Georgia Press, 1989.

McPhee, Constance C., and Nadine Orenstein. *Infinite Jest: Caricature and Satire from Leonardo to Levine.* New York: Metropolitan Museum of Art, 2011.

McWilliam, Neil. *Lines of Attack: Conflicts in Caricature.* Durham, NC: Nasher Museum of Art, Duke University, 2010.

Mill, John Stuart. *On Liberty*. New York: Norton, 1975.

Miller, Arthur. *After the Fall*. New York: Viking Press, 1964.

———. *Death of a Salesman*. New York: Penguin, 1996.

———. *The Crucible*. New York: Penguin, 1996.

———. *A View from the Bridge*. Oxford: Heinemann, 1995.

Mitchell, W. J. T. *Cloning Terror: The War of Images, 9/11 to the Present*. Chicago: University of Chicago Press, 2010.

———. *What Do Pictures Want?: The Lives and Loves of Images*. Chicago: University of Chicago Press, 2005.

Mouly, Françoise. *Blown Covers:* New Yorker *Covers You Were Never Meant to See*. New York: Abrams, 2012.

Mumford, Alan. *Stabbed in the Front: Postwar General Elections through Political Cartoons*. Canterbury, UK: Centre for the Study of Cartoons and Caricature, University of Kent at Canterbury, 2001.

Nader, Ralph. "The Soviets' Satirist." *Christian Science Monitor*, August 18, 1962.

Navasky, Victor S. *Naming Names*. New York: Viking Press, 1980.

———. "Parody." *Frontier*, October 1958.

Nelson, Otto M. " 'Simplicissimus' and the Rise of National Socialism." *The Historian* 40, no. 3 (1978).

Nicholson, Eirwen. "Consumers and Spectators: The Public of the Political Print in Eighteenth-Century England." *History* 81, no. 261 (1996).

Noë, Alva. *Out of Our Heads: Why You Are Not Your Brain, and Other Lessons from the Biology of Consciousness*. New York: Hill and Wang, 2009.

Nuremberg Trial Proceedings, vol. 12. Lillian Goldman Law Library, Yale Law School. Accessed October 30, 2012. http://avalon.law.yale.edu/imt/04-29-46.asp.

O'Neill, William L. *Echoes of Revolt: The Masses, 1911–1917*. Chicago: Quadrangle Books, 1966.

Packard, Vance. *The Hidden Persuaders*. New York: D. McKay, 1957.

Porter, Roy. "Seeing the Past." *Past & Present* 118 (February 1988).

Porterfield, Todd B. *The Efflorescence of Caricature, 1759–1838*. Farnham, UK: Ashgate, 2011.

Press, Charles. *The Political Cartoon*. Rutherford, N.J.: Fairleigh Dickinson University Press, 1981.

Ramachandran, V. S., and William Hirstein. "The Science of Art: A Neurological Theory of Aesthetic Experience." *Journal of Consciousness Studies* 6–7 (1999).

Raphael, Max, and John Tagg. *Proudhon, Marx, Picasso: Three Studies in the Sociology of Art*. Atlantic Highlands, NJ: Humanities Press, 1980.

Rhodes, G. "Configural Coding, Expertise, and the Right Hemisphere Advantage for Face Recognition." *Brain and Cognition* 22, no. 1 (1993).

Robert, Michael B. Lewis. "A Unified Account of the Effects of Caricaturing Faces." *Visual Cognition* 6, no. 1 (1999).

Rose, Flemming. "Muhammeds Ansigt," *Jyllands Posten*. September 30, 2005.

———."Why I Published Those Cartoons." *The Washington Post*. February 19, 2006. Accessed June 2, 2011. http://www.washingtonpost.com/wp-dyn/content/article/2006/02/17/AR2006021702499.html.

Rushdie, Salman. *The Satanic Verses*. New York: Viking, 1989.

Saraceni, Mario. *The Language of Comics*. London: Routledge, 2003.

Schmölders, Claudia, and Adrian Daub. *Hitler's Face: The Biography of an Image*. Philadelphia: University of Pennsylvania Press, 2006.

Schwarz, Julia. "The Image of Anti-Semitism." Thesis, Munster University, 2009.

Seymour-Ure, Colin, and Jim Schoff. *David Low*. London: Secker & Warburg, 1985.

Shikes, Ralph E. *The Indignant Eye: The Artist as Social Critic in Prints and Drawings from the Fifteenth Century to Picasso,*. Boston: Beacon Press, 1969.

———. *Slightly Out of Order: Best Cartoons from the Continent*. London: Hammond, 1959.

Shikes, Ralph E., and Steven Heller. *The Art of Satire: Painters as Caricaturists and Cartoonists from Delacroix to Picasso*. [New York]: Pratt Graphics Center and Horizon Press, 1984.

Showalter, Dennis E. "Letters to *Der Stürmer:* The Mobilization of Hostility in the Weimar Republic." *Modern Judaism* 3, no. 2 (1983).

Sorel, Edward. *Making the World Safe for Hypocrisy: A Collection of Satirical Drawings and Commentaries*. Chicago: Swallow Press, 1972.

Spiegelman, Art. "Drawing Blood: Outrageous Cartoons and the Art of Outrage." *Harper's*, June 2006.

———. *Maus: A Survivor's Tale*. New York: Pantheon, 1986.

———. *Maus II: A Survivor's Tale: And Here My Troubles Began*. New York: Pantheon Books, 1991.

———. *MetaMaus*. New York: Pantheon, 2011.

Steadman, Ralph. *The Joke's Over: Bruised Memories: Gonzo, Hunter S. Thompson, and Me*. Orlando: Harcourt, 2006.

———. *Sigmund Freud*. New York: Paddington Press, 1979.

Steinberg, Saul. *The New World*. New York: Harper & Row, 1965.

Stokes, Hugh. *Francisco Goya: A Study of the Work and Personality of the Eighteenth-Century Spanish Painter and Satirist*. London, 1914.

Streicher, Lawrence Harold. *The Political Imagery in the Caricatures of David Low*. Ph.D. thesis, University of Wisconsin, 1965.

Strömberg, Fredrik. *Black Images in the Comics: A Visual History*. [Seattle, WA]: Fantagraphics, 2003.

———. *Comic Art Propaganda: A Graphic History*. New York: St. Martin's/Griffin, 2010.

Suares, Jean-Claude. *Watergate without Words*. San Francisco: Straight Arrow, 1975.

Thorn, David L. "Political Satire: The Influence of Humor." *Littlewolf Anthropology* (blog). Accessed Spring 2011. http://www.littlewolf.us/politicalsatire.html.

Tripp, C. A., and Lewis Gannett. *The Intimate World of Abraham Lincoln*. New York: Free Press, 2005.

Tucholsky, Kurt. *Deutschland, Deutschland über Alles;*. Amherst: University of Massachusetts Press, 1972.

Turner, Mark. *The Literary Mind*. New York: Oxford University Press, 1996.

Untermeyer, Louis, and Ralph E. Shikes. *The Best Humor of 1949/50*. New York: Holt, 1950.

Varnedoe, Kirk, and Adam Gopnik. *Modern Art and Popular Culture: Readings in High & Low*. New York: Abrams and The Museum of Modern Art, 1990.

Wallis, David. *Killed Cartoons: Casualties from the War on Free Expression*. New York: Norton, 2007.

Williamson, Skip. *The Scum Also Rises: An Anthology of Comic Art*. Westlake Village, CA: Fantagraphics Books, 1988.

Wittgenstein, Ludwig. *Philosophical Investigations*. New York: Macmillan, 1968.

Wright, Thomas. *A History of Caricature & Grotesque in Literature and Art*. London, 1865.

Zeki, Semir. *Inner Vision: An Exploration of Art and the Brain*. Oxford, UK: Oxford University Press, 1999.

Index

Abacha, General Sanai, 206
Abrams, Floyd, 49–50n
Abu Ghraib, 22
Actors Studio, 135
Adatto, Kiku, 22, 35, 169;
 Picture Perfect, 19, 169
Adewale, Adenle, 206
Afghanistan, 148
African-Americans, 36
African National Congress
 (ANC), 191, 192, 194
Ahmadinejad, Mahmoud, 148
Aitken, Jonathan, 148
AIZ, 104
Akbulut, Yildirim, 204
Akhbar al Khaleej, 110; "The
 Sixtieth Anniversary of
 the Holocaust," *109*
Akhenaten, Pharaoh, xix
Al Fajr, 202
Algeria, 205
Ali, Naji al-, xv, 4, *150,* 151–3;
 Hanthala, *150,* 151–2,
 203
Ali, Saleh, 4, 205
Al Jazeera, 22
Al-Qabas, 151
Al-Watan, 110
Amari, Chawki, 205
Americana, 133
American Civil Liberties
 Union (ACLU), xviii
anti-Communists, 155 (*see
 also* McCarthy, Joseph/
 McCarthyism)
anti-Semitism, xv, 28, 36, 45,
 45, 106, 108–11, *108–10,*
 133, 146, 149, 175, 205

Arab-American Anti-
 Defamation League, 13
Arafat, Yasser, 4, 151, 152, 203
Arendt, Hannah, "Eichmann
 in Jerusalem," 13
Argentina, 70n, 202, 205
Arisman, Marshall, 19
Aristotle, 29
Art Students League, 97
Ashtiani, Ahmad Lotfi, 209
Assad, Bashar al-, 209
Associated Press, 88, 183
AT&T, 97n
Attica prison uprising,
 6 and *n*
Auden, W. H., 40
Austria, 206
Awlaki, Anwar al-, 208
Azeris, 4, 21n, 207

Bahomane, Walid, 209
Bahrain, 109
Balasubramanian, S., 203
Baldinucci, Filippo, 69
Barasch, Moshe, 59
Bartholomew, Guy, 118
Baruter, Bahadir, 208
Baudrillard, Jean, 18
Beaverbrook, Lord, 113, 114
Beckmann, Max, 33
Bedford, Duke of, 61
Beerbohm, Max, 31
Begin, Menachem, *31,* 146–9,
 147, 175, 177
Belarus, 4, 206
Belgium, 208
Bell, Steve, 39, 42, 43
Benny, Jack, xvii

Benny v. Loews (1956),
 xvii–xviii
Benson, Timothy, 113, 115
Berger, John, 199
Bergman, Ingrid, xvii
Berlin Secession, 94
Bernini, Gianlorenzo, xix;
 caricature of Pope
 Innocent XI, *xix*
Bible, 18, 28, 29
Bin Laden, Osama, 13
Biya, Paul, 4
Black Power, 200
Blackshear, Lisa, 158–60
Blair, Tony, 148
Blickman, Sophia, 100
Blimp, Colonel, 113 *and illus.*
Blitt, Barry, 12–14, 17, 37, 169;
 "The Politics of Fear,"
 3, 12–14, *13,* 119
Block, Herbert (Herblock),
 34, 42, 46, 129–31, 185;
 "Carry On, Lads," xv,
 128, 131; "Here
 He Comes Now,"
 34, *34;* "Untitled,
 12/8/1953" (United
 Nations Building),
 130, 131
Blood and Honor, 148
Bonaparte, Napoleon, 30, *30*
Bostantzoglou, Crysanthos
 Mentis (Bost), 5; "St.
 George Triumphant
 and the Prophet Iliou,"
 5, 202
Boyer, Charles, xvii
Brando, Marlon, 134n

Brecht, Bertolt, *The Three Penny Opera*, 56
Britain, *see* United Kingdom
British Broadcasting Company, 117
British Cartoon Archive, xvi, 38, 137, 181
British Journal of Medical Psychology, 33
British National Party, 146
Brodner, Steve, 13, 37, 42
Brooks, Cleanth, 14
Brown, David, 109, 110; "After Goya," *110*
Brown, Tina, 171, 172
Brunwasser, Matthew, 188
Bryant, Mark, 137
Buddhists, 19
Bulgaria, nurses in Libya from, 187–9
Bush, George W., 148, 191
Byron, Lord, 31
Bytwerk, Randall, 107, 108, 110
Byzantine Empire, 18

Caesar, Julius, 181
Callaghan, Lord, 117
Cambodia, 177, 205
Cameroon, 4, 206
Campbell, Duncan, 137
Canada, 88, 155
Cape Times, 191
Caricature, La, 69, 75, 201
Carracci, Annibale, vii, xix, 18, 33
Carrier, David, 28
Cartoonists Rights Network International (CRNI), xvi, 3
Cascabel, 70n
Caterpillar, 156
Catholics, 18, 29, 133, 155, 178

Cenedella, Robert, 94, 100; "Hostility Dart Boards," 97; *The Illustrated Gift Edition of the Communist Manifesto*, 97, 100n
Central Intelligence Agency, 161
Champfleury, 73
Chanin, A. L. (Abe), 84–5
Charles X, King of France, 69
Charlie Hebdo, 209
Charlotte, Queen, 62
Charlotte Observer, The, 175
Charmatz, Bill, Letter to the Editor, *157*
Chast, Roz, 95
Chavkin, Samuel, 65
Cheney, Dick, 148
China, 204
Christians, 184; fundamentalist, 177, 178
Christian Science Monitor, The, xvin
Churchill, Winston, 38, 117
City Press, 194
Civil War, 32, 77
Coe, Sue, 95, 157–8
Collier's, 87
Colombres, Juan Carlos, 70n
Columbia University, xiiin, 44, 49, 88, 159, 182
Columbus, Christopher, 181
Comix-Scholars, xvi
Committee to Protect Journalists, xvi, 3
Communists, xvin, 84, 91, 100n, 104, 127, 134n, 135, 204; antagonism toward, 155 (*see also* McCarthy, Joseph/McCarthyism); *see also* Soviet Union
Confucius, vii
Congress, U.S., 123, 129
Conrad, Joseph, vii

Conservative Party, British, 117, 118, 121
Constitution, U.S., First Amendment, xviii, 47, 178
Content Theory, xxi, 3–14, 17–18, 23, 27, 42
Cooper, Gloria, 159
Cosby, Bill, 159
Coughlin, Father, 133
Council on American-Islamic Relations (CAIR), 177
Coupe, W. A., 114
Cranach, Lucas, the Elder, 29; "The Birth and Origin of the Pope," *29*; *The True Depiction of the Papacy*, 29
Croatia, 172, 205
Cruikshank, George, xx, 46, 62
Cubism, 84, 85
Cumhuriyet, 206
Czechoslovakia, 104

Dachau, 107
Dada, 94, 97, 100, 103, 105
Daily Compass, The, 84
Daily Maverick, 192
Daily Worker, 84
Danto, Arthur, 49; "Metaphor and Cognition," 72
Darwin, Charles, 46
Daughtry, Herbert, 172
Daumier, Honoré, xv, 28, 30, 31, 41, 42, 46, 49, 71, 72–5, 84, 103, 185; "Gargantua," 73, *74*, 201
Davies, Russell, 121
Day, Dorothy, 88
Dean, John, 135
Debord, Guy, 18
de Gaulle, Charles, 37
Delacroix, Eugène, 83
Dell, Floyd, 89

Democratic Party, 12, 32, 77, 130, 175

Denmark, cartoons of Muhammad published in, xiv–xv, 20–2, 28, 37, 49, 148, 181–5, 189, 207, 208

DePastino, Todd, 126

Derby, Lord, 61

Diallo, Amadou, 173

Diderot, Denis, xiv

Disney, Walt, 103

Dix, Otto, 33, 94

Doe, Samuel K., 203

Donald, Diana, 29, 56

Douglas, Roy, 139

Duarte, Jessie, 192

Dürer, Albrecht, "Ten Heads in Profile," xix, xx

Dworkin, Ronald, 49

Dzwonik, Cristian (Nik), 205

Eastman, Max, 88–91

Economist, The, 168

Edwards, Robert, 31, 145–9, 203; "The Real Menachem Begin Story," 31, 146, 147, 148–9

Egypt, ancient, xix

Ehrlich, Paul, 40

Eisenhower, Dwight D., 129–31

Eknaligoda, Prageeth, 208

Eliot, T. S., 167

Emerson, Thomas, xviii, 145

England, see United Kingdom

Enlightenment, xviii, 48

Erdogan, Recep Tayyip, 206

Espionage Act (1917), 89, 201

Esquire magazine, 162

Fabian Society, 167

Faith and Politics Institute, 191

Falklands War, 139

Falwell, Jerry, 47, 178

Farad, 204

Fauconnier, Gilles, 45

Feaver, William, 103; Masters of Caricature, 83

Federal Bureau of Investigation (FBI), 84

Feiffer, Jules, 8, 156

Ferzat, Ali, 4, 209

Fielding, Henry, 56, 57

Fips, see Rupprecht, Philipp

Food and Drug Administration, U.S., 49–50n

Foot, Michael, 10, 31, 114, 118, 121

Four Powers Pact, 12

Fox, Charles James, 61, 62

France, 12, 30–2, 46, 49, 62, 69–75, 189, 201, 209; in World War II, 126

Franco, Francisco, 115

Frankfurt School, xviii

Franklin, Benjamin, 32

Freedberg, David, 18, 20

French Revolution, 62, 75

Freivalds, Laila, 207

Freud, Sigmund, 20, 26, 43, 143

Frontier magazine, xvii

Frontline News, 146

Garlin, Sam and Sender, 83–4

Gay, John, The Beggar's Opera, 55–6

Gedung Kartun, 207

Geertz, Clifford, 184

George III, King of England, 56

George IV, King of England, 62

Georges, "The Grim Reaper," 11

Germany, xvi, 33, 113; Nazi, see Nazis; Weimar, 99, 157, 201; in World War I, 32, 94, 201

Gestapo, 94

Gevisser, Mark, 194

Gibbs, Wolcott, xvii

Gillray, James, xx, 30, 35, 46, 61–3, 68, 83, 198; Doublures of Characters, 60, 61; "Fashionable Contrasts," 63; "Maniac Ravings, or Boney in a Strong Fit," 30; "A Toadstool Upon a Dunghill," 35

Giovannitti, Arturo, 88

Girgir, 204

Glaser, Milton, 23–5

Glintenkamp, H. J., 89

Goebbels, Joseph, 10, 115, 117–18

Goethe, Johann Wolfgang von, xiv

Goldstein, Robert Justin, 31, 69, 73, 75

Gombrich, Ernst Hans Josef, 33–5, 42, 51, 69, 71; The Cartoonist's Armory, xiv

Gopnik, Adam, 85

Göring, Hermann, 115

Goya, Francisco, 65–8, 110, 125, 171; Los Caprichos, 66, 68; "Duendecitos," 64, 67

Graham, Katharine, 130

Graham, Phil, 130

Greece, 5, 202, 206; ancient, 19, 61

Gregory I ("the Great"), Pope, 38

Grelot, Le, 32, 75

Grootes, Stephen, 192

Gropper, William, xiiin

Grossman, Robert, 37, 156, 157, 161–5; "Babe Lincoln," 161–2, 163, 164–5; "Chairman Meow," 161, 161; "Mutton Luther King," 161, 161

Grosz, George, xiii*n*, 33, 43, 93, 94, 96–100, 103, 104, 133, 157, 201–2; "Fit for Active Service," *98*, 99; "The Guilty One Remains Unknown," *101*; "Shut Up and Obey," 201
Group Theater, 135
Guston, Philip, 49
Guzel, Dogan, 206

Habermas, Jürgen, xviii, 48
Haderer, Gerhard, *Das Leben des Jesus,* 206
Hafstaengl, Ernst (Putzi), *Hitler in der Karkatur der Welt,* 11–12
Halifax, Lord, 10
Halloran, Fiona Deans, 77*n*
Hamshahri, 148
Harper's Weekly, 77, 80, *81*
Harrison, Ted, 40–1, 43
Harte, Liam, *Drawing Conclusions,* 139
Harvard University, xiii*n*, 88, 175; Law School, xvi*n*
Harvey, William, 26
Hayden, Tom, 200
Health and Efficiency, 137
Heartfield, John, 33, 97, 103–5, *105*; "Adolf the Superman," *102*
Hecht, Ben, *A Flag Is Born,* 145
Hegelian dialectics, 65
Heilbrun Foundation, 85
Heine, Heinrich, 70, 72
Heller, Steven, xx, 36, 42, 133, 134, 142, 161
Helms, Jesse, 175
Herblock, *see* Block, Herbert
Hergé, *Tintin in the Congo,* 208
Herzfelde, Wieland, 103, 201–2
Hiley, Nicholas, 181
Himmler, Heinrich, 110

Hindus, 172
Hirschfeld, Al, 133–5; "Famous Feuds: Strasberg vs. Kazan," *132*, 134–5
History Magazine, 117
Hitchens, Christopher, xiii, 66, 68, 199
Hitler, Adolf, 3, *9*, 9–13, 31, 40, 43, 93, 99, 103–5, 113–15, *112*, *114*, 121, 178, 202
HIV/AIDS, 187, 191, 193
Hobbs, Jack, 181
Hofmann, Werner, xix, 38, 56, 84–5; *Caricature,* 62
Hogarth, William, xix, 46, 55–9, 62, 68, 83; *Characters and Caricaturas, xxii,* 57, *58*; *Gin Lane, 54*; "The Tête à Tête," *57*
Hoggart, Paul, 146
Hokusai, Katsushika, 133
Holbein, Hans, the Younger, 29
Holland, 32–3, 201
Holland, Brad, "Attica Uprising," 6, *6*
Holland, William, 62
Holocaust, 171; denial, 31, 146, 148
Hoover, J. Edgar, 97
House of Commons, 118
House Un-American Activities Committee (HUAC), 129, 134–5
Howard, Roy, 127
Howe, Irving, 88
Hughes, Robert, 67, 68
Hungary, xvi*n*
Hunt, James B., Jr., 175
Huntington, Samuel, *the Clash of Civilizations and the Remaking of the World Order,* 184

Hustler Magazine Inc. v. Falwell (1988), 47

I Avgi, 5, 202
Iliou, Ilias, 5, 202
Image Theory, xxi, 14–23, 27, 43
Independent, 36–7, 137
India, 181, 203, 208, 209
Innocent XI, Pope, xix *xix*
Inquisition, 66, 67
Institute for International Security Affairs, 189
Institute for Social Research, xviii
Institutional Revolutionary Party (PRI), Mexican, 207
International Federation of Newspaper Publishers, 152
Iran, 4, 148, 204, 207, 209
Iraq, 148
Ireland, Doug, 165
Irish Republican Army (IRA), 139
Islam, *see* Muslims
Israel, 4, 36, 151–3, 172, 175, 177, 202, 203, 205
Italy, 12, 115

Jabari, Muhammad Ali al-, 202
Jackson, Raymond (Jak), 137–9; "Homo-Electrical Sapiens Britannicus circa 1970," *136*, 137–8; "The Irish," *138*, 138–9
Jacquinot-Pampelune, Claude-Joseph, 32
Jak, *see* Jackson, Raymond
Japanese, 36
Jay, Martin, 18
Jenner, William, 131
Jetter, Frances, 94–6; "The Republican Platform Against Choice," *95*

Jews, 107, 141, 145, 148, 153, 171, 177, 178; Israeli, 109–10; Lubavitcher Hasidic, *170*, 171–2; negative stereotypes of, *see* anti-Semitism

Jiedueh, Harrison ("Black Baby"), 203

Johnson, Haynes, *Herblock*, 131

Johnson, Lyndon Baines, 41, 42, *42*, 161

Jolson, Al, 173

Jones, Spike, 9

Judaism, *see* Jews

Jyllands-Posten, xiv, 21, 181, 183, 207

Kahneman, Daniel, *Thinking Fast and Slow*, 23–4

Kaltenbrunner, Ernst, 110

Kanafani, Ghassan, 151

Kandel, Eric, 26

Karimzadeh, Manouchehr, 204

Kart, Musa, 206

Kazan, Elia, *132*, 134–5

Kempton, Murray, 97n

Kennedy, John F., 16–17, *16–17*

Kent, Rockwell, xiiin

Kent, University of, 40, 114; British Cartoon Archive, xvi, 38, 137, 181; Centre for the Study of Cartoons and Caricatures, 121

Kentish Gazette, 40

Keynes, John Maynard, 167

Khomeini, Ayatollah Ruhollah, 21n, 204

Kimmelman, Michael, 19, 20

King, Alexander, 133

King, Martin Luther, 161, *161*, 200

Kirchwey, Freda, 145, 167

Kissinger, Henry, xi–xiv, *xii*, 26, 38, 142, 155, 193, *196*, 197–9

Klausen, Jytte, 13, 183–5; *The Cartoons That Shook the World*, 21

Koelble, Thomas A., 193

Koestler, Arthur, 34, 44; *The Act of Creation*, 45

Kohn, Richard C., 125

Kollwitz, Käthe, 93–6, 99, 121; *Memorial to Karl Liebknecht*, 92

Kopkind, Andrew, 200

Koran, 18, 21

Kraus, Jerelle, 5–6; *All the Art That's Fit to Print*, 6

Kris, Ernst, 33–4

Krokodil, xvin

K*S*K, *see* Kuskin, Karla Seidman

Ku Klux Klan, 22

Kurds, 206

Kuskin, Karla Seidman (K*S*K), 15–17; "The Rocky Road Upwards," 15, *16–17*

Kuwait, 152

Labour Party, British, 10, 31, 118, 167

Lakemfa, Owei, 206

Lamb, Richard, 122

Latimer, Clare, *166*, 167–8

Lavater, Johann Kaspar, 61

League of Arab Cartoonists, 152

League of Nations, 113

League of St. George, 146

Lear, Frances, 7–9, 155–9

Lear, Norman, 8

Lear's magazine, 7, 157

Lebanon, 153

Leech, John, 31

Lenin, V. I., 97, 194

Leo X, Pope, 29, *29*

Leonard, John, 44

Leonardo da Vinci, xix, 28, 199; "Five Grotesques," *xxi*

Levine, David, 7, 36, 55, 83, 125, 171, 197–200; Lyndon Baines Johnson, 41, *42*; "Screwing the World," xi–xv, *xii*, 26, 38, 142, 155, 193, *196*, 197–9

Liberia, 203

Libya, 187–9

Liebknecht, Karl, *92*, 94

Life, 87

Lincoln, Abraham, 32, 48, 161–5, *163*

Livingstone, Margaret, 25n

Lloyd George, David, 181

Lloyds bank, 167

Loden, Barbara, 134n

London Daily Mirror, 37, 117–18

London Evening Standard, 9, 10, 113, 121, 137–9

London Morning Post, 181

London Observer, 103

Lorillard Tobacco, 50n

Louis Philippe, King of France, xv, 31, 41–2, 49, 69–73, *71*, *74*, 103, 201

Low, David, 3, 9–12, 14, 31, 39–40, 43, 113–15, 181, 182, 202; Colonel Blimp, 113; "Hitler at the League of Nations," *114*; *Hit and Muzz*, 115; "Little Adolf Tries On the Spiked Moustache," *9*; "Low's Topical Budget," *113*; "Rendezvous, *112*; "Suezcide," *115*

Lowell, Amy, 88

Lozowick, Louis, xiii*n*
Lucie-Smith, Edward, 83, 104
Ludas Matyi, xvi*n*
Lukashenko, Alexander, 206
Lundberg, Kirsten, 182, 183
Luther, Martin, 29, 30, 93
Luxemburg, Rosa, 94

Macmillan, Harold, 41, *41*, 42, *120*, 121–2
Mad magazine, 96
Magazine Distribution Committee, 88
Major, John, 42, *166*, 167–9
Malaysia, 207
Mammadguluzadeh, Jalil, 21*n*
Mankoff, Bob, 7, 36
Mantashe, Gwede, 192, 194
Manufacturers Hanover bank, 159
Marlette, Doug, 34, 175–9; "What Would Mohammad Drive?" *176*, 177
Martin, Kingsley, 167
Marx, Karl, 85; *The Communist Manifesto,* 97
Marxists, xviii, 65, 84, 94
Masses, The, 42–3, 87–91, 201
Mauldin, Bill, 123–7; Willie and Joe, *124*, 125–6
Maxwell, Robert, 36
McCarthy, Joseph/ McCarthyism, xv, 65, 66, 129–31, 134*n*
McCloud, Scott, *Understanding Comics,* xvi
McCreery, Cindy, 61
Melot, Michel, 84
Menem, Carlos, 205
Mercury, The, 191
Mexico, 207
Mill, John Stuart, "On Liberty," xvii

Miller, Arthur: *After the Fall,* 134*n*; *The Crucible,* 134*n*; *Death of a Salesman,* 134; *A View from the Bridge,* 134*n*
Minich, Oleg, 4, 206
Minor, Robert, 43, 133; "The Perfect Soldier," 91, *91*
Mitchell, W. J. T., 19–20
Modi, Narendra, 208
Mohammed VI, King of Morocco, 209
Molla Nasraddin, 21*n*
Monde, Le, 182, 183
Mondondo, Bienvenu Mbutu, 208
Monocle, xvi and *n*, 3, 15, 37, 97, 155, 161
Monroe, Marilyn, 34, 134*n*
Montaigne, Michel de, 56
Morocco, 209
Morrison, Herbert, 117, 118
Mosley, Oswald, 145
Mossad, 151, 152, 203
MOVE, 203
Msomi, S'Thembiso, 194
Muhammad, 209; Danish cartoons of, xiv–xv, 20–2, 28, 37, 49, 148, 181–5, 189, 207, 208
Mumford, Alan, *Stabbed in the Front,* 142
Murray, Brett, 194, 195
Muslims, xiv–xv, 13, 14, 18, 20–2, 172, 177–8, 181–4, 203, 204, 207, 208
Mussolini, Benito, 9, 114, 115

Nader, Ralph, xvi*n*
Nadu, Tamil, 203
Nameye Amir, 209
Napoleonic Wars, 62
Nasser, Yusuf (Joe), 202

Nast, Thomas, 32, 43, 46, 49, 77–80; "The Brains," *78*, 78; "A Group of Vultures Waiting for the Storm to Blow Over," 78–9, *79*; "Santa Claus in Camp," *81*; "The Tammany Ring-Dom," *76*, 78; "The Tammany Tiger Loose," 77; *Thomas Nast's Christmas Drawings for the Human Race,* 80; "Under the Thumb," 78, *78*; "Who Stole the People's Money?," *77*, 78
Nation, The, xi and *n*, xii–xv, 3, 8, *11*, 12, 49, 65, 66, 68, 72, 145, 155, 156, 160–2, 167, 194, 197–9
National Front, 146
Navasky, Macy, 87
Navasky, Victor: *A Matter of Opinion,* xv*n*; *Naming Names,* 134
Navasky & Sons, 87
Nazis, xv, 9, 10, 43, 93, 94, 97, 99, 103, 104, 107, 114, 115, 118, 145, 171, 175, 202; anti-Semitic propaganda of, 179 (*see also Stürmer, Der*); neo-, 146
Nefertiti, Queen, xix
Nelson, Andrea Jeannette, 104
Neuroscience Theory, xxi, 23–7, 43–4, 189
Neuweiler, Richard C., 103
New Masses, The, 90, 133
New Republic, The, 158, 161
Newsday, 34, 177
New Statesman, 36, 39, 137, 144, *166*, 167–9
Newsweek, 161

New Yorker, The, xvii, 3, 7, 12–13, *13,* 36, 37, 169–74, *170, 173*
New York Herald, 91
New York magazine, 161
New York Observer, The, 161
New York Post, 173
New York Review of Books, xi, 49, 197, 200
New York Times, The, 19, 22, 49–50*n,* 133, 135, 141, 164, 181, 183, 188–9; *Book Review,* 44; Op-Ed page, 5–6, 28, 95
New York World Telegram, 127
Neyestani, Mana, 4; *An Iranian Metamorphosis,* 207
Nietzsche, Friedrich, 38
Nigeria, 206
Nixon, Richard M., 16–17, *16–17,* 25, 34, *34,* 42, 46, 49, 97, 129, 130, 131, 135, *140,* 142, 144, 177
Noë, Alva, 25, 26, 44, 45; *Out of Our Heads,* 25
Norfolk, Duke of, 61
Norris, Molly, 208
Novinar, 187, *188–9*
Ntooguée, Paul-Louis Nyemb (Popoli), 4, 206
Nuremburg Tribunal, 107, 110–11

Obama, Barack and Michelle, 3, 12–14, *13,* 17, 37, 119, 169
Observer, The, 143
Oesterheld, Héctor, 202
O'Hara, Jim, *Drawing Conclusions,* 139
Ohio State University, xvi, 43, 61, 90, 212
O'Neill, William, 90; *Echoes of Revolt,* 87, 91

Ottaway, Liz, 121
Özal, Turgut, 204

Packard, Vance, *The Hidden Persuaders,* xviii
País, El, 209
Pakistan, xiv–xv, 148
Palestine Liberation Organization (PLO), 151, 152, 203
Palestine/Palestinians, 4, 145, 151–3, 187, 203
Papandreou, George, 5, 202
Parliament, English, 37, 61
Parsons School of Design, 96
Parvanov, Georgi, 189
Patton, General George, 126–7
Pehlivan, Ismail, 204
Peretz, Martin, 158
Perón, Juan, 70*n*
Philadelphia Daily News, 203
Philipon, Charles, 31, 41, 69–73, *70,* 75; "La Poire," 31, 42, *70,* 72, 201
Phoenix, The, 40
Photoshop, 105
Picasso, Pablo, 83–5, 133; *Guernica, 82–3,* 83
Pissaro, Camille, 65
Pitt, William, 35, *35,* 61
Plantureux, Jean (Plantu), 183–5; "I Must Not Draw Muhammad," *180*
Plato, 38
Platt, Steve, 36, 37, 167–9
Playboy, 193
Pleite, Die, 103
PM, 84
Poland, xvi*n,* 202
Political Cartoon Society, 11
Politika, 203
Pontual, Jorge, 165
pop art, 100

Popoli Messager, Le, 4
Post Office, U.S., 89
Pretoria News, 191
Price, Aimée Brown, xiv
Primadas, Ranasinghe, 4, 204
Profumo affair, 122
Proudhon, Pierre-Joseph, 85
Prussian Academy of the Arts, 94
Puck, 87
Punch, 31

Qaddafi, Muammar, *186,* 187–9, *illus. 188*
Qatar, 110
Queens College, xiv

Raemaekers, Louis, 32–3, 201; "The German Tango," *33*
Ramachandran, V. S., 25, 44
Raphael, Max, 85
Reagan, Ronald, 143
Reed, John, 88
Reformation, 29
Régis de La Bourdonnaye, François, Comte de La Bretèche, vii
Reichstag fire, 113
Rembrandt van Rijn, 68
Remnick, David, 13, 14
Repertory Theater of Lincoln Center, 134*n,* 135
Republican Party, 32, 77, 95, 130, 131, 175
Reston, James, 141
Robins, Steven L., 193
Robinson, Boardman, 89
Robinson, H. Perry, 32–3
Robles Patiño, Mario, 207
Rolling Stone, 161
Roosevelt, Franklin D., 48
Roosevelt, Theodore, 48
Rose, Flemming, 183
Rosenthal, Debra C., 199

Roth, Arnold, 156
Rowlandson, Thomas, xx, 41, 46, 62, 68
Rowson, Martin, 36–7
Rupprecht, Philipp (Fips), *106*, 107; "The Bloodbath," *108*; "The Satanic Serpent Judah," *108*; "The Vermin," *45*
Rushdie, Salman, *The Satanic Verses*, 6
Russia, 204; Communist, *see* Soviet Union

Sandburg, Carl, 88, 162
Saturday Evening Post, The, 87
Saussure, Ferdinand de, 18
Scanlan's Monthly, 141–2
Scarfe, Gerald, 83
Schlesinger, Arthur, Jr., 46
Schmölders, Claudia, *Hitler's Face*, 105
Schwarz, Julia, 109
Schwarzburg, Oleg, 205
Scripps-Howard newspaper chain, 127
Searchlight magazine, 146
Senate, U.S., 129, 175; Watergate Committee, 135
Shabab, al-, 208
Shahn, Ben, xiii*n*, 66, 94
Selçuk, Turhan, 202
Serbs, 172
Shapiro, Jonathan (Zapiro), 191–5; "The Rape of Lady Justice," *190*, 191–3, 207
Sharon, Ariel, 109, *109*
Sharpton, Al, 174
Shaw, George Bernard, 167
Sheridan, Richard Brinsley, 61
Shikes, Ralph, 55, 65–6, 68, 69, 75, 93

Shikes, Ruth, 65
Shokraye, Mahmoud, 209
Show magazine, 134
Siegert, Judge, 201–2
Simplicissimus, 33, 94, 103, 121
Simpson, O. J., 173
Sobesednik, 204
Socialists, 91, 93, 121
Sorel, Edward, 3, 14, 37, 162; "Enter Queen Lear, Triumphant," 7–9, *8*, 155–60; *Making the World Safe for Hypocrisy*, 155; "Pass the Lord and Praise the Ammunition," *154*, 155
South, 191
South Africa, 191–5, 207; Human Rights Commission, 193
South African *Sunday Times*, 191, 192, 194, 195*n*
Soviet Union, xvi*n*, 99–100, 167
Sowan, Ismail, 203
Soweto, 191
Spartacus League, 94
Spellman, Cardinal Francis, 155
Spiegelman, Art, xv, 34, 42, 171–4; "41 Shots 10 Cents," *173*; *Maus*, 171; "Valentine's Day," *170*
Sports Illustrated, 161
Sri Lanka, 4, 204, 208
Stalin, Joseph, 167
Stanislavksy, Konstantin, 135
Star, The, 191
Steadman, Ralph, vii, 17, 33, 38, 39, 99, 141–4, 182; "The Cabinet of the Mind," 143; Richard M. Nixon, *140*, 142, 144
Stein, Gertrude, 85

Steinberg, Saul, 42, *43*
Stern Gang, 149
Stevenson, Adlai E., 130
Stewart, Potter, 36
Stokes, Hugh, 66
Stormer, The, 146
Strasberg, Lee, *132*, 134, 135
Streicher, Julius, 28, 107, 108, 110
Stroop, General Jürgen, 110
Sturdybuilt Company, 87
Stürmer, Der, xv, xvi, 9, 28, 36, 45, *106*, 107–11, 146, 149, 173; "The Bloodbath," *108*; "The Satanic Serpent Judah" *108*; "The Vermin," *45*
Suares, Jean-Claude, 141, 157; *Watergate Without Words*, 46
Supreme Court, U.S., xvii, 47–8, 129
Swarthmore College, 40
Sweden, 207
Swiftly Turning Mind, 204
Syria, 4, 209
Szabo, Joe, 203
Szpilki, xvi*n*

Taiwan, 204
Tammany Hall, 32, 49, *76*, 77–9, *77–9*
Tenniel, John, 31
Thatcher, Margaret, 39, 151, 168, 203
Thomas Aquinas, St., 29
Thomas, Cecil, 118
Thompson, E. P., 19
Thompson, Hunter, 141–2; *The Scum Also Rises*, 142
Thorn, David, 29
Thurschwell, Huey, 125
Tierney, Charles, 61
Time magazine, xvii, 67, 161

Times of London, 117, 146;
 Literary Supplement,
 The, 40
Today's News Today, 206
Tories, 62
Toulouse-Lautrec, Henri de,
 133
Tribune, La, 205
Tripp, C. A., 161, 164
Trivedi, Aseem, 209
Tucholsky, Kurt, 104;
 Deutschland, Deutschland
 Über Alles, 105
Turkey, 189, 202–4, 206,
 208
Turner, Mark J., 44–5
Tweed, William M. ("Boss"),
 32, 43, 46, 49, *76,* 77–80,
 77–9
12-Uhr Blatt, 121

Ulhaque, Zulkiflee Anwar
 (Zunar), 207
Ündeger, Sema, 203
United Kingdom, xx, 10–12,
 30–1, 37, 46, 55–63, 68,
 113–15, 117–19, 121,
 137–9, 181, 182, 202, 203;
 Georgian, 29, 62;
 Union of Fascists in,
 145, 146
United Nations, 110, *130,*
 131
United News company, 88
United States, 32, 46, 51, 89,
 201, 203, 204, 208
Untermeyer, Louis, 65
Ure, Colin Seymour, 40
Utne, Eric, 158

Velázquez, Diego, 68, 83
Velev, Zdravko, 188
Versailles, Treaty of, 12
Verve magazine, 83
Vicky, *see* Weisz, Victor
Vietnam, 41
Vietnam War, 155
Vincent, Howard, 73
Vinson, J. Chal, 78

Wallace, Henry, 65
Wardell, Michael, 10
Warhol, Andy, 100
Washington, George, 48
Washington Post, The, 12, 13,
 183
Watergate scandal, 46, 135, 144
Webb, Beatrice and Sidney, 167
Weber, F. Palmer, 65, 68
Wechsler, Judith, 30
Weill, Kurt, *The Threepenny*
 Opera, 56
Weiner, Jonathan, 44
Weir, Stuart, 167
Weisz, Victor (Vicky), 40, 137;
 "Conservative Road for
 Britain," *41*; Supermac,
 41, 42, 120, 121–2
Wells, H. G., 167
Weltbühne, Die, 104
Werenfels, Isabelle, 189
Westergaard, Kurt, 208
West Indians, 172
Whetton, Cris, 11–12
Whigs, 61, 62
Wilhelm, Kaiser, 32
Wilkinson, Signe, 95
Williams, Tennessee, 134
Wilson, Charles, 117

Wittgenstein, Ludwig,
 Philosophical
 Investigations, 144
Woolf, Leonard, 167
Workers International
 Relief, 94
World War I, 32, 43, 87, 89,
 93, 94, 99
World War II, 9, 36, 40, 93,
 117, 123, 125, 145
World Wide Web, 46–7

Yadav, Harish (Mussveer),
 208
Yale University, xvi–xviii, 15,
 145, 182–3
Yemen, 4, 205
Yoonoos, Jiffry, 4, 204
Young, Art, 43, 87–90, 93,
 201; "Gee Annie, look
 at the stars, thick as
 bedbugs!," *87*; "Having
 Their Fling," *86*;
 "Jesus Christ Wanted,"
 88; "Poisoned at the
 Source," 88, *89*

Zapiro, *see* Shapiro, Jonathan
Zec, Donald, 118
Zec, Philip, 117–19; "The
 price of petrol has been
 increased by one penny,"
 37–8, *116,* 117–18
Zeki, Semir, 24, 44
Zion, Sidney, 141
Zlatkovsky, Mikhail, 204
Zoroastrianism, 177
Zulus, 192, 193
Zuma, Jacob, 191–4, 195*n,* 207

Illustration Credits

xii, 196: © Eve and Matthew Levine

xix: Public Domain

xx: Public Domain

xxi: Public Domain

xxii: Public Domain

5: © Kostas Bostantzoglou

6: © Brad Holland

8: © Edward Sorel

9: © Solo Syndication / Associated Newspapers Ltd.

11: Reprinted with permission from *The Nation* magazine. For subscription information, call 1–800–333–8536. Portions of each week's *Nation* magazine can be accessed at http://www.thenation.com.

13: Cover artwork for the July 21, 2008 issue of *The New Yorker* by Barry Blitt. Copyright © 2008 by Barry Blitt.

16–17: © *Monocle*

29: Public Domain

30: Public Domain

31: © Robert Edwards

33: Public Domain

34: A 1954 Herblock Cartoon © The Herb Block Foundation

35: Public Domain

41: © Solo Syndication / Associated Newspapers Ltd.

42: © Eve and Matthew Levine

43: © The Saul Steinberg Foundation / Artists Rights Society (ARS), New York

45: Courtesy of Randall Bytwerk

54: Public Domain

57: Public Domain

58: Public Domain

60: Public Domain

63: Public Domain

64: Public Domain

70: Public Domain

74: Public Domain

76: Public Domain

77: Public Domain

78 (both): Public Domain

79: Public Domain

81: Public Domain

82–83: © 2012 Estate of Pablo Picasso / Artists Rights Society (ARS), New York

86: Public Domain

87: Public Domain

88: Public Domain

89: Public Domain

91: Public Domain

92: © 2012 Artists Rights Society (ARS), New York / VG Bild-Kunst, Bonn

95: © Frances Jetter

98: Art © Estate of George Grosz / Licensed by VAGA, New York, NY

101: Art © Estate of George Grosz / Licensed by VAGA, New York, NY

102: © 2012 Artists Rights Society (ARS), New York / VG Bild-Kunst, Bonn

105: © 2012 Artists Rights Society (ARS), New York / VG Bild-Kunst, Bonn

106: Courtesy of Randall Bytwerk

108 (both): Courtesy of Randall Bytwerk

109: *Akhbar al Khaleej*

110: © Dave Brown 2003

112: © Solo Syndication / Associated Newspapers Ltd.

113: © Solo Syndication / Associated Newspapers Ltd.

114: © Solo Syndication / Associated Newspapers Ltd.

115: © Solo Syndication / Associated Newspapers Ltd.

116: © Mirrorpix

120: Solo Syndication / Associated Newspapers Ltd.

124: © Estate of Bill Mauldin LLC

128: A 1954 Herblock Cartoon © The Herb Block Foundation

130: A 1954 Herblock Cartoon © The Herb Block Foundation

132: © The Al Hirschfeld Foundation. www.AlHirschfeld Foundation.org. Al Hirschfeld is represented by the Margo Feiden Galleries Ltd., New York

136: © Solo Syndication / Associated Newspapers Ltd.

138: © Solo Syndication / Associated Newspapers Ltd.

140: © Ralph STEADman

147: © Robert Edwards

150 (both): © Khalid El-Ali (on behalf of the estate of Naji El-Ali)

154: © Edward Sorel

157: © Bill Charmatz. Reprinted with permission from *The Nation* magazine. For subscription information, call 1–800–333–8536. Portions of each week's *Nation* magazine can be accessed at http://www .thenation.com.

161 (both): © Robert Grossman

163: © Robert Grossman

166: Public Domain

170: Cover artwork for the February 15, 1993, issue of *The New Yorker* by Art Spiegelman. Copyright © 1993 by Art Spiegelman.

173: Cover artwork for the March 8, 1999, issue of *The New Yorker* by Art Spiegelman. Copyright © 1999 by Art Spiegelman.

176: © Doug Marlette

180: © Plantu

186 (both): *Novinar*

188: *Novinar*

190: © Zapiro

INSERT

1 (both): Public Domain

2 (top): © Ralph STEADman

2 (bottom): © Edward Sorel

3 (top): Public Domain

3 (bottom): *Novinar*

4 (top): Cover artwork for the February 15, 1993, issue of *The New Yorker* by Art Spiegelman. Copyright © 1993 by Art Spiegelman.

4 (bottom): Cover artwork for the March 8, 1999, issue of *The New Yorker* by Art Spiegelman. Copyright © 1999 by Art Spiegelman.